The Treasure Hunter's Handbook

Britain's buried treasure – and how to find it

Brian Grove

D1328898

pıatkus

PIATKUS

First published in Great Britain in 2005 by Piatkus Books Limited
This paperback edition published in 2010 by Piatkus
Reprinted 2012 (twice), 2013, 2014

A CIP catalogue record for this book
is available from the British Library.

ISBN 978-0-7499-4136-9

Edited by Krystyna Mayer
Text design by Paul Saunders

Typeset by Action Publishing Technology Ltd, Gloucester
Printed and bound by CPI Group (UK) Ltd, Croydon, CR0 4YY

Papers used by Piatkus are from well-managed forests
and other responsible sources.

MIX
Paper from
responsible sources
FSC
www.fsc.org FSC® C104740

Piatkus
An imprint of
Little, Brown Book Group
100 Victoria Embankment
London EC4Y 0DY

An Hachette UK Company
www.hachette.co.uk

www.piatkus.co.uk

Contents

Introduction

RIGHT NOW, as you are reading this, billions of pounds worth of treasure is buried just beneath your feet. At the same time, there are people out there looking for this treasure. The treasure includes hoards of gold and silver coins, ornate figurines and chalices, ancient jewels with royal connections, gold nuggets, gemstones, pirate treasure and ancient ceremonial tools and weapons, in some instances worth tens or even hundreds of thousands of pounds. You would probably think this was a plausible notion if I was talking in the context of the world as a whole, but in fact I'm only actually talking about Britain.

I doubt whether there has ever been anyone who hasn't lost something valuable – money, a piece of jewellery or something else precious relative to the period in which they lived. If you try to imagine the number of people who have lived throughout history, you may begin to get an idea of what this means. Then you need to add to that the huge amount of treasure that has been buried deliberately; and there's the natural treasure – gold and gemstones, for example, both of which are found in Britain. Millions of pounds worth of gold have been extracted from the hills of Scotland and Wales over the centuries. If you are reading this on a hot day, I guarantee there will be people

out there panning for gold at this very moment, and searching for gemstones.

Some treasure is relatively easily to find. Metal detectors are a fairly recent invention, and with the help of these thousands of valuable artefacts are found annually by detectorists, with millions more waiting to be discovered. Bottle digging is another little-known hobby. Bottle diggers seek out Victorian and Edwardian dumps and recover artefacts that were considered rubbish at the time they were made, but have value now. Bottles, pots and other collectables materialise in every dump, and each one is worth something. Fossils are another popular area of collecting. You would be amazed how much some fossils trade for when you consider how easy they can be to find.

I've no idea what first triggered my interest in treasure, but my grandfather was a gold miner in the 1930s. Dad recounts a great story, which was apparently common among miners at the time. Periodically my grandfather would return home, reach into the back of his mouth, pull out a small nugget, place it on the table in front of him and say to my grandmother, 'There you are, love – the rates,' much to her (we suspect feigned) disapproval. Another childhood memory was of reading a book about the Californian gold rush. The pioneering spirit of the individuals involved enthralled me. That is when I became an occasional treasure hunter – finding a wild pearl as a boy (*see page 130*), metal detecting as a youth and digging for bottles as an adult.

So what constitutes treasure? Well, for the purposes of this book, anything you can dig out of the ground worth money, outside farming. Some people are squeamish about selling artefacts. I'm not. Providing you stay within the law, if you choose to sell your finds that's your business – and in any case, they will generally end up in the hands of someone who values heritage above money. *The Treasure Hunter's Handbook* is written with a heavy emphasis on techniques, locations and valuations. It

discusses how to find treasure, where to look for it and what the finds are worth. There are also many great stories about people who have actually found valuable treasure in Britain.

There have been numerous books written about treasure hunting, but this is the first time – at least as far as I am aware – that all the aspects of a broad range of treasure-hunting subjects have been brought together in one easy-to-read, practical guide specific to Britain. I'm not an obsessive hobbyist or an academic, and I certainly don't claim to be a leading expert on treasure hunting. I've just done my research and, with some personal experience and help from a lot of knowledgeable individuals, written the type of book I would buy were it available. Whether you just want to do a little treasure hunting part-time, or go all out for it, everything you need to get you started is here.

If I could sum up how I think what you will learn by reading this book can best be utilised, I would suggest a hypothetical walk around Britain. You will go over the mountains, valleys and streams to search for gold and gemstones, and to the meadows of middle England to look for buried historical treasure. You will search the quarries and mines for fossils and minerals, and check out the coastal locations – the beach for its modern coins and jewellery, and the cliffs and foreshores for the remains of long-extinct creatures. You will read wonderful stories about ordinary people who have found fabulous treasure, as well as gaining indispensable practical guidance to discovering some for yourself. Treat *The Treasure Hunter's Handbook* as a book of possibilities.

Happy hunting.

Brian Grove

CHAPTER ONE

Metal Detecting

MENTION THE WORDS metal detector and you will get different reactions from different people. To some it means walking through security at airports, while builders and DIY enthusiasts use detectors to locate hidden pipes or cables. To a handful of dedicated treasure hunters, however, metal detectors are linked to the search for buried treasure.

Devices that can detect metal have been in existence for well over a hundred years. In 1881 the Scottish physicist Alexander Graham Bell used a primitive device in an attempt to locate a bullet lodged in the back of the American President James Garfield. In 1937 Dr Gerhard Fisher patented a machine that incorporated a resonating searchcoil powered by a battery – the first metal detector. During the Second World War his designs were put into practice as mine detectors, and after the war a glut of surplus machines came onto the market, which were snapped up by fledgling treasure hunters. The hobby of metal detecting was born.

Early metal detectors were crude, unreliable and used far too much battery power. The next major development came in the 1960s with the invention of the transistor. Detectors became lighter and more reliable, and used far less battery power. The

hobby of metal detecting grew in the 1970s, and manufacturers sprang up everywhere to feed a growing demand. Metal detecting reached a crescendo in the 1980s, when over 50,000 people were involved in the UK alone. Today there are around 30,000 detectorists, and 3,000 new machines are sold each year.

Metal detecting is a hobby that can appeal to people of all ages and backgrounds. Detecting can be a solo hobby, or it can be done with friends or family, or by attending metal-detecting rallies. It has obvious benefits for participants, such as providing gentle exercise and fresh air, but most important, of course, are the finds. These range from individual coins and artefacts, to hoards worth tens or even hundreds of thousands of pounds. There is nothing quite like that beep in your headphones – it really could be anything ...

A major find for a first-time detectorist

In September 1998 cousins Kevin and Martin Elliot were metal detecting in a field of barley stubble on the family farm at Shapwick, near Glastonbury. Kevin had never used a detector before and had just received instruction from Martin, an experienced detectorist. Within minutes he found a coin in a gateway. Mr Elliot was milking at the time, and was surprised when Kevin appeared saying he wanted a bucket. Fifteen minutes later he returned with the bucket full to the brim with coins. Within a short period the cousins filled several more buckets with thousands more coins that were buried just beneath the surface.

In total, Kevin and Martin unearthed over 9,000 Roman denarii. The find comprised the largest single hoard of Roman silver coins ever discovered in Britain, three times the size of the previous largest find. The hoard was reported to the West Somerset coroner and the coins were transferred to the British Museum for cleaning and identification. Excavation of the find spot by archaeologists established that the coins had been

buried in the corner of a room of a previously unknown Roman villa. A few later bronze coins were also found, suggesting that the site had continued to be occupied for some time.

The earliest coins found came from around 31 BC, the time of the emperor Mark Antony's reign; the latest were minted for the emperor Severus Alexander, who reigned until AD 224. Most of the coins were produced in Rome, Egypt and Syria, and depicted images of classical gods and goddesses, imperial events and battle victories. The majority of the coins were relatively common, and many were in poor condition, but apart from its sheer size two anomalies set the hoard apart.

The first was that two of the coins were exceptionally rare. They depicted Manila Scantilla, wife of Didius Julianus, one of the more obscure Roman emperors who ruled for just sixty-six days before being murdered in AD 193 during a period of civil war.

The second thing that made the hoard exceptional was that it is unusual for any treasure to be discovered from the early part of the third century, a time of relative peace and prosperity. Finds usually date from towards the end of the Roman empire, when enemies were closing in and valuables were hastily hidden away. The hoard represented the equivalent of ten years' pay for a Roman legionary, and there is no way of knowing why they were never retrieved.

Martin's family had been farming the land as tenants for thirty-six years until they bought it in January 1997, allowing them to search for treasure for the first time. Martin's father built him his first metal detector when he was ten, and this was his first big find. In November 1999 Somerset coroner Michael Rose declared the coins treasure, and as such they belonged to the finders. Grants to enable Somerset County Museum to buy the coins came from Somerset County Council, the National Heritage Memorial Fund, the National Art Collections Fund and the Victoria and Albert Museum. The coins are currently on

display at the County Museum in Taunton, and Kevin and Martin received a reward of £265,000.

How does a metal detector work?

The three main components that make up a metal detector are: an oscillator, a frequency amplifier and a battery. The oscillator is essentially a coil of wire with a current flowing through it, supplied by the battery. The oscillator generates an electromagnetic field, and as that magnetic field passes over a metallic object the properties of the coil change. This change can be measured and converted into a signal.

The four main parts that make up a metal detector are:

1. **Stabiliser** This is the armrest designed to counter-balance the weight of the detector, providing stability while searching.

2. **Control unit** This contains the circuitry and batteries. It also houses the controls necessary to operate the detector. Some control units also have an additional display screen.

3. **Stem** This connects the control unit to the searchcoil. The stem can be adjusted to suit the height of the user.

4. **Searchcoil** Also known as the search head, loop or antenna, the searchcoil is the part that actually detects the metal. Standard ones are usually 20 cm in diameter.

What will a metal detector find?

The two most commonly asked questions regarding metal detectors are: how deep will they search, and what will they find? The answers to these questions depend to one degree or another on a combination of factors.

A metal detector will emit a signal when passed over any

object that is made wholly or partially of metal. The larger an object is, the deeper it is likely to be detected. Typically coins will be found if buried up to 20 cm deep, although larger coins may be found at deeper levels. A hoard of coins could be detected at a depth of 60 cm or more, but a badly positioned coin, one buried on its edge for example, may be missed. Detectors measure surface area, not mass. The length of time a metallic object has been buried will also have an effect on its detectability.

Metal detectors will detect gold, silver, coins, jewellery, necklaces, bracelets and watches, in fact anything valuable that is made of metal. Unfortunately they will also detect tin cans, pull rings, bottle tops, hinges, brackets, rusty nails and other rubbish. To address this problem modern metal detectors incorporate a facility called a discriminator. In discriminator mode, a detector can be made to differentiate between the two classes of metals – ferrous (or containing iron) and nonferrous – an obvious advantage for detectorists. Unfortunately there is usually a trade-off between discrimination and the depth an object can be found – using a discriminator will help eliminate the rubbish but may also reduce depth range.

The size of an object, how deep it is buried, how it is positioned in the ground, its metallic composition and the period of time it has been buried all come into play. In addition you have to consider ground conditions and the skill of the operator. This final component, the skill of the operator, is the single most important factor in metal detecting. Getting to know your detector and learning to use it properly are the two most important things a detectorist can do to maximise finds.

Buying a metal detector

There are several things you need to consider when deciding which metal detector to buy. Be honest with yourself about how

much use you are likely to get out of it. Metal detectors can be bought for as little as £100, but can also cost well over £1,000. There is little point in paying a fortune for a machine that is going to spend most of its time in a cupboard. Having said that, a detector must be adequate for the job, which eliminates the cheap 'fun' machines. A quality detector will cost you about £300.

You will hear many confusing terms being bandied about when researching which machine to buy – surface mount, motion, non-motion, RF two box, pulse induction, TR, VLF, VLF/TR and so on. They all have meanings, of course, but they need not concern you. Once you have decided on a budget, and have some idea of where you intend searching, a specialist retailer will be able to guide you through the jargon and point you in the right direction. Choose a retailer that supplies a range of detectors from all the leading manufacturers. These include, in no particular order of merit, Bounty Hunter, Fisher, Garrett, Minelab, Tesoro and Whites, but there are several others, too. Absorb as much information as you can before reaching a decision.

Read the reviews and independent field tests that are regularly conducted in metal-detecting magazines and on the Internet. A dealer may have a test area where you can try out models, which is well worth considering. Buying second-hand from the classifieds is not recommended. Detectors are sensitive scientific instruments and are susceptible to knocks and bumps, so you may find the reason a detector is up for sale isn't one you had bargained for. Don't buy blind, either, from a catalogue or by mail order, for example; the chances of finding the right machine for you are virtually zero.

Finally, consider how fit you are. You will be using your detector for prolonged periods of time, and although most modern detectors are fairly lightweight, some can weigh up to twice as much as others. Ask yourself the following questions:

What is my budget? What types of objects will I be searching for? Where do I intend searching, and how often? Some detectors are much better at certain tasks than others, so firm answers to these questions will help narrow down the options for you.

Ground effect

One of the main problems detectorists face is the effect the ground has on the detector. Mineralisation in the form of ferrous oxide (iron) in soil can register signals on a detector that don't exist. On beaches, the interaction of salt in the water can make the sand conductive. Detectors have a built-in facility to counteract this, called ground balancing. Ground balancing can either be automatic (preset by the manufacturer), or manual, allowing the user to adjust for various conditions. In most circumstances automatic ground balancing is fine, but if, for instance, you wish to search for gold nuggets in mountainous areas, where there is a lot of naturally occurring ferrous oxide, it could be advantageous to have a manual ground-balancing feature on your metal detector.

Features of metal detectors

Every make and model of detector comes with its own range of gadgets and gizmos, each of which will vary in complexity depending on how much you spend. The discrimination feature on a cheaper model, for example, may be relatively primitive, while a higher priced machine is likely to incorporate a sophisticated computerised system. Here are some terms for the more common features found on detectors, and their meanings:

1. **Target ID** This can be either an audio or visual indicator (*see* Visual ID *below*). Target ID is designed to help identify an object before digging it up.

2. **Depth indicator** A facility that helps measure the depth of a find.

3. **Notch discrimination** A type of discrimination feature. Can be set to either accept a narrow band of finds (notch accept) or reject a narrow band of finds (notch reject).

4. **Target pinpointing** A feature that will accurately pinpoint the position of a find.

5. **Visual ID** This can be either a LCD (Liquid Crystal Display) or a meter/needle indicator that registers a visual signal in addition to an audio tone.

A word of caution here. Learning to use a detector requires practice, and too many features can overly complicate a machine, making it unsuitable for beginners. It's also worth remembering that many metal detectors only work up to a point. A relatively expensive detector may have target ID, but target ID will only tell you what an object probably is, not what it definitely is. A pull ring can read the same as a gold ring. There is also a huge range of accessories available, none of which are particularly essential, or even desirable in some cases for the beginner, so think carefully about what you really need and are actually prepared to pay for.

Most importantly, don't let any of the literature convince you that the more expensive machines will detect finds at greater depths than the reasonably priced machines. Some detectorists say they do, others say they don't. I think it can be concluded that the difference, if any, is negligible. Most finds come from the top 10 cm of soil anyway, and near to the surface a lower priced detector will locate the same finds as an expensive model. Decide on a budget first, then address the other considerations within it.

Once you have decided on a detector, you could make a considerable saving by buying an ex-demonstration or second-hand machine from a retailer. Make sure, though, that you are offered a comprehensive guarantee or warranty.

One essential piece of equipment all detectorists need is a 'digger' to retrieve finds. As well as being durable a digger needs to be lightweight, because you will be carrying it around for many hours. It is possible to make your own digger by cutting down a garden spade, but there is a range of reasonably priced ones available from detector suppliers.

Using a metal detector

Once you have bought your metal detector you need to learn how to use it correctly. The first technique to master is called sweeping.

Sweeping

Keep the searchcoil parallel to the ground, and no more than 2 to 3 cm above it. Sweep the searchcoil from side to side in a semi-circular motion. Sweep systematically, overlapping a little each time and making sure you don't miss anything. Beginners have a tendency to tilt the searchcoil and lift the head from the ground, both of which cause loss of detection and depth. Moving the searchcoil too quickly also results in missed signals.

Listen carefully for signals while sweeping. Don't just dig the loud signals – a faint signal may be a small or deep object. If in doubt go back and check again. Bury some coins and other items in your garden and familiarise yourself with the different signals they produce. Eventually, as you become more experienced, you will learn to distinguish between the different signals and dig up less rubbish. If you live in an old property, or have a friend or relative who does, this is as good a place as any to get some practice. Having seen concentrated human activity throughout its history the land around an old property will almost certainly contain some predecimal coins and possibly even the odd valuable, and being private land it is unlikely to

have been searched before. You will also get a crash course in excavating junk!

Pinpointing

Once you have detected a signal you will need to pinpoint the target accurately, which saves digging a large hole. If you have a pinpointing facility the target should be located directly below the centre of the searchcoil. If not, the target can be located by moving the coil over the area at 90-degree angles in an X-shaped pattern, and noting where the signal is strongest.

Retrieving a find

Once you have pinpointed the target, carefully dig out a few centimetres of soil and check among the surface material for a signal. This is where a depth indicator can be useful. After you have retrieved your find it is a good idea to run the detector over the hole again to ensure you haven't missed anything – hoards often start with just one coin. Always refill the hole, and neatly replace any turf.

Dealing with finds

Certain metallic compositions deteriorate quickly when exposed to air. After digging out your find wash it gently with water and pat it dry. Coating with olive oil can provide a little extra protection. Unless you are happy that a find has little value, leave any cleaning and restoration to an expert. Modern coins can be brought into spendable condition with various types of cleaning kit, advertisements for which can be found in specialist treasure-hunting magazines.

Where to search

With a little practice under your belt, it is time to start detecting for real. In general terms this will be for either modern or historical finds. You can divide the types of site likely to contain each of these broadly into two categories. A few suggestions for modern finds include fairgrounds, parks, pathways, playing fields, festival grounds and pub gardens. For historical finds try farms, country houses, religious buildings, woodland, lakesides and meadows. Sites and finds often overlap, of course – many an historical coin has been found in a public area.

Researching the history of a particular site can often prove rewarding. Start with the library, study old maps and check books and historical documents for evidence of villages and buildings that once existed in your chosen location. Take a look at the land and try to visualise where you would have lived – sheltered from the elements, perhaps, or near a spring. According to a 1995 survey, detectorists find as many as 400,000 objects of historical significance each year, and 89 per cent of these are recovered from ploughed land, so farms are an obvious target. It transpired the Shapwick Hoard (*see page 5*) came from a Roman settlement, but as far as Kevin and Martin were concerned they were just searching a field, so in addition to research, a little imagination is clearly required.

If the land you wish to search is private, the first priority is to get permission to do so. The direct approach usually works best – knocking on someone's door, for example. Many people's natural inclination is to say no, but if you have done your research and show an interest in the history of the land, it will show diligence and may persuade an owner to let you go ahead. An offer to split finds 50–50 also helps. If you intend detecting on your own, always tell someone where you are going and when you expect to return, wear clothing appropriate to the

conditions and take a supply of provisions unless you know they are readily available.

When searching an area the key is to find the hot spot(s), places where there has been a high concentration of human activity. Take a look at modern sites when they are in use. On historical sites look for signs of previous habitation such as patches of worked stone or shards of broken pottery. Search each area carefully and methodically. Think logically about where you are and adjust your machine accordingly. With discrimination remember that the higher the setting, the less detection depth you will get. Adjust as low as conditions will allow and be prepared to dig up some rubbish, otherwise you will miss some good finds.

As a beginner the first few times you go out detecting will be fairly unproductive compared with subsequent trips. Don't worry – you are just learning to use your machine. If an experienced detectorist were to search a patch of ground previously covered by a novice, finds would almost certainly turn up; it's just a question of experience. Finally, don't be too concerned if you have found somewhere that you think looks so promising that you can't possibly be the first there. Just because an area has been covered before does not mean there is nothing left in it. Detectorists have a saying: 'Nobody gets it all.'

British coins

All detectorists find the odd historical coin every now and then. Nothing beats the excitement of digging up an old coin, and part of the fun is trying to discover what it is, and whether it has any value. Some of the earliest coins in Britain were Celtic. Early Celtic coins were hand struck and have quite a rough appearance – it wasn't until relatively recently that machine dies came into use. Roman coins were in circulation by the middle of the first century AD following the Roman invasion of Britain in

AD 43, and they remained in circulation until the Romans left Britain at the beginning of the fifth century. Anglo-Saxon coins began to appear later, and continued to be issued until the Norman Conquest in the eleventh century and the beginnings of what we know as predecimal modern coinage. Many early coins have historic and often collectable value and should be considered rare finds.

Celtic and Roman coin finds that haven't deteriorated will almost certainly have some value, but many are not as uncommon as you may think. Collectors now have full access to a global market and there are plenty for sale. Common sense will tell you that gold or silver coins will generally be more valuable than those made of base metal because they deteriorate less, but values depend on a lot of other factors.

Celtic coins

Celtic coins were among the earliest coins to appear in Britain in around the second century BC, and they were either hand struck or cast from bronze, silver or gold. The stater, a very popular coin of the period, was often concave in shape, and has the appearance of being more like a stamped sculpture than a coin. Celtic coins often have distinctive patterning, with pictorials of gods and goddesses, the sun or the Moon, birds and animals, and sometimes morphed combinations.

Values Celtic coins are typically worth from just a few pounds rising to several hundred pounds for the rarer examples; near-unique coins have been known to sell for in excess of £1,000.

Roman coins

Following the Roman invasion, Roman coinage became the order of the day and remained so until the end of the fourth century. There is a vast array of Roman coin designs spanning

the various emperors. The denominations of Roman currency were based on the relative weight of the coins and the value of the constituent metal, and these could be altered depending on economic conditions. Roman coins were hand struck and are generally off-centre. Sometimes coins were cut in half to make change, and as was the case with Celtic currency there were also forgeries – base metal coins that were coated with silver or gold.

The four most common denominations of Roman coinage were the aureus, denarius, sesertius and as. There were other, less common denominations, too.

Aureus

The aureus was a gold coin, which had a value of 25 denarii. The aureus's standard weight was 7.8 grams and it was 20 mm in diameter. There was also a half aureus, which was also gold and half the weight, and measured 15 mm in diameter.

Denarius

The denarii were silver coins, 19 mm across and weighing 3.8 grams. The denarius was in circulation for around 400 years and as a result is one of the most commonly found Roman coins.

Sesertius

The sesertius was worth one-quarter of a denarius. Early sesertii were made of silver, later ones from an alloy. Sesertii were huge coins, approximately 30 mm in diameter and weighing 30 grams.

As

The as was the basic unit of Roman currency and was worth one-quarter of a sesertius. Asses were made of copper or bronze, weighed 11 grams and were around 26 mm in diameter.

Values Roman coins in collectable condition can be worth

anything from under £10 for common varieties, right up to £10,000 plus for unique examples. Coins in poor condition, however, have very little value, and are often sold in batches.

Anglo-Saxon to predecimal coins

Following the Roman occupation Britain began to mint her own coins. Listed below are some of the coins that were minted in the UK from the Anglo-Saxon period right up until decimalisation. I have by no means covered the whole spectrum, and for brevity I have dispensed with detailed descriptions and used approximate weights and sizes to help with identification. More detailed descriptions can be found in some of the excellent specialist books available.

The valuation figures given for the coins are approximate, and based on a coin being in 'fine' condition, which is about midway between poor and mint. Fine means that inscriptions and dates must be visible, but the coin will have some wear. Fine is the minimum condition collectors require, and the best that can be expected from a coin dug out of the ground. Coins in better condition are worth considerably more – 'extremely fine', for example, could command a value of perhaps five to ten times more.

Many predecimal coins had fixed denominations that were inter-devisable. For example, where our 10p is worth 2 x 5p, 5 x 2p and 10 x 1p, an old 2 shilling piece was worth 2 x 1 shilling, 4 x sixpence, 6 x three pennies, and so on. The descriptions below start with the sovereign, one of the highest denominations, and work down from there, although not all denominations are covered.

Sovereign and guinea

Coins of a higher denomination than the sovereign or guinea have been minted, but a sovereign or guinea would be an exceptional find. A sovereign was worth 20 shillings, a guinea 21. The

guinea was first introduced by Charles II in 1663, and was minted until 1799. The sovereign dates from 1489, starting from Henry VII's reign. It ran to 1553, and then was minted again from 1603 to 1604, and for most of the years between 1817 and 1917, and is still issued as a bullion coin today. In 1816 the sovereign officially replaced the guinea as a staple unit of currency, being worth one pound, although interestingly the guinea is still used as a unit by some auction houses and in horse-breeding circles. Both guineas and sovereigns are made from gold, the guinea being the larger of the two coins, typically 25 mm in diameter and weighing 8.4 grams, with the sovereign being 22 mm and 8 grams respectively. The guinea was often embellished with an elephant/castle design, and there are numerous designs on sovereigns.

Values A guinea in fine condition would be worth between £85 and £700, a sovereign from £55 to £500, and with both generally the older they are the more valuable they tend to be. Exceptional issues include the 1917 sovereign, which would fetch £2,500, and some early guineas are also extremely rare and worth many thousands of pounds.

Half sovereign and half guinea

The half sovereign and half guinea are, as their names suggest, half denominations of the one sovereign and guinea coins. The half guinea was minted between 1669 and 1813, the half sovereign between 1544 and 1553, 1603 and 1604, and 1817 through to 1937, and then again from 1980 to the present day. A half guinea is 20 mm in diameter and weighs 4.2 grams, while the sovereign is 19 mm and 4 grams.

Values Half guineas are worth between £55 to £400 or more for the older examples, half sovereigns £50 to perhaps £200.

Crown

The crown was worth 5 shillings, half of a half sovereign. The crown was first struck as a gold coin in 1526 during the reign of Henry VIII, and a silver version followed in 1551. Gold and silver crowns continued to be minted up until 1662, when the gold versions were phased out. The crown continued as currency right up until 1965, although none were produced between 1751 and 1818. The denomination ended in 1965, although coins of the same size are still minted today with £5 face values. Crowns were large coins, 39 mm in diameter and weighing 28 grams, allowing for a lot of detail in their design.

Values A crown needs to be pre-Second World War and in fine condition to have any value. They are worth from a few pounds up to £100 or more for some of the very early examples. Some later editions are also valuable, such as the 1934 crown, which is worth £400.

Half crown

The half crown is worth 2 shillings and 6 pence. Circulation dates mirror those of the crown, except that the half crown was minted for five years longer, until 1971. The half crown, like many other British coins, was 97.5 per cent silver, but the content was reduced to 50 per cent in 1920 due to the rise in silver prices. The half crown typically measured 32 mm and weighed 14 grams, and featured many designs and portraits of monarchs.

Values Like crowns, half crowns need to be pre-Second World War to be worth anything. Prices start at £1 to £2, and rise to £50 plus for much older examples. Exceptional issues include the 1905, which is worth £150, and an 1839 example worth £400.

Florin

The florin, or 2 shilling piece, is the currency equivalent of our modern 10p. The florin was minted between 1849 and 1970, and

early versions were made of silver. The florin typically measured 28 mm and weighed 11.3 grams, although sizes fluctuated. Between 1851 and 1887, 30 mm coins were issued featuring a Gothic script that became known as the Gothic florin. In 1920 the florin's silver content was reduced to 50 per cent, and in 1947 it began to be produced in 75 per cent copper and 25 per cent nickel. From 1936 the word florin was removed from the coin and it became the 2 shilling piece, and in 1968 it reverted to the decimal 10p.

Values Pre-1946 florins start at around £1, rising to between £4 and £14 for nineteenth-century examples. Occasional years are worth considerably more, such as the 1863, worth £175, and the 1854, worth £500.

Shilling

The shilling piece was equivalent to 12 old pennies. The coin was first introduced in 1502 during the reign of Henry VII, and went on to have an impressive 488-year history, featuring the heads of no less than a dozen different monarchs. The shilling weighed 5.8 grams and measured 24 mm, although this fluctuated up to 26 mm. As in the case of the florin, the shilling's silver content was reduced to 50 per cent in 1920, and it began to be produced in copper/nickel in 1947. After decimalisation the shilling continued in circulation until 1990, when it was replaced by the 5p coin.

Values The older the shilling is the more valuable it is likely to be, but there are many exceptions and the following should only be treated as a guide: twentieth century (pre-1920), £1; nineteenth century, £2 to £7.50; eighteenth century, £10 to £50; seventeenth century, £35 to £100. Rarer examples include a 1905 issue worth £50, an 1863 issue worth £80 and an 1850 issue worth £300. There are additionally many special editions, which also command higher prices.

Sixpence

The sixpence, often referred to as a 'tanner', was worth half a shilling. Sixpences were introduced fifty years later than the shilling by Edward VI and featured a portrait of the king. Early sixpences measured 21 mm and weighed 3 grams, but in 1816 this was reduced to 19 mm and 2.8 grams respectively. Production of the sixpence mirrored the shilling throughout its history, and continued for a few years after decimalisation until 1980 with a value of 2.5p.

Values Pre-1920 silver sixpences start at £1, rising to £50 or more for some very early examples. Occasional issues are worth between £10 and £50. An 1893 sixpence with a jubilee head is valued at £200.

Groat

The groat is one of Britain's oldest coins, and was first in circulation during the reign of Edward I in 1279. Early hammered groats were worth the equivalent of 4 pennies, and were issued in various sizes and designs right through until 1662, when they were withdrawn. Between 1836 and 1862 a new standardised groat was introduced, depicting an image of Britannia. The Britannia groat measured 16 mm and weighed 1.9 grams. The groat is still minted today and used as Maundy money for celebrations on the Thursday before Easter, reclassified with a value of 4p.

Values A Britannia groat is typically worth £5 in fine condition, while very early hammered versions are worth considerably more.

Threepence

The threepence was first introduced in 1551 during the reign of Edward VI but proved unpopular, and it wasn't until the mid to late seventeenth century that production recommenced. Early

issues varied in size from 19 to 21 mm, but by 1845 the standardised silver threepence was in general circulation, measuring 16 mm and weighing 1.4 grams. In 1937 a twelve-sided nickel and brass threepence was introduced, although the silver version continued to be minted until the 1950s.

Values Threepence coins from the turn of the twentieth century and before are worth anything from £1 to £10. Exceptions include an 1869 example worth £30 and one from 1765 worth £100. You may get £1 for an early twentieth-century silver example, but generally they need to be better than fine condition. Twelve-sided threepence coins are very common and virtually worthless, although a 1946 or 1949 example might command a couple of pounds.

Half groat or two pence

The silver two pence, or half groat, was first issued by Edward III in 1351, and remained in circulation until 1795. In 1797 a copper two pence was introduced which was huge – 41 mm in diameter, 5 mm thick and weighing 56.7 grams. It proved too cumbersome and was withdrawn after one year and no more two pence coins were issued again until modern decimalisation.

Values Silver two pence coins are worth anything from around £5, rising to between £15 and £20 for much earlier examples. A 1797 copper two pence in fine condition has a value of £18, a 1766 silver example, £100.

Penny

The penny is the oldest surviving British coin, and the one by which others were measured. The abbreviation 'd', as in 1d, derives from the Roman denarius coin. The penny was first introduced to England in AD 785 by king Offa of Mercia, and it was eventually, for a time, virtually the only denomination in circulation. Early pennies were silver, and the Norman, Tudor

and Stuart periods saw numerous sizes, weights and designs issued. The copper penny emerged at the beginning of the nineteenth century measuring 34 mm and weighing 18.8 grams, although there was also a larger 'cartwheel penny'. In 1860 the penny's metallic composition was changed to bronze, and its size was reduced from 34 to 31 mm, its weight by half from 18.8 to 9.4 grams. This penny remained in circulation until 1970.

Values To have any value the newer bronze pennies need to be from the nineteenth century. These fluctuate from £2 to £3 on either side of £5. Copper pennies are worth anything from £5 rising to around £9 to £12 for the pre-Victorian examples. Seventeenth- to eighteenth-century silver pennies typically command £6 to £10. The value of early examples depends on period and design, and there are many years that are worth considerably more than others. The Holy Grail is the 1933 penny, which would be absolutely priceless if one was found, but beware – there are a lot of forgeries!

Halfpenny

The halfpenny's history has been almost as impressive as that of the penny. Detectorists have found silver halfpennies from as early as the reign of Henry I (1100–1135). There have been many halfpennies issued: a copper one was introduced in 1672, a tin one in 1685, then it was back to copper in 1694. In 1860 a bronze halfpenny was settled upon that was 28 mm in diameter and weighed 9.3 grams. This ran until 1969 – the onset of decimalisation.

Values Turn of the twentieth century bronze halfpenny coins start at £1 and rise to £4 for earlier examples. Copper halfpenny coins are worth from £4 rising to £30, £50 or even £75 for very early issues. Tin halfpennies are worth £100 plus. A real rarity would be an 1689 halfpenny, worth £300.

Farthing

Finally we reach the lowly farthing, worth one-quarter of a penny. Bronze farthings were 20 mm in diameter, about the same size as our modern 1p, and weighed 2.8 grams. There were also one-third and one-quarter farthings, which were even smaller. Silver farthings have been in existence since the thirteenth century, but these were tiny and are very difficult to detect. In 1672 a copper farthing was introduced, and along with the penny and halfpenny a bronze version began to be produced in 1860. The farthing was withdrawn in the 1950s.

Values Pre-twentieth-century bronze farthings are worth between £1 and £2. Copper issues start at £2 and rise to £30 or even £50 for the very early issues. A few of the later years stand out, with values from £10 to £25, but the real rarity is the 1860 farthing, worth £750.

The Hoxne Treasure

On Monday 16 November 1992 Eric Lawes, a retired professional gardener, was out with his metal detector looking for a hammer that had been lost by a farmer friend. After three hours he received a signal that would change his life forever. Eric found a coin, and then another. As he removed earth from the ground every handful contained coins. The excavation soon revealed a solid layer of gold and silver coins. Beneath the mass of coins lay silver cutlery and gold jewellery.

Realising the find was significant Eric took appropriate action. Suffolk Archaeological Unit were called in and the treasure was carefully excavated. The final total was over 15,000 items, including 14,780 coins, 565 gold, 14,191 silver and 24 bronze, all dating from the fourth century AD. Sixty of the coins were described as rare, two were previously unrecorded. The coins alone were worth £6 million in today's money. The

jewellery included three rings, necklaces, nineteeen bracelets and armlets. Twenty-nine of the pieces were made from the purest gold. In addition there were 200 pieces of gold jewellery and silver tableware. The silver tableware consisted of dishes, bowls and jugs, seventy-eight spoons, twenty ladles, four pepper pots, plus statues, figurines and other decorative objects. Probably the best-known piece is an ornate tigress, originally the handle from one side of a vase. It is likely there was once also a male version belonging to the other side.

The hoard became known as the Hoxne Treasure and made national headlines. Because of the early involvement by archae-ologists it was possible to preserve other items of interest such as fittings from the chest that originally contained the treasure, and fragments of woven textile and silver sheet in which some of the objects had been wrapped. On 3 September 1993 the find was declared treasure. Eric was praised for the exemplary manner in which he had handled the find, one of the most sig-nificant ever discovered in Britain. The treasure was acquired by the British Museum and Eric received £1.75 million in compen-sation, which was shared between himself and Peter Watling, the owner of the land. The British Museum planned to recon-struct the hoard as it would originally have been buried in a forthcoming exhibition.

The Appledore Hoard

In August 1997 three coins were unearthed in a field in Apple-dore near Kent. Detectorists Bert Douch, Phil Collins and Laura Dickinson returned the following day and uncovered a hoard of nearly 500 Anglo-Saxon silver pennies. The coins were discovered with fragments of dull red terracotta, thought to be the remains of the vessel in which they were stored. The pot appeared to have been recently disturbed by ploughing.

The hoard contained coins from thirty-four different English mints. Half were from Canterbury, but there were also rarer coins from the smaller mints of Romney and Sandwich. The money was probably buried between 1051 and 1052, around the time of the rebellion of Earl Godwine of Wessex. At the time the estate of Appledore was owned by the Archbishop of Canterbury, one of Godwine's most powerful enemies. The hoard represented around a third of the annual value of the estate. The British Museum described the find as significant. Each coin was reported to be worth between £100 and £2,000, valuing the hoard at £750,000.

Other hoards found

Hoards continue to be unearthed all around the UK. Over fifty million pounds worth of treasure has been found by detectorists since the hobby became popular in the 1970s.

- In Kelso, Scotland, William Swanston was out metal detecting when he uncovered a broken clay pot buried about 45 cm below the surface. It was crammed to the brim with over 1,000 sixteenth- and seventeenth-century gold and silver coins. The National Museums of Scotland described it as 'the largest hoard from this period ever found in Scotland'. It was valued at £500,000.

- On 19 November 2000 retired technology teacher Ken Wallace found two silver coins near Market Harborough in Leicestershire, a find that eventually led to the discovery of 3,000 Iron Age silver and gold coins and a Roman cavalry helmet. The discovery was the largest hoard of Iron Age coins ever found in Britain, and was described as being of international importance. Only 32,000 Iron Age coins had been found in Britain before this discovery, and this added 10 per cent to the total. The value of the hoard remains

undisclosed, but a figure of between £150,000 and £350,000 has been suggested.

- Some metal detectorists have unearthed more than just one valuable find. John Hunt recently found a gold bezel on farmland near Stowmarket valued at between £5,000 and £8,000. The previous year he found a fifteenth-century ring worth about £3,000. He was quoted as saying 'It's a nice hobby, two to three hours a week is plenty long enough.'

Possible future finds

It is impossible to say exactly how much treasure is still buried out there, but hoards – particularly large ones – are on the increase as metal detector technology improves. More than 200 hoards were unearthed in 2000 alone, a nine-fold increase on the figure ten years ago. The Portable Antiquities Scheme annually reports dozens of other finds running into thousands of pounds. Today we use banks to hide our valuables, but this simply wasn't an option years ago. All the evidence suggests that there is still a colossal amount of treasure buried out there just waiting to be found.

It's worth noting that hoards can also reveal themselves gradually. One area that still remains a closely guarded secret has produced more than 2,000 Anglo-Saxon artefacts during a fifteen-year period, worth a total of £100,000. The finds range from bits of bronze metalwork to silver and gold coins. Below are two more stories with interesting twists to them.

Double hoards

On 24 September 2000 two hoards of Roman coins were found just 5 metres apart in the same field. What made the hoards even more unusual was that they were unconnected, the two batches having been buried twenty years apart.

Friends Stephen Best, Paul Rennoldson and Jimmy Haley were metal detecting on farmland in Langtoft, East Yorkshire. Their first find revealed a ring pull; the second signal came just a minute later, producing the first coin. A total of 1,902 coins was discovered in two earthenware pots. The trio removed the coins, but realising the importance of recording the pots while they were in situ, called in archaeologists. The pots were duly recorded and excavated. Involving professionals proved particularly relevant because archaeologists were able to establish that the two hoards had actually been buried separately around AD 305 and AD 325, near to a Roman road.

The coins were auctioned at the New Connaught Rooms in London. The sale attracted buyers from all over the world, and many bids were taken by telephone. The highest price paid was £410 for a single rare coin. A total of £16,502 was raised. Mr Best, who made the discovery, said, 'If anyone had said we would ever be involved in finding one hoard, never mind two, we would have said that it would have been easier to win the lottery, but that's exactly what happened.'

There was a similar incident in Reigate, Surrey, where two hoards were found buried in close proximity. They were discovered in 1972 and 1990, near to where a medieval road passed through a wood. It is obvious that the area was considered suitable on two separate occasions by the individuals who buried their valuables.

Crime pays

When off-duty policeman James Hawkesworth was out metal detecting in October 2001, he never imagined he would stumble across evidence of a 1,650-year-old crime.

James was metal detecting in West Bagborough, Somerset. While searching a farmer's field, he found 669 early fourth-century Roman coins. In addition to the coins were sixty-four

pieces of scrap silver known as 'hack silver'. After reporting the find to the relevant authorities it became apparent that a proportion of the coins consisted of deliberate forgeries. Some had copper bases and were plated with silver, others actually had the same or an even higher silver content than the genuine coins.

Other forgeries have been found from the fourth and early fifty centuries, but this discovery proved that forgery was taking place much earlier. Following a treasure inquest a valuation committee set a figure of £40,650 for the hoard, and a fund-raising campaign was launched to raise the money. Mr Hawkesworth commented, 'It goes to show there were dishonest people 1,650 years ago just as there are today.'

Non-coin finds

Until now you have mainly read about exceptional coin finds. There is nothing wrong with searching exclusively for hoards of course, and in fact there are specialist 'cache' metal detectors and conversion kits that are specifically designed for this purpose. These finds are rare, however, and there is a whole labyrinth of other collectable and often valuable artefacts besides coins, some of which you certainly will find if you go detecting regularly enough.

The first category of items could be termed general/non-personal. This category will typically include basic tools, items of hardware, fixings, furniture mounts, lock plates, keys, horseshoes and so on. Many of these items seem mundane today, but a bucket was a prized possession to an Iron Age farmer, and examples have been found depicting decorative handle mounts. Musket balls, another relatively common find, engender a sense of history.

The second category is what could be termed personal/decorative items, and these are also relatively common. They include pins, clasps and buckles used to connect belts and

harnesses. Also in this category one might include token coins depicting special events, and medals, decorative buttons and badges. Many of these items are quite collectable, particularly the finer examples.

Finally, the real gems are the personal items. These include axes and other fine tools, many of which will be of archaeological interest. Gold, silver and lead seals are also highly collectable, as are thimbles. Also valuable, of course, are all the items of personal jewellery lost throughout the centuries, such as rings, charms, brooches and necklaces.

There are dozens of other types of find apart from the above, including that ubiquitous final category – unknown/unidentified. You will definitely find a few of these ... everyone else does!

Here is an overview of some of the more significant non-coin finds made by metal detectorists in recent years.

The Ringlemere Cup

On 4 November 2001 Cliff Bradshaw, an amateur archaeologist and detectorist, was searching ploughed farmland at Woodnesborough, Kent. This was his third or fourth trip to the field, and he had already found some Saxon coins. His detector beeped, and as he scraped away the soil he saw the unmistakable glimmer of gold. Buried 45 cm below the surface Cliff uncovered a precious Bronze Age ceremonial gold chalice. It was partly crushed, probably as the result of damage by agricultural machinery.

The vessel, dating from between 1700 and 1500 BC, measured just 112 mm high and weighed 184 grams. It had been skilfully beaten from a block of solid gold, some of the oldest ever found in Britain. It had a curved base and broad handles attached by lozenge-shaped rivets and was embossed. The chalice clearly belonged to a very powerful leader, or was made as an offering to one. Excavations also revealed a grave pit con-

taining bone fragments, flint tools and pottery.

The only other find of equal significance, which looks very similar, was the Rillaton Cup found by a tin miner on Bodmin Moor in Cornwall in 1837 buried next to a human skeleton. David Miles, English Heritage's chief archaeologist, described the Rillaton Cup as being not just important, but something that opened up a new chapter of previously unrecorded history. The Treasure Valuation Committee set a figure of £270,000 on the cup, and this amount will be split between Mr Bradshaw and the owner of the field in which it was found.

Iron Age mirror

On 12 November 2000 Messrs S. Pyper and S. Leete found a bronze Iron Age mirror and silver brooch while out metal detecting in Shillington, Bedfordshire. The mirror had three parts: the plate, handle and a decorative ring near the handle. The back was decorated with an early Celtic design. Bronze mirrors were used for at least 150 years from 100 BC to AD 50, and over thirty examples have been found in Britain. The mirror was discovered with pieces of pottery in what was probably a disturbed grave, of which richer examples have occasionally been found to contain this type of mirror. The mirror was valued at £35,000.

Bronze Age torcs

Ron Howse and Bob Acton had been metal detecting for over twenty years. One field they had permission to search in Chickerell, Dorset, had started out very dull and they nearly abandoned it, but the odd Roman find started turning up so they decided to stick with it. A signal came in at about 25 cm, and among the clay they retrieved what they first thought was a brass bearing from farm machinery. A second find quickly followed, which was bigger and thicker than the first.

What they had actually discovered were two magnificent solid gold torcs, or neck rings, dating from between 1000 and 800 BC. The torcs measured 172 mm and 192 mm and contained 80 per cent and 86 per cent gold respectively. It was first thought that the torcs were Celtic, but Weymouth Museum later identified them as Bronze Age.

These particular torcs were unique to the UK. Similar examples had previously only ever been discovered in Ireland and on the Continent. On 7 April 2000 Dorset County Museum took delivery of the torcs from the British Museum, and Ron and Bob received £110,000.

The Middleham Jewel

On a cold, wet September day in 1985, Ted Seaton and a couple of friends were detecting beside a footpath near Middleham Castle, North Yorkshire. They were about to call it a day when Ted detected a faint signal on his machine. From about 35 cm down he unearthed what at first appeared to be a lady's compact.

It was only when Ted returned home and washed the find that he realised the significance of the discovery. It was a medieval diamond-shaped gold pendant dating from about 1460. The pendant had a Latin inscription around the border and a mounted 10-carat, oblong-shaped sapphire as a centre piece. Engraved on the front was an image of the Trinity, while the reverse featured a scene of the Nativity and saints. It was an exquisite piece of jewellery that had been worn to ward off sickness and death, possibly by a member of the aristocracy.

The pendant became known as the Middleham Jewel. In 1986 Ted Seaton, together with the owners of the land, auctioned the pendant at Sotheby's. It was bought by an unnamed foreign buyer for £1.3 million. The owner applied for an export licence, but an appeal was launched to keep it in the UK.

Following generous contributions from various trusts and organisations it was reacquired for £2.42 million, and is now on display at the Yorkshire Museum.

Interestingly, five years later another detectorist, Bob Angus, was searching a field not far from the pendant discovery. He found a fifteenth-century gold ring engraved with what is thought to be a royal inscription, which was later valued at £30,000.

Gold Iron Age jewellery hoard

While out metal detecting in a field near Winchester, Hampshire, in 2000, Kevan Halls unearthed a spectacular collection of Iron Age gold jewellery.

The finds, discovered over a three-month period, comprised two matching sets of gold jewellery, one for a man and one for a woman. There were two necklaces, bracelets and two gold brooches, used to secure a cloak. The finds were unique – no other gold necklaces like these had been discovered anywhere else in Europe. The owners must have been extremely important, possibly even royalty.

Archaeologists dated the brooches to between 80 and 25 BC, 100 years before the Roman conquest. It has been hailed as the most important Iron Age find made in the last fifty years. The reward paid for it was £350,000.

Metal detecting and the law

You don't need a licence to operate a metal detector in the UK, but there are several rules and regulations that you should adhere to. Most importantly, it is illegal to use a metal detector on a scheduled archaeological site. Metal detecting has come a long way since the 1970s, and most detectorists are now law abiding, but even today there are still occasional cases of

nighthawking – the illegal raiding of archaeological sites. It is estimated that £3.5 million pounds worth of coins alone has been plundered from the Iron Age site where Ken Wallace made his find, and this is just one of many such examples.

Permission should always be obtained to search all land except that provided by local authorities for public recreation, and in some areas even this is out of bounds. If in doubt, check. The provisions of the 1996 Treasure Act outlined below should also be adhered to, for everyone's benefit including your own. Finally, all modern valuable finds, such as rings, watches and jewellery, should be handed in at your local police station as lost property. If not claimed they will be returned to you after a reasonable period of time.

The Treasure Act 1996

In 1996 the medieval law of treasure trove was repealed, and replaced with the Treasure Act. Before 1996 all treasure belonged to the Crown, and valuables could only be kept if the finder could prove they could never be returned to the owner. Not surprisingly, many important artefacts were lost to history, causing friction between archaeologists and detectorists. Treasure is now thankfully clearly defined, and providing the correct procedures are followed, if a museum wishes to acquire something the finder can expect to receive the full market value.

In England and Wales all treasure finds must be reported to the coroner within fourteen days. Your local police station or museum will be able to tell you where to go. After you have reported your find, the coroner will tell you which museum or archaeological body to take it to. Under no circumstances should any attempt be made to clean or restore a find. If the museum judges the find treasure, it will inform the British Museum or the National Museum of Wales. If they, or a local museum, then wish to acquire the find, the coroner will hold an

inquest to decide whether or not it is deemed treasure. If the find is judged to be treasure, the Treasure Valuation Committee, which meets at the British Museum, will set a value.

Although the government does not actually provide funds for new finds, there are several sources a museum can turn to, and once these are in place you will receive 50 per cent, the other 50 per cent going to the owner of the land where the find was made. If the find is judged to not be treasure it will be disclaimed and returned to you and you can sell it if you wish.

The law is different in Scotland, where all finds of potential historical or archaeological significance must be reported to the relevant authorities. More details can be obtained by contacting the Department for Culture, Media and Sport.

Here is a brief definition of what qualifies as treasure:

1. All finds *other* than coins that are at least 300 years old, which contain 10 per cent or more gold or silver.

2. Two or more coins that come from the same find and are at least 300 years old when discovered. If the coins contain less than 10 per cent gold or silver there must be ten or more.

3. Any prehistoric base metal hoards.

4. Any other object, metallic or nonmetallic, found or associated with either of the above.

The Portable Antiquities Scheme

The Portable Antiquities Scheme (PAS) is a voluntary recording scheme for archaeological objects found by members of the public, whether detecting or not. It isn't connected with treasure. The aim of the scheme is to increase public awareness of the importance of finds, and to trace patterns that help provide vital clues about our ancestors.

The PAS records all objects, metallic and nonmetallic, made

before 1650; later objects may also be recorded at the PAS's discretion. If you unearth something you think may qualify, the find spot should be carefully recorded and reported to your local PAS Finds Liaison Officer. If the object is delicate it should be left in situ; the Liaison Officer will help arrange for an expert to retrieve it. A receipt will be issued for the period during which the find is in the care of the PAS, and the object will be returned to you after recording.

Detectorists code of conduct

In addition to the above, detectorists have their own code of conduct, as outlined below:

1. Never trespass. Ask permission before venturing onto private land.

2. Respect the Country Code. Do not leave gates open while crossing fields. Do not damage crops or frighten animals.

3. Do not leave a mess. Practise pinpointing and extract your finds with the minimum of disturbance to the ground. Fill the hole back in, stamp the earth back down and replace any turf. Leave the area as you found it.

4. Help keep Britain tidy, and help yourself. Dispose of any rubbish that you find. Take any rusty iron and junk to the nearest litter bin – this may help to prevent damage to expensive farm machinery.

5. If you find live ammunition or any other potentially lethal object do not touch it. Mark the spot carefully and report the find to the local police and landowner.

6. Report all historical finds to the landowner. Abide by the requirements of the Treasure Act 1996 (*see page 35*).

7. Familiarise yourself with the law relating to archaeological

sites. Remember that it is illegal to use a metal detector on a scheduled ancient monument unless permission has first been obtained from the Secretary of State for the Environment.

8. When you are out with your metal detector you are an ambassador for the hobby. Don't do anything that might give it a bad name.

Finding out more

There are many sources you can turn to if you want to find out more about metal detecting, including the two official bodies, the National Council for Metal Detecting (NCMD), which has member clubs in most regions of the UK, and the Federation of Independent Detectorists. Joining one of these is an excellent way to meet fellow enthusiasts. If you don't fancy detecting on your own, or want some help or expert tuition, there are also organised rallies and even detecting holidays. Check out magazines such as *Treasure Hunting* and *The Searcher* (*see* Further Information, *page 276*). There are also many metal-detecting sites, chat rooms and newsgroups online.

CHAPTER TWO

Finding Gold

GOLD IS AN extraordinary metal. It combines beauty, rarity and malleability, yet is virtually indestructible. An ounce of gold can be hammered so thin that it will cover an area of 10 square metres – so thin, in fact, that light will penetrate it. It is estimated that only 100,000 tons of gold has ever been mined worldwide throughout history. This may sound like a lot, but because gold is so dense – twice as heavy as lead – this only equates to a cube with 17-metre sides. In fact, more steel has been produced in one hour than gold since the beginning of time.

Ironically, even the rarity of gold is a contradiction. It is all around us; in the Earth's crust, the sea, plants, even our own bodies. It is a testament to gold's elusiveness that although the Earth contains billions of tons of it, humans have so far only managed to recover a tiny fraction of what is available.

Gold in Britain

Gold is mined in sixty countries worldwide, but how many people know there is also gold in the UK? The British, too, have been mining gold for centuries, and are still mining it today.

Gold has been found in Wales, Scotland, Devon and Cornwall since prehistoric times, and there is even one ancient mine in Cumbria. The Dolaucothi Mine in Carmarthenshire, South Wales, is believed to be 3,000 years old, and gold was recovered from streams in Scotland and Cornwall hundreds of years before the Romans arrived. After the Roman conquest of Wales, the Romans constructed huge aqueducts to fill lakes that when emptied literally stripped sides of mountains clean, exposing rich seams of gold, a technique called 'hushing'. It's hard to imagine now, but for hundreds of years parts of Wales and Scotland resembled scenes from an American gold-rush film.

Members of the royal family have traditionally worn jewellery made from Scottish and Welsh gold. In 1911 the Moel Croesau Mine in Wales, later renamed the Prince Edward Mine, supplied gold that was incorporated in the regalia for the investiture of the Prince of Wales. In 1934 the Bedd-y-Coedwr Mine provided gold for the Duchess of Kent's wedding ring, and in fact all members of the royal family traditionally wear wedding rings made from Welsh gold. In 1968 Her Majesty Queen Elizabeth II was presented with a 1 kilogram ingot of pure Welsh gold to ensure the tradition could continue. In 2000 the Queen Mother was presented with a brooch made from Welsh gold to mark her hundredth birthday. Welsh gold is not just the prerogative of royalty. When Michael Douglas married Swansea-born Catherine Zeta Jones in 2000 he bought her a ring made of Welsh gold from a jeweller in Aberystwyth.

Scotland, too, has its traditions. During the reign of King James V, gold from Wanlockhead, an area of Scotland that became known as 'God's treasure house', was incorporated into the Scottish crown jewels, over 5,000 people having been sent to retrieve it. Coinage from that period was also minted from Scottish gold, and Charles I had coronation medals made of gold from nearby Crawfurd Muir. Today, Scotland continues its proud tradition. In 1999 the Mace, made for the formation of

the Scottish parliament, incorporated gold panned by local men from burns around Leadhills. Even today, dedicated amateur panners still work the streams of Scotland, particularly around the Wanlockhead area of Dumfries and Galloway. Barely a year goes by without a newspaper headline announcing the onset of a new gold rush in Scotland, usually as the result of some unexpected find by a member of the public, or explorative drilling by a mining company.

Gold weight

Gold is weighed by the troy ounce. One troy ounce is about 10 per cent heavier than what we traditionally recognise as an ounce, that is, one-sixteenth of a pound. The term 'troy' originated from Troyes in France, where the measurement was first adopted in Europe. There are other historical references to weight measurements that are derivatives of one troy ounce, such as the pennyweight and grain, most of which are now redundant. Part of the fun is being able to read about historical finds in a modern context, so to help I have converted all weight references into grams and kilograms. One troy ounce equals 31.1 grams.

Where does gold come from?

The origin of gold is the subject of considerable, often heated academic debate. There is, in fact, no conclusive evidence that gold is formed on Earth, and one theory even suggests that it originates in space. A team of Swiss scientists recently calculated that the Earth does not have the extremes of pressure necessary to produce a metal as dense as gold, and it therefore must have been formed before the creation of the planet. Based on calculations relative to other elements, the research suggested that gold was formed in star collisions and thrown into space in

nuclear reactions. The gold mixed with gas and other matter in the galaxy, forming little lumps when it cooled. This material went on to form new stars and planets, each containing some gold. But there are other, less radical theories, too, probably the most accepted being that gold is volcanic in origin.

Gold emanates from geological environments such as deep magma chambers, ancient volcanoes and hot springs. Gold is hydrothermically released from deep in the Earth's crust through fault lines, and settles in bedrock; it is often embedded in quartz deposits. Gold can then be further dispersed by glacial action or weathering.

Gold lying in situ is called lode ore. The lode eventually gets eroded out of its matrix (rock) and works its way elsewhere. These deposits are known as 'placers'. Gold that has become washed away, that is separated from the surrounding matrix and washed into streams and rivers, is called alluvial gold. Alluvial gold is made up of tiny pieces of almost pure gold that have in effect been refined by nature. The best way to search for these is by panning.

One question commonly asked is why gold is found in certain regions of the UK and not others. Interestingly, the gold found in Britain falls roughly along the line four degrees west of longitude, encompassing parts of Devon, Cornwall, Wales and Scotland. It would be convenient if this could lead to an all inclusive theory for gold in the UK, but unfortunately geology is complicated and things are not that simple. British gold can be partially explained by plate tectonics when, 400 million years ago, North America collided with Europe. Gold in the Dolgellau area of Wales originated from volcanic activity, but the two main producing areas in Wales are quite different, the north being much older than the south, and the gold found is deposited differently. To confuse matters further, in the case of Kildonan and Suisgill in Scotland it is most likely that gold arrived there by glacial action from what is now Iceland.

Another frequently asked question is whether gold is ever likely to run out in Britain. Certainly, some areas have been virtually picked clean, but new sites that show potential are being discovered all the time – commercial operations wouldn't be interested if this wasn't the case. Placer deposits are also said to replenish themselves every 200 to 300 years due to weathering, and winter storms regularly renew supplies in rivers and streams, ensuring that gold is continually panned from many of the same popular areas in the UK each year.

Scottish gold

Gold has been found in several areas of Scotland over the centuries, from Kildonan in the north, through to the Leadhills in the south.

Old records of Scottish gold finds

The earliest records date from the reign of David I in 1153, and alluvial gold was reported in Durness, Sutherland in 1245 by Gilbert de Moravia. The Auchentaggart Lunula, a Druid priest's breastplate that was found near Wanlockhead, was made from Scottish gold. There is archaeological evidence of Roman settlements in Scotland, so it is likely they mined there too. The earliest reports of systematic mining in Scotland date from the early 1500s, when licences were granted to a number of Dutch and German prospectors over a five-year period. In 1567 further groups obtained leases in return for a 6 per cent royalty paid on results. One story recounts that 4.3 kilograms of gold were recovered in just thirty-eight days.

In 1576 Thomas Foulis, an Edinburgh goldsmith and banker, engaged a Cornishman called Bevis Bulmer to assist him in the lead mines of Leadhills. Bulmer's interest in lead was short-lived, and he quickly turned his attentions to gold. In 1578, armed with letters from Queen Elizabeth and King James VI, he

procured a patent from the Scottish government to prospect for gold in Wanlockhead. It is reported that with a team of 300 men, paying the labourers just four pence (1.5p) a day, he mined £100,000 worth of gold from the area in just three years. This would have been worth over £25 million today. An inscription above a house he owned in Gonner reputedly read, 'In Wanlock, Elwand and Glengonner, I wan my riches and my honour.' He returned triumphant to England and presented the Queen with a porringer of Scottish gold inscribed:

> *I dare not give, nor yet present,*
> *But render part of that's thy own,*
> *My mind and heart shall still invent,*
> *To seek out treasures yet unknowne.*

Having struck it rich, Bulmer turned his attentions to other interests and became 'Farmer of duty on Sea-borne coals'. He went on to mine lead in Somerset and silver in Devon. He also mined in Ireland, refining production at his Devonshire works. But bad business decisions were already ruining him. Stephen Atkinson, one of Bulmer's pupils, referred to him as 'an ingenious gentleman', but also stated that 'he had always many irons in the fire besides these which he presently himself looked on'. Appointed Chief Governor of the King's Mines by James VI in 1605, Sir Bevis Bulmer returned once more to Leadhills to resume operations, but this time they were unsuccessful. Finally he moved to Alston Moor in Cumberland, where he died in 1613, owing £340.

During the sixteenth century it is estimated that nearly 1,000 kilograms of gold was recovered from Scotland, but what followed was clearly becoming a time of mixed fortunes. In 1603 a contemporary of Bulmer's, an engineer named George Bowes, held a commission 'to dig and delve as he would' in Wanlockhead. He discovered 'a small vein of gold' which 'had

much small gold upon it'. The Queen was so encouraged that he was commanded to return in the spring to resume his search. But spring 'returned not' for George Bowes. Visiting a copper mine in Cumberland he turned aside to look, fell down the shaft and was killed.

On 11 June 1616 Stephen Atkinson was granted a licence to prospect for gold by the Scottish Crown on condition that all gold found was bought to the Scottish mint to be coined, and one-tenth was given to the King. This is where details become blurred. One account claims that King James outlaid £3,000, yet received only 60 grams of gold in return, while another suggests that the combined reigns of James V and James VI received as much as £500,000. In 1621 a similar licence was issued to another prospector and speaks of a Crawford gold field that had been lying neglected for years, but little more was recorded for nearly 250 years.

The 1869 Scottish gold rush

The history of the area that actually triggered the Scottish gold rush, Kildonan, can be traced back to 1818, when a single nugget weighing about 15 grams was found in the River Helmsdale. It was acquired by the Sutherland family and made into a ring. Credit for starting the 1869 Scottish gold rush officially goes to one Robert Nelson Gilchrist, a native Scotsman who had spent seventeen years as a gold miner in Australia. In late 1868 he was granted permission to pan the Helmsdale and associated tributaries by the Duke of Sutherland. His most promising finds were in the Kildonan and Suisgill Burns, and they were substantial enough to spark considerable local interest. The story was carried by several local Scottish newspapers and the *Scotsman*, and eventually filtered through to the *Illustrated London News*, creating a rush to the normally deserted glen.

In the summer of 1869, between 400 and 600 hopeful novices as well as seasoned prospectors, some from as far away

as America and Australia, had set up home in one of two camps: *Baile an Or* (the town of gold) and *Carn na Buth* (hill of the tents). The first bout of panning was lucrative, with £12,000 worth of gold being declared – worth about £1 million today. Many nuggets were also discovered. The largest of these weighed 63 grams and was bought by a Dr Rutherford for £9. In April the Duke of Sutherland introduced a licensing system: a claim measuring 40 square feet cost £1 per month, about an average weekly wage, and in addition prospectors were required to pay a 10 per cent royalty on all gold found, a decision whose principal benefactor was the system of barter. By the height of summer 1869 around 200 licences a month were being issued.

On 2 June 1869 the Duke of Sutherland presented Robert Gilchrist with a watch made from Kildonan gold in recognition of his discovery, but things were not going well. The bedrock source was never found, and it quickly became apparent that the Kildonan, Suisgill, Kinbrace and Torrish Burns were more rush than gold. Fresh-faced hopefuls, egged on by exaggerated newspaper reports and unscrupulous equipment suppliers, were becoming disillusioned. By September the number of miners had fallen to fifty, and as the weather drew in, disputes between miners and tenant farmers over land rights forced the authorities to take decisive action. At the end of November it was announced that no new licences would be issued, the Scottish gold rush officially ended at midnight on 31 December 1869. It had lasted just one year.

Below are extracts from a letter dated 17 July 1869, said to be an eyewitness account of a young man from the south observing the Kildonan gold mining community. The letter was originally sourced by R. M. Callender, author of *Gold in Britain*.

> I shall endeavour to dissipate the false halo of romance in which the Sutherland gold fields have been partially enveloped, owing to the glowing and exaggerated reports

which have found their way from time to time into the columns of the press.

Without further preamble, I hold that the Sutherland gold diggings have as yet, for all practical purpose, proved a most complete failure. It is a fact that with the exception of a few poor fishermen who, owing to the introduction of the licence system, are now precluded from digging, few, if any, have made their own of the Scotch gold diggings. True, some dozen shopkeepers, a publican or two, and three or four storekeepers, all more or less interested in the circulation of inflated reports of them, have benefited by the diggings.

More than one instance has come under my own direct observation of men who left their families, travelled a long journey – provided themselves by dint of severe pinching with expensive tools – paid £1 a month for permission to dig 40 square feet of rocky moor – worked like galley slaves month after month – and in the end were obliged to sell their all in order to provide themselves with the very necessaries of life as they trudged miserably home on foot.

Arrived in Helmsdale from Golspie after a walk of 18 miles, I loose no time in procuring cheap lodgings, for the day had been excessively hot, and I was tired and footsore. Having but ten miles before me 'ere I reached the land of gold, I am up with the lark on the morrow. My way lay along a dreary and uninteresting strath, through which flowed the river Helmsdale ... A mile or two further, and here comes the sight of the old parish church of Kildonan. I was not prepared to find it the neat, trim, comfortable-looking little church it is. Once past the church, the township of Kildonan, the great centre of attraction, speedily comes in sight, and a curious conglomeration of nondescript erections it looks. It consists of one street of about 150 yards in length, with a style of architecture more varied than elegant – wooden huts, canvas tents, inverted boats, old sails spread

over the walls of turf, dilapidated vehicles covered with tarpaulin, old vans, strongly reminding one of travelling shows – anything and everything that the inventive genius or necessity of the owners could convert into partial shelter from wind and weather.

My approach attracted the attention of one of the storekeepers who happened to be on alert.

'Going to try your luck at the diggings sir? That's right. Plenty of gold here, if one could only get it. I suppose you have no tent of your own, if you step in, and have a look at our crib, I think I can fix ye.'

I stepped in as desired.

'There you are, Sir; this is our store. We shall be glad to supply you with anything you may want from a needle to a cradle.'

'A cradle,' I exclaimed with astonishment. 'What in the wide world do you want cradles for at Kildonan?'

'Not for rocking babies, you may be sure. Meantime you had better step in at the next door and have a look at our cooking and sleeping departments.'

The cooking and sleeping departments turned out to be one and the same – a pretty sizeable room with an American stove at one end and on each side rude shelves that served for beds, built one above the other after the manner of berths on board ship – while a narrow deal table ran down the centre. I was informed if I had blankets I might have the use of one of these shelves – or rather the use of part of one of them – for 2s per week…

I laid in a sufficient supply of provisions and set out for 'the creek' to view the operations of the diggers. On reaching the summit of an adjacent hill, I could obtain a fine view of the burn for at least a mile, with the diggers hard at work. And a most picturesque and animated scene they presented – these hundred or so stalwart men, as they shifted to and fro

– some digging with spades and shovels, some with picks pulling down the banks, some tearing up rock with crowbar, some carrying 'stuff' in buckets or wheeling it in barrows, some working sluices and 'long toms', some rocking the mysterious 'cradles' with the regularity of clockwork, while some with pick and gold pans were searching eagerly every nook and corner for 'prospects' of better 'claims'.

Upon returning to the township I inaugurated my camp life by preparing my own tea. With scanty utensils for cooking – large common ware basins for teacups, and huge iron of pewter tablespoons instead of teaspoons – the bare deal in lieu of plates – no milk nor cream – rank, vile-smelling, hairy butter, and suet pretty much like the size and consistency of ordinary macadams – it may readily be imagined that my first meal at Kildonan was far from being a very enjoyable one. The diggers who lived in the hut – some twelve or thirteen in number – now dropped in one by one, and tired and hungry enough they looked.

After supper there was a general adjournment, some to spinning yarns over their pipes, some to making necessary repairs, some to reviewing their day's work.

'Well, Ballarat, I suppose you have made a pile today?'

'O yes, Bill, I have, and a good one too – of rubbish.'

'How have you got on today, Bob?'

'Middling, just some five or six pennyweights.'

Night creeps on, and there is a general scramble to bed, hard boards, each several inches apart with common thin sacking filled with nothing by way of mattress, a blanket and transparent coverlet, both of limited dimensions and questionable cleanliness.

No sleep for me, squeezed between two stout fellows who snored like porpoises, the frosty night air whistling in at every chink and cranny. Little wonder I could not sleep. Not many nights were destined to pass before I could sleep as

soundly as the loudest snorer in the camp. About four o'clock I was startled by the information conveyed in language by no means of the choicest, that 'boiling' was ready, and that it was high time to rise. Then a scuffle for tea- and coffee-pots, and the other varied utensils requisite for cooking and eating breakfast. Many were blessed with enormous appetites, and had plenty of good substantial food. A few, with appetites probably equally keen, were under the necessity of contending themselves with partaking but sparingly, and that of dry bread and coffee, oatmeal brose without milk or butter.

Five o'clock sharp, and we are off, our pipes in full cloud, and half a loaf of bread and butter under our arm. My 'claim' is two miles away, but as the burn winds considerably, we can take a nearer cut across the hill. The morning is a misty and drizzly one, for it has rained hard during the night. It is very wet underfoot, but what of that when one is digging for gold! So off with coat and vest, roll up sleeves to the shoulder, for we must strip a 'paddock' sufficient in size to keep us cradling and washing for the day.

Smoking? No time for that; I can't afford it; but a drink of water we must have and a glorious, cool refreshing draught it is. That? Why it is only a snake I have startled from this tuft of heather. Plenty of them hereabouts – and ugly, venomous creatures they are – but we diggers know how to fix them – a cut with the shovel and all is over.

Twelve o'clock! Dinnertime already, and how little accomplished! A good three feet yet before we reach the bedrock, and that will take two hours at least, so we must have a short half hour for dinner today. Doesn't the bread and butter taste delicious! And this crystal water – why it beats Bass's hollow! Seven o'clock, and our day's work is over, and not a bad day's work either, taking the ordinary run of luck. Over half a pennyweight of gold! About 1s 8d worth for fourteen hours' work! Nearly a penny and a half per hour!

I have myself worked from five o'clock in the morning till seven or eight at night – worked up to the knees in mud and water, with hands blistered and hacked, and chipped and bruised, pulling down banks, tearing up rocks, rolling away great boulders, shovelling aside sand, gravel and stones; and I have found in the end that I have earned about 9d or 10d.

Lest, however, any of your readers might imagine that I have only been indulging in a fit of spleen owing to my own disappointment, permit me, in conclusion, to say, one having time and money at his disposal, but whose health may not be quite so vigorous as he would wish it, or may desire to obtain a souvenir of Sutherland gold of his own digging, nothing could be more jollier or more pleasant than to provide himself with a tent and all the necessary concomitants, and to pitch his camp for a month or so during the summer at Kildonan or Suisgill Burns ... I'll guarantee that he will soon pick up an appetite of the very first magnitude, which, after all is more to be desired than gold.

Twentieth-century Scottish gold

Prospecting continued throughout Scotland after the gold rush on both an amateur and a professional basis. It is reported that locals took around £300 worth of gold a year from Kildonan for a further fifteen years following the strike. In 1895 Sutherland County Council reopened diggings, but 476 man-days only produced 714 grams of gold and the enterprise was judged unprofitable. In 1911 the Marquis of Stafford appointed a 'Mr William Heath', a formidable man with over thirteen years experience in the Yukon, to oversee local men in a modest operation around Suisgill Burn. A small strike was made, but again it was concluded that recovery would be uneconomical. This view was reinforced again in 1969, when the Institute of Geological Sciences together with the Highland Development Board carried out a survey of Kildonan.

In the 1970s the British Geological Survey funded by the Department of Trade and Industry prompted further exploration by private companies. In 1985 the Ennex Corporation conducted explorations on Beinn Chuirn mountain and confirmed 'showings' at seventeen locations. In 1995 one of the subsidiaries of another company, the Canadian-based Caledonia Mining Corporation, which has interests all over the world, conducted exploratory drilling at a mine close to Tyndrum, northwest of Glasgow, and also managed the Coronish gold project in Argyll on the west coast of Scotland. Results for the former were published two years later anticipating ambitious production levels and predicting an eleven-year lifespan for the mine, but the project became immediately unviable due to low gold prices. Gold has also recently been found in the Ochil Hills, Glen Clova, the southwest Highlands and southern Scotland.

In 1992 the Gold Study Group set up by Dr Rob Chapman of Leeds University put forward its aim to learn more about the origins of gold deposits in the UK through cooperation between amateur prospectors and exploration geologists. Credit for taking the spirit of independent Scottish gold prospectors into the twenty-first century has to go to people like Charlie Smart. Following twenty-five years service in the police force, Charlie and his wife retired to a cottage near the Mennock Water. After learning to pan, Charlie eventually acquired enough gold to have several pieces of jewellery made for his wife. He is considered to be one of the country's leading panners, and went on to become a member of the British Gold Panning team. In the 1997 World Championships he reached the semi-finals.

Hundreds of people still flock to Scotland each year to try their luck at gold panning. There are many regulars and old hands whose knowledge and experience inspire newcomers – there is even a lady of ninety who regularly pans for gold.

Welsh gold

Wales has an impressive gold-mining history spanning centuries. There is a reference in early writings to three Welsh chieftains possessing chariots of gold, and to others wearing magnificent gold torcs and armbands denoting their wealth and status, generated from trading in precious metals. When the Romans invaded Britain they quickly commenced operations in South Wales. One theory suggests that they chanced upon gold while extracting other metals, such as copper and lead, but there is now strong evidence that they actually took over earlier workings. In 1198 the monks of Cymer Abbey, Dolgellau, were given 'the right in digging or carrying away metals and treasure free from all secular exaction'. Evidence also exists of a few workings associated with the seventeenth century. Thomas Bushell, an adventurer of that time, reputedly owned a gold mine near Dolgellau. There is also an eighteenth-century watercolour depicting alluvial diggings in Wales.

The goldfields of Wales are situated predominantly in two areas: Dolgellau in the north, not far from Barmouth, and Dolaucothi about sixty miles south. Traces of gold have also been found elsewhere, but only in quantities considered of academic interest. Overall gold production in Wales has been tiny by world standards, but individual yields have been known to be exceptionally high, with claims of up to 933 grams per ton of ore having been recorded. Mines in the Dolgellau area often contained ore with coarse visible seams of gold that, once removed, could be relatively easily extracted by hand picking, crushing and washing. It is impossible to say how much gold has been recovered from Wales over the centuries, but some put the estimates as high as 30,000 kilograms, while others settle for a more conservative 1,000 kilograms.

During the nineteenth century, the onset of the industrial revolution saw Wales experience its own mini gold rush.

Between one and two dozen mines sprang up, creating work for hundreds of miners. Some mines were small, employing just a few men, while others were larger operations. They all opened, closed and changed hands on a regular basis. There were companies such as the Eurion Eurglawdd Mining Company (1871), South Wales Gold Mines Ltd (1888), the Ogofau Proprietary Gold Mining Company (1905), Cothy Mines Ltd (1909) and Roman Deep Holdings Ltd (1934).

New mines were regularly developed or existing workings taken over – examples of these include the Cwm-heisian, located on the east bank of the River Mawdach. Formerly a lead mine, gold was first discovered there in 1843 and excavations began in two areas. There were the Cefn Coch and Berthllwyd Mines, both located near Ganllwyd village, and the Dolfrwynog, which became known as the Turf Mine because gold was recovered there by burning. Historically, the three most famous gold-producing areas in Wales are Clogau, Gwynfynydd and Dolaucothi.

Clogau

The Clogau Gold Mine is situated in the hills behind Bontddu, between Dolgellau and Barmouth. Formerly a copper mine, Clogau was first found to contain gold in 1854 and is credited with being at the forefront of the Welsh gold rush. Between 1904 and 1906 Clogau was a major gold producer. Some lumps of quartz and shale from there were reported to be so rich that they contained gold grades as high as 15 grams. During the twentieth century Clogau provided the gold for royal wedding rings and other regalia, but recent production only amounted to little more than 3 kilograms a year, and with extraction costs approaching £32 a gram the mine was deemed uneconomical and forced to close in 1998. In late 1999 a company called Cambrian Goldfields Ltd acquired an exploration licence for the mine. It concentrated on familiarising itself with the mine's

huge complex of old tunnels. Cambrian has recently claimed to potentially be able to address the needs of the Welsh jewellery market.

Dolaucothi

The Dolaucothi Gold Mines near Pumsaint, Llanwrda, encompass various diggings distributed over a distance of about a kilometre, including the original Roman Ogofau pit. Thought to have initially been operated by the Celts, the mines lay abandoned for centuries but were revived when gold was rediscovered in them in 1844. Victorian children as young as eight shovelled shale and quartz into trucks in the pitch dark. Between 1872 and 1912 the mine was further developed, and in the 1930s another shaft was dug to 146 metres. This resulted in the most productive modern period for the mine, during which time £11,106 worth of gold was extracted. Production at Dolaucothi reached a peak in 1938, when over 150 men were employed, and records show that in September of that year 4,800 tons of ore containing 38 kilograms of gold were milled. Mining was suspended temporarily at the end of 1938 due to the onset of the Second World War, but exploratory work continued until 1940, when the mine flooded and was abandoned. The Dolaucothi Mines are now owned by the National Trust.

Gwynfynydd

The Gwynfynydd Mine is situated 6 miles north of Dolgellau on the River Mawddach in what is now Snowdonia National Park, and there are a number of old mines located along the valley. Panners have worked the Mawddach for centuries and refer to it simply as 'the River'. Gwynfynydd first opened in 1863, then changed hands in 1887. By the following year the first rich deposit of gold had been found. The new owner, Pritchard Morgan, initially tried to keep the find secret – the Crown has rights over most gold mined in Britain and there was a question

mark over whether or not he was entitled to extract it. Eventually his discovery became public knowledge anyway, and it turned out to be so rich that police had to be drafted in to guard it. The problems were eventually resolved, and Morgan successfully floated the Morgan Gold Mining Company on the Stock Exchange and received £45,000 in cash, a huge sum in those days.

The mine continued operating through several ownerships until 1917, when it closed. It was reopened in the early 1980s by Sir Mark Weinberg, but closed again at the end of the decade. The mine opened yet again in 1992 under the auspices of Roland Phelps of Welsh Gold Plc, adopting stringent environmental constraints, but finally closed in early 1999 with the loss of twenty-five jobs. Mining underground has now ceased, and the shaft is currently being blocked, although the reprocessing of spoil dumps continues.

The future of Welsh gold mining

As we move into the twenty-first century, Welsh gold mining once again looks promising. Anglesey Mining plc, through the purchase of Anglo Canadian Exploration (Ace) Ltd, has acquired a Crown lease covering 11,000 acres surrounding the Dolaucothi gold property and Parys mountain. The lease runs until 2012, and Anglesey intends to explore the entire area, drilling specific targets and particularly previously unexplored locations. Another company, Cambrian Goldfields Ltd, who supplied gold for royal wedding rings and the Queen Mother's brooch, has also been granted an exclusive licence to explore 150 square kilometres of the Dolgellau gold belt. One other company is reported to have funding for exploration around the Bontddu area.

Gold in Devon and Cornwall

Gold has been found in the counties of Devon and Cornwall for centuries, and both areas were known to have been occupied by the Romans. No mines in the south-west have ever been viable for their gold content alone, and production has always been the by-product of tin. In 1602 Richard Carew remarked in his *Survey of Cornwall* how 'tinners' found little pieces of gold among their ore, which they kept in the hollow shafts of birds' feathers. This practice continued until at least the 1830s, when Henry de la Beche also commented on 'quills of gold' being taken to Truro. Quantities were small, but tinners sometimes recovered enough to have rings made for loved ones.

In 1852 the Poltimore copper mine at Moulton, North Devon, was found to contain gold. Content as high as 30 grams per ton was reported, and one year over 4 kilograms was recovered. In the same year the Geological Society of Cornwall reported gold-bearing veins at Davidstow in north Cornwall. In 1922, while leading a team of students, Professor W.T. Gordon of King's College discovered gold at Hope's Nose, a headland in Torbay, an area that is now a Site of Special Scientific Interest.

It is not known exactly how much gold has been recovered from Devon and Cornwall over the years. In 1904 J.H. Collins put forward a figure of 3 tons, based on known tin/gold ratios. Simon Camm, author of *Gold in the Counties of Cornwall and Devon*, gives a more recent cash estimate of £2 million at current prices.

Commercial interest in gold from Devon and Cornwall is still alive and well. In 1968 gold was discovered on the north Cornish coast between Redruth and Gwithian. More recently, in 1996, the Crown Commissioners issued a licence to Crediton Minerals plc, a subsidiary of Minmet, a company with gold interests in Russia and the US, to drill exploratory boreholes in an area that runs 10 miles from Hatherleigh to Crediton, known

as the Crediton Trough. A report subsequently indicated considerable enrichment of free metallic gold present in the rock.

Gold nugget finds in Britain

One definition of a nugget is a piece of gold that weighs more than half a gram, but there are other, looser definitions, such as 'If it rattles in a glass phial – it's a nugget.' Legend has it that 'A lump of gold as large as a horse's head' lies buried in the 'Limpen', a burn on Robbart Moor, Dumfries. This does beg the obvious question: if there is any truth to the story, why has no one ever tried to dig up the gold?

Throughout history, gold nuggets have been found by prospectors throughout Britain and have even been stumbled upon by accident. The following are examples of notable nuggets found:

- The largest gold nugget ever found in Britain weighed well over 1 kilogram. It was discovered in 1502 on Crawford Moor and was described as being the size of a cricket ball.

- The second largest gold nugget, found in Pontshields 101 years later, weighed just under a kilogram.

- At least one other giant nugget was unearthed in Scotland in the Lowthers, which weighed 840 grams, but when is unclear.

- Some of Bevis Bulmer's nuggets were said to have weighed between 150 and 200 grams, and there are several other reports from between the sixteenth and twentieth centuries of nuggets weighing upwards of 30 grams.

- A nugget found in the Leadhills in 1567 was described as being the size of a 'bird's egg', and there are other historical references to nuggets 'of the size of birds' eggs and eyes'.

- During the Scottish gold rush, besides the famous 63 gram example, it is reported that several miners found nuggets each as large as a bean.

These are just the recorded examples; there is evidence to suggest that there have been other big finds that for obvious reasons have been kept quiet.

More recent finds include one made by a girl playing on Dod Hill in Scotland. She found what she described as a 'bonnie stone', which turned out to be a nugget weighing 41 grams. After passing through several hands it was eventually placed on loan at the Edinburgh Museum of Science and Art.

On 6 June 1940 a retired lead miner called John Blackwood found a piece of quartz the size of a pullet's egg beside Wyngate Burn in Scotland. The nugget, which weighed over 32 grams, contained more than 50 per cent pure gold. Blackwood, a religious man, was reported to have exclaimed, 'Lord, don't let this gold get a hold on me.' In 1997, Ken Williamson found a nugget weighing 21 grams in the Dolgellau gold belt in Wales. The nugget, together with another 10 gram example, is on display at the National Museums and Galleries of Wales, Cardiff. The largest nugget ever found in Cornwall weighed 56 grams. It was unearthed in the Carnon Valley, near Truro, in 1808 and is now on display at the Royal Cornwall Museum

Modern nugget finds are getting rarer in Britain; the majority found nowadays only weigh between one and six grams, and anything over a gram is considered noteworthy. Only a fool would melt them down, for they are literally worth more than their weight in gold. In June 2002 panner George Patterson found a 6.1 gram nugget in the Lowther Hills, Dumfriesshire. About the size of a pea, it was described as the largest find in the area for sixty years. George had an offer of £600 for it but wouldn't sell, since to him it is priceless. Panning instructor

John Whitworth found a nugget weighing 4.1 grams worth £400 to £600, which now resides in the museum at Wanlockhead. Another nugget weighing over 8 grams was found recently in the Shortcleuch Water by metallurgy lecturer Dr Rob Chapman. It was about the size of an almond and would probably fetch £1,000.

Finding nuggets requires a combination of experience, local knowledge and no small measure of luck. But they do still occasionally turn up, and many weigh in excess of a gram. If you take panning or detecting for gold seriously enough you may eventually find one. During my research I came across one anonymous panner who, after five years hard work in various Scottish streams and rivers, had amassed over 200 grams of gold. In addition he has a collection of more than fifty nuggets, some of which were found with a metal detector. One weighs 8.6 grams but has some quartz attached – its true weight is 7.5 grams. If you need further evidence that gold is still lying around in Scotland there is a jawbone of a sheep at a museum in Montrose whose teeth are coated with gold from simply grazing in Kildonan.

Prospecting for gold

There is no reason, in the legal sense, why any individual or company cannot commercially prospect for gold in the UK. The Crown Estate Commissioners issue licences to explore for precious metals throughout most of Britain, but obtaining a licence would just be the start of your problems. Besides locating a site and obtaining permission to explore from the landowner, a team would need to demonstrate considerable geological and mining expertise, not to mention have a healthy bank balance to fund ongoing operations. Once these obstacles were overcome modern environmental issues would need to be addressed, and of course there would still be no guarantee that the team would find any gold to make an operation viable. It is

understandable why very few people embark on commercial gold mining in the UK these days.

Gold panning

For the amateur prospector, the best way to find gold in Britain is to pan for it.

Panning equipment

Basic equipment is cheap. All you need is a plastic pan, although there are stories of people using old frying pans, a small shovel, a pair of Wellington boots or waders and a glass phial in which to put any gold. The standard plastic pan is about 45 cm in diameter, has a flat bottom with gently sloping sides and often riffles halfway around, which help trap the gold.

If you intend to take things more seriously you will also need a gravel or 'Henderson pump'. The Henderson pump was invented by George Alfred Henderson, and is an invaluable yet simple piece of equipment designed to suck gravel from a stream bed, saving hours of back-breaking digging. Henderson pumps are expensive, but a version can be made by using materials as simple as a tennis ball and length of drainpipe. Additional equipment such as a 10 mm gardener's sieve and a rake can also be useful for screening out large stones on the river bed before using the pump.

How to pan

The principle of panning involves progressively sifting through the material on a river bed until only the heaviest material – gold – remains. The gold particles found in Britain are minute, and are usually recovered at the rate of perhaps one or two per panful, and that's if you are lucky! You also have to keep your eye out for iron pyrite, or fool's gold, which is associated with the real thing and similar in colour but brittle and more crys-

talline. The colour of gold in Britain varies from area to area depending on the amount of silver and other impurities present. In Scotland it tends to be bright yellow, whereas Welsh gold can have a reddish hue, but both are generally at least 80 per cent pure.

Panning in itself is not particularly difficult, but the technique is only part of the story. Detailed knowledge of an area is the key to successful panning, and this can only be acquired through experience. Inexpensive day courses run by panning instructors are available in Scotland, and local knowledge is worth – pardon the pun – its weight in gold. Notwithstanding that, here is a description of the basic panning technique:

1. Find a stretch of water that is flowing at a moderate pace, and ideally at least 150 mm deep.

2. Push the end of the pump into the gravel and pull back the handle; you will hear the gravel being sucked up.

3. Feed the gravel through your sieve into the pan until it is about half full.

4. Submerge the pan and shake vigorously back and forth and from left to right, being careful not to lose any material.

5. Find somewhere comfortable to sit with access to slow-moving water, and begin rotating the pan in a gentle oscillating movement to dissolve any dirt, using the flow of water to help disperse it.

6. Separate any clumps of moss or roots over the pan with your fingers, and remove larger rocks after making sure they are washed clean.

7. Take the pan halfway out of the water and tilt it away from you until the gravel slides down the riffles.

8. Swirl the pan using a slight forwards rocking motion, letting the water wash over the lighter material and spilling it slowly over the edge.

The above stages should be repeated several times until there is just a small amount of heavy material called concentrate left in the pan. With a little water, flick the concentrate in a circular motion and check for pieces of gold that can be picked out by hand. Washing off the remaining concentrate should be done with a great deal of care as impatience will result in lost gold. The whole process should take around ten minutes.

Where to pan

When assessing a potential stretch of water for gold there are several things you should look out for:

- Keep an eye out for areas such as the inside of a bend, places where the stream widens or where the flow of water slows, or pools at the bottom of a change of gradient. Results will generally be better after a dry period, when the water is low.

- Gold is heavy and therefore settles at the lowest possible point, usually around solid bedrock. Pay particular attention to exposed rocks and stones, which may contain trapped gold, often in pockets or cracks. This will save a lot of digging through several layers of gravel to find bedrock.

- Cracks in rocks are sometimes worth scraping into, and larger rocks can be prised up to access what might be trapped around and underneath them.

- Other heavy deposits such as lead shotgun pellets and black sand (magnetic iron oxide) are a good indication that you are looking in the right area.

If you are panning a known location but don't find any gold, simply change tactics.

Panning tips

1. Don't work too much material in your pan at once. Gold may not sink to the bottom and could be lost.

2. Don't handle equipment with greasy hands. Oil is the panner's worst enemy and will cause gold to float, so that it may be lost. Clean your hands and equipment with very weak detergent – one drop on each hand and one in the pan is adequate, and will not harm fish or plant life.

3. Always transfer any gold to your phial over the pan in case you drop it.

4. If you are using a plastic pan, a magnet on the underside in the final stages will sometimes help separate the metallic concentrate from the gold.

5. Occasionally rewash your tailings, the material that accumulates near your workings. It is possible you may have missed something.

6. Natural flakes of gold are typically 0.6 mm in diameter and weigh 3.5 milligrams. These tiny grains can sometimes be transferred to your phial using a camel-hair brush.

7. Keep a sharp eye out. Scottish gold rarely tarnishes and is usually unmistakable in the bottom of the pan, but Welsh gold can be stained red or black by oxides.

8. Don't dig into banks, leave litter or remove material from the stream. Observe the country code and keep the area in which you work clean and tidy.

Where to pan in Britain

There are literally hundreds of locations where you can pan for gold in Britain. Much of the detailed information relates to

Scotland, but there are also several locations in Wales and the southwest. The three books I have listed in Further Information (*see page 277*) are very useful in this regard. Permission should always be obtained from the landowner, and a licence purchased wherever appropriate.

Scotland It is said that gold has been found in every county in Scotland except for East Lothian and Renfrew. Anything from one or two up to a couple of dozen locations exist in each of the following areas: Aberdeen, Angus, Argyll, Ayrshire, Berwick, Caithness, Dumfries, Glenrae, Galloway, Inverness, Kincardine, Lanark, Lothians, Nairn, Peebles, Perthshire, Selkirk, Strath Brora, Sutherland. (Don't forget the midge repellent.)

Wales The Afon Mawdach and Afon Wen and associated tributaries in Gwyndd to the north are areas that have been panned throughout history. Currently, Cambrian Goldfields Ltd, who own rights in the area, are proposing a permit system for hobbyists similar to those available in Scotland. Other areas to consider include the River Annell, near Pumsaint, Carmarthenshire and any stream in close proximity to an old mine.

Devon and Cornwall St Austell and Truro have probably been the most productive panning areas in the south-west, although gold has been recovered from most Devonshire and Cornish streams that flow to the south coast, particularly the Carnon. Areas include: Bodmin, Camborne, Crediton, Dartmoor, Exmoor, Falmouth, Helston, St Austell, Truro and Wadebridge.

To summarise, probably the best place to start panning is Wanlockhead in Scotland. There is expert tuition on hand during the season, accommodation and often other panners working the vicinity. Most importantly of all, gold is consistently found there.

Obtaining permission to pan

Permission should always be sought not only to pan, but also to access any adjoining land, and a licence should be obtained if one is required. Licences are relatively inexpensive, typically £3.50 a day or £30 annually. A licence entitles a person to pan a prescribed area and keep what is found. If permission has been sought from a landowner but no licence is necessary, a 'Letter of No Objection' should be obtained from a Crown Mineral Agent. Areas such as sites of special scientific interest, National Trust property and private land are restricted, and it is also worth remembering that some stretches of water are closed during the fish-spawning season.

Safety considerations

If you intend panning on your own, always be vigilant because rivers can be dangerous. If you fall in, waders can fill with water and hold you down, and conditions can change very quickly in remote areas. Always wear warm clothing and take a good supply of provisions plus basic survival equipment including a compass, mobile phone and if possible a GPS, and always tell someone where you are going and when you expect to return.

Sluicing

Throughout history, prospectors have used several other techniques apart from panning to extract gold from streams and rivers. One ancient method involves laying down sheepskins and allowing the flow of the water to trap particles of gold in the fleece. Another technique is called sluicing. A sluice allows a prospector to wash a large quantity of material efficiently, leaving just the fine concentrate for panning out.

Sluice boxes are quite simple, but a degree of skill is needed to use one and they are usually the preserve of experienced panners. There are several different types. Some have plastic

riffles that trap the gold, others have black rubber matting. If a sluice is used correctly the material transferred to the pan will contain gold normally spread through many kilos of unwashed gravel. The use of sluices is highly restricted in the UK, so check whether they are permitted in your area.

Using a sluice

When setting up a sluice box, look for somewhere where the current is flowing quite swiftly. Set the box directly in the flow so that the chute is partially filled with water, with the upper end slightly higher than the discharge end, at about a one in ten gradient. If the sluice is unstable, place some rocks around it to hold it down. Load small carefully regulated quantities of gravel into the sluice, ensuring that the crest of each riffle is visible at all times. The angle of flow should be adjusted so that small rocks and stones flow along the box due to the force of the water. Check the sluice periodically for the heavier gold, which should become trapped at the ends of the riffles. When black sand begins to extend downwards to each next riffle, it is time to remove the box from the current and wash the resulting concentrate in your pan.

Metal detecting

One other way to search for gold nuggets is by using a metal detector. You can search using an all-purpose detector, but there are specialist detectors on the market specifically designed for the purpose, and they will find the little pieces of gold that a standard machine will miss. Because of the rarity of nuggets in the UK a detector is best used in conjunction with panning to search areas you might consider hot spots. Once again, the use of metal detectors in conjunction with panning is restricted in the UK, so check first.

Gold jewellery from the British Isles

Gold glistening at the bottom of a glass phial will always draw admiration, but gold's true beauty only becomes apparent when it is fashioned into jewellery. Gold from the British Isles is rare, even taking on a mythical quality in certain circles. In its purest form it is worth £1,000 a troy ounce, around three times the world gold price, and that figure magnifies many times again once it is turned into jewellery. There is the royal connection, of course, but there are also many superb pieces in private hands or that have been bequeathed to museums.

A woman living in Edinburgh was given a gold pendant as a child by her grandfather, who took part in the 1869 gold rush. The pendant is decorated with a Celtic motif, has four garnets and also features a pearl from the Brora River. On the reverse is the single word 'Kildonan'. Another pendant from the same period, at the time in the care of the Bishop of Moray, Ross and Caithness, was also made from Kildonan gold. It measures 125 cm, again has a Celtic design and features around eleven pearls.

The search is still on for the watch the Duke of Sutherland presented to Robert Gilchrist, which reputedly is still in existence. Today, only a handful of specialist jewellers still make 18-carat plus jewellery from genuine Welsh or Scottish gold (royal rings incidentally are 22 carat). There are David Milne and Chris Engels using Scottish gold, and David Thomas of Asprey's and Baird & Co of London using Welsh gold.

One panner recently sold his entire collection, accumulated over ten years, consisting of 400 grams of pure 22-carat Scottish gold, to an Edinburgh jeweller. The price received was reported to be £25,000. The jeweller plans to create 250 new pieces, mainly wedding rings.

Companies working with Scottish and Welsh gold use a sterile environment to ensure absolute purity. All pieces are stamped with a special registration mark and accompanied by a signed certificate of authenticity, a sensible precaution when

you consider a simple engagement ring can cost several thousand pounds. So where does this leave the hobbyist panner? With an average day's labour producing perhaps a tenth of a gram of gold, and a ring requiring 3 to 4 grams, unless you are extremely lucky – like the one panner who recently found 70 grams (£2,000) worth of gold in just one day – enough gold for a ring will require about 40 to 50 days panning, and on top of that you will still have to pay to have the ring made. Modern panners, however, don't do it for the money, but because they love panning – the skill and challenge required, and the involvement with nature and the outdoors. Some would say that to alloy Welsh, Scottish or Cornish gold with world gold is sacrilege, but look at it this way: if you were to only ever go panning once, what could be more romantic than incorporating a few grains of hard-won gold from your labours in the freezing rivers of Britain into your sweetheart's engagement or wedding ring? Think about it boys (or girls)!

Learning more

If you want to learn more about gold in Britain there are a number of sources open to you. The Dolaucothi Mine in Wales is open to the public, and guided tours are available in two of the underground shafts, plus you can try your hand at panning. There are day, weekend and extended panning courses and holidays available in Scotland, usually between the months of April and October. Courses include equipment and tuition, plus accommodation for longer stays. There are often discounts for families and in some cases children can go free. If you want to take things more seriously, the University of Leeds offers academic courses on the geological aspects of gold in Britain. Courses are open to adult students and offer the opportunity to learn in detail the technical as well as practical aspects of gold prospecting. Details and addresses are available in Further Information (*see page 277*).

CHAPTER THREE

Bottle Digging

I T MAY BE fair to say that bottle digging is not as glamorous as prospecting for gold or unearthing pots of Roman coins, but it does offer increasingly attractive returns for the modern treasure hunter. Let me say first of all that we are not talking about rummaging around in refuse tips. Dump hunting, or bottle digging as it is more commonly called, involves uncovering historical dumps, typically Victorian or Edwardian ones, and digging out artefacts such as bottles and pots that were considered rubbish at the time they were deposited there, but have value now.

The two main advantages that bottle digging has over many other types of treasure hunting is equipment and availability – if you can lay your hands on a fork and shovel, and own a pair of boots and some sturdy gloves, once you have found a dump you are in business. Also, dumps are not area specific. They are found all around the UK, and the chances are that there are dumps yet to be discovered in your area.

Bottle digging began to take off in Britain during the 1970s, spreading from America, where it was already popular, and it now has a small but dedicated group of enthusiasts. Bottle digging offers the opportunity to amass a large collection of

fast-appreciating artefacts free of charge, simply by digging them up. Individual finds can be worth anything from a few pence through hundreds and occasionally even over a thousand pounds. Taking treasure hunting as a whole, searching for dumps is a good outside bet, something that costs nothing to keep an eye out for, but that when found can deliver a windfall. It is not unusual for an untouched dump – and it is reckoned that there are still quite a lot of them out there – to contain hundreds of intact finds, each of which will have a value.

The finds bottle diggers recover from dumps can be split broadly into four categories: bottles, stoneware, pot lids, and miscellaneous, the latter being anything that doesn't fall into the first three categories. To fully appreciate the finds bottle diggers uncover requires a breadth of knowledge that covers several disciplines encompassing history, manufacturing techniques, distribution and usage. It is assumed that you don't want to know what a Birch blue top or a slab seal porter is at present, so this chapter is confined predominately to showing you how to locate dumps, how finds are recovered, what the artefacts are and their values, and how to prepare them for sale. Also highlighted are many of the rare and interesting artefacts bottle diggers have found over the years.

In twenty-first-century Britain there has been a resurgence in the popularity of antiques for investment. This can partly be explained by television programmes, but it is also probably due to people's realisation that it is sensible to spread financial risk in times of uncertainty. I can remember when not so many years ago there was a rush for pop memorabilia, but today much of that is financially out of reach, and new affordable avenues of collecting are being examined. The range and multitude of shapes and colours of bottles and pots make them ideally suited to backlit display cabinets, and as a result prices are rising. Bottle and pot collecting is still in its infancy and collectors are still deliberating on values, and as a result bottle diggers are getting

some pleasant surprises. Some finds, for instance, are rarer than originally thought, and the prices of many others are already beginning to soar.

Incidentally, there is no shortage of opportunities to sell your finds. There are passionate collectors both in Britain and abroad willing to pay handsomely for the pieces they want.

Bottles

The history of glass is as ancient as it is diverse. The Venetians began to manufacture glass 4,000 years ago, and it is known that the Romans were producing blown glass by the first century BC, several examples having been found in Britain. These early Roman bottles were discoloured because of impurities in the glass, and it wasn't until 200 years later that clear glass was developed and colour added deliberately. Early vessels were highly prized and only contained precious commodities like perfumes and oils; water and other mundane consumables were still confined to wood, parchment and stoneware.

This early period of glass development spanned the Roman occupation of Britain, but it is believed that the Romans didn't pass their glassmaking skills on. The earliest evidence of indigenous glass making arises from a site in Jarrow dating from 640 AD. There were also later wood furnaces that existed in thirteenth-century Surrey, and an ancient manuscript dating from that period refers to the making of 'brode glass and vessel'.

The seeds of the British bottle industry began to take hold in the sixteenth century. It is documented that 'ale' bottles were in use in 1575, the same types of bottle that were used for wine, and depictions in early paintings seem to confirm this. These primitive bottles were only available to the very wealthy, and were even coveted to the same high extent as gold and silver. To illustrate the point, bottles and glassware were listed among

King Henry VIII's other valuable possessions in a sixteenth-century inventory.

By the end of the sixteenth century, refugees began arriving from the Netherlands and the British bottle industry really began to take off. For 250 years, a thriving hand-made bottle-manufacturing industry existed in Britain, but the method of production involved was expensive and excise duty was levied on all glass produced between 1745 and 1845, so reuse was prevalent.

In the mid nineteenth century bottles rapidly became the container of choice for a wide variety of products, and a vast industry grew up to feed demand. In fact, at one time or another, virtually everything apart from fresh produce was bottled or potted. Although stoneware was still the container of choice for some drinks and foodstuffs, by the 1850s minerals, beers and spirits as well as many other products became widely available in glass. However, the days of the hand-made bottle industry were already numbered.

By 1887 the first semi-automatic bottle-making machine began operating in Britain, initially turning out 200 units an hour, and just twenty years later, in America, the first fully automated machine was developed. Within just a few short years hand-made bottle production ceased in Britain, and bottles were being produced automatically without any human intervention whatsoever. Glasshouse cones like the one in my home town, Stourbridge in the West Midlands, are the only surviving reminders of a bygone era.

Bottle diggers and collectors alike categorise all antique bottles by use, manufacturer or design, and often a combination of all three. Many bottle types are self-explanatory, such as cures, veterinary, poisons and inks, but there are also others that are less obvious relating to manufacturers such as Codds, Warners and Hamiltons. Terms that relate to a design or a manufacturing process include freeblown, moulded and embossed,

and bottles with combined descriptions include flat-bottomed Hamiltons and Warner safe cures. Bottle terminology can seem like a foreign language to the uninitiated, but it's actually quite simple once you understand the basics. Here are some of the most common bottle terms and what they refer to, which should help you understand the more detailed descriptions given later.

Bottle terms

- **Blob top (or blob lip)** Bottle with a heavy type of lip. Blob tops were designed to survive repeated reuse.

- **Codd** Patented in the 1870s by Hiram Codd of Barnsley, a 'codd' was a type of bottle that was designed to keep the carbonated contents fresh. A glass or marble stopper was held in place inside the neck between two lugs by the pressure of the contents. There have been many variations of codds and there are several sizes including the jumbo and giant codd. Incidentally, 'codd' is thought to be the source of the phrase 'codswallop', a reference to the contents. Codds are often found with broken necks because children collected the stoppers to use as marbles – one bottle digger found around 500 in one dump!

- **Coloured lip** Bottles were expensive to manufacture, and to be cost effective they needed to be reused several times. To ensure companies kept to their own bottles a system of colouring the lips was developed. Examples include greens, browns and blues.

- **Dumpy** Stout, wide-shaped bottle, for example a 'dumpy codd'.

- **Embossed** Bottles were often embossed with the manufacturer's name and product details, formed in a relief mould

that produced lettering. By the end of the nineteenth century around three-quarters of all bottles were embossed. They were eventually superseded by machine-made bottles with printed labels.

- **Freeblown** Bottle that has been blown 'free' by a glass blower, as opposed to blown into a mould. Early freeblown bottles are usually distinguishable by their highly irregular shape.

- **Hamilton** Invented in the 1800s, a 'Hamilton' was a glass or stoneware torpedo-shaped bottle with no base that was designed to be stored on its side to prevent the cork from drying out.

- **Hinged mould** Two-piece mould that allowed for the formation of the shoulders as well as the body of a bottle, which meant less finishing. Other types of early mould include turn moulds and strap moulds. Early moulded bottles are identifiable by seam marks on their sides.

- **Hybrid** Bottle that incorporates two or more manufacturing techniques or processes. An example would be a Hamilton codd (a torpedo-shaped bottle with a marble stopper).

- **Pontil** The rough edge left at the bottoms of early bottles due to the snapping off of the pontil rod, a tool that held the bottle in place during finishing.

- **Seals** Wealthy patrons, taverns and other organisations would sometimes have a seal or a coat of arms embossed onto the shoulders of their bottles, particularly wine bottles. There are also pie-crust style embellishments called 'slab seals' found on stoneware. Many 'seals' are highly collectable.

- **Sheared lip** Term used to describe a bottle that was cut from

the blowpipe with shears. Other types of lip finish include applied lips, flared lips and laid-on lips.

- **Sick glass** Term used to describe a dump-recovered bottle that has been attacked by acids in the ground. The surface has a milky pearlesque appearance.

- **Transfer print** Early method of attaching information onto stoneware bottles, pots and jars.

- **Warner** Warner Safe Cures, sometimes just called Warners, were a type of bottle manufactured by a company called H. Warner, which began life in America and eventually spread throughout the rest of the world. Warners are usually green, brown or amber, and were manufactured in a variety of sizes, all of which have a picture of a safe embossed on them together with the word 'cure'. Warner cures are highly collectable and command good prices.

> *Let's raise a glass to Hiram Codd,*
> *a man who pulled a whopper,*
> *He lost the cork and fed instead*
> *the neck with a glass balled stopper.*
> *Anon.*

Collectable bottles

There are no hard and fast rules when it comes to judging what makes some bottles more collectable than others, but there are some rough guidelines that can help. Rarity is a factor, obviously, and as a rule the older the bottle the better. Generally speaking collectors are only interested in pre-1920s bottles, which if not entirely hand made are at least hand finished. Bottles made from coloured glass are often quite sought after, particularly greens, deep blues, ambers and blacks, as are some embossed bottles and bottles with prominent pictorials or trademarks. Early patents, regional rarities and bottles with

unusual shapes or features will also often command higher prices. It's worth noting that collectors are also only interested in bottles in mint or near mint condition, which means no chips, cracks or scratches. Allowances are sometimes made for very rare finds, but badly damaged or broken bottles have no value whatsoever.

When it comes to prices and valuations, I don't want to give the impression that some of the exceptional examples high-lighted below are by any means typical. The vast majority of bottles found, even in good condition, are only worth from a few pence to perhaps a pound or two. Some may be worth a little more – £5, £10 or £20 perhaps – but bottles running into the hundreds let alone thousands of pounds are phenomenally rare finds, and anyway not usually in an acceptable condition when recovered from a dump. The pennies and pounds soon add up, however, and bottle diggers do build collections worth many hundreds if not thousands of pounds, although rare mint finds are exceptional and only come to light occasionally, and certainly shouldn't be considered everyday finds. Having said that, they *are* out there, and bottle diggers *do* occasionally find them.

When it come to classifying bottles one of the main prob-lems is deciding what is what. Bottles have been put to hun-dreds of uses, and there are thousands of variations in design, shape and colour. To start with it's simply a case of establishing what is, or isn't, a bottle. A ginger beer container may be shaped like a bottle and therefore be classified as one, but they are usually made of stoneware and may therefore be categorised as such. A tonic, if liquid, may come in a bottle, whereas a cream would be in a pot, but both are chemist or cure related and both of those are usually in separate categories. Baby feeders and inks can be made from either glass or stoneware, and yet both are in a category of their own. To confuse matters further, as already mentioned some collectors prefer to classify bottles and

stoneware by the manufacturer's name or a process, rather than according to what they were actually used for. Collectors tend to be more type specific with bottles, but below is my interpretation of the categories, which are broadly usage based.

Beers, wines, spirits and minerals

Beers

Beer and stout bottles are relatively common finds, but still have a dedicated following of collectors. Some of the earliest bottles are from the early eighteenth century and were designed specifically for porter. Corked beer bottles only began to appear from the 1870s.

Values Early beer bottles, which are typically brown or green, are usually at best only worth a couple of pounds, but a giant display bottle could be worth more, sometimes in excess of £50. Regional rarities in good condition can also fetch surprisingly high prices. Embossing became popular from the 1870s, and early examples from brewers like Ind Coope and Adnams are particularly sought after. An exceptionally rare Emmerson factory beer bottle was recently on sale in a specialist magazine for £500. Collectors often specialise in a particular brewery, and anything related to the brewery of choice might be of interest to them. It's worth noting that only labelled examples of later beer bottles are usually collected.

Wines

Wine was probably the first alcoholic drink to be bottled. Very early British examples like those from the early to mid seventeenth century were made from what is termed black glass, which is actually dark green or brown. Early bottles are quite brittle and resemble coloured glazed stoneware more than glass. Early wine and port bottles were free blown and usually misshapen, making them individual in their own right, and there

are some great designs with names such as shaft, globe, onion and, later, mallet.

Values A very early mallet was recently on sale for £120. Seals are particularly sought after – one rare sealed onion from 1709 is valued at £1,700, and an even earlier example was sold in 1992 for £4,600. Development of the cylindrical-shaped bottle similar to the one we recognise today began in the early eighteenth century, but to be of any value they usually need to be corked and full of wine!

Spirits

Spirits, cherry brandies, gins and particularly early Scotch whisky bottles are all sought after by collectors. The British have historically had a taste for gin, and some collectors have developed a taste for rare and interesting gin bottles. 'Case gins' were blown into square wooden moulds so that a dozen would fit neatly into a case. Most were imported from Holland, giving rise to the phrase 'Dutch courage', and rare examples can command £50 or more.

Values One 'Philanthrop' embossed gin bottle from the late nineteenth century has a value of £150, and other gins have also reached three figures. Whisky was traditionally available in glazed stoneware crocks (see what I mean about categories!), and some exceptionally high-quality, transfer-printed examples have been valued at several hundred pounds.

Minerals

Bottles containing minerals, sodas, seltzers and bitters began to appear during the late eighteenth century. These drinks were produced by companies such as Joseph Schweppe and Schnapps, names that are still familiar today. Bitters were patent medicines that usually contained alcohol, whereas sodas were the nonalcoholic variety. Earthenware was initially used to

contain the carbonated products, but it soon became apparent that the contents became flat because the gas in them permeated through the stoneware. Manufacturers therefore quickly switched to glass. Early examples were corked, and corks were followed by marble stoppers, internal screw stoppers in 1872 and finally by the crown top (introduced in 1892) we recognise today.

Values Minerals are quite common, and sought-after examples usually need to be local rarities or examples with coloured glass, marbles or lips, which in good condition can be worth anything from a pound or two up to £30. Scarcer examples like a dark red, lipped R. White codd, or a green Dawson of Norwich, might fetch as much as £100. Early stoneware bitters with embossed lettering are also quite sought after, as are some patents, commanding prices as high as £3,000. A particularly rare early nineteenth-century green Hamilton was recently sold at auction for £4,060. Other glass rarities include the cobalt blue, and some other coloured codds from the Newcastle area. *Antique Bottle Collector* magazine recently brokered a deal in excess of £5,000 for one coloured mineral from the north-east.

Cures, baby feeders and veterinary

Cures and tonics

Long before medicines were established there were quacks who peddled products claiming to cure everything from coughs to cancer. These dubious claims were often embossed on the bottles themselves, with names such as lung restorer, blood mixture, asthma cure and hair restorer. A. W. M. Radams germ, bacteria and fungus destroyer from the late nineteenth century audaciously states 'Cures all Diseases'. Patent medicines gradually began to appear from the turn of the nineteenth century, and manufacturers' names, together with dosages and other

information, were often embossed or printed on the bottles themselves.

Values Although generally less collectable than quack cures, rare examples of early patent medicines can command good prices. Typical values start from around £1, but interesting shapes such as flats and ovals are particularly sought after, often selling for £20 to £30 each, which is the starting price for many Warners. A miniature amber Warners cure was recently offered for £400, and a particularly rare embossed Daffy's Elixir in olive green from the early part of the nineteenth century has been valued at £800.

Baby feeders

Baby feeders, or nursers as they are often called, are another category of find with a thriving collectors' market. Early examples were made of earthenware, or sometimes even of pewter, but by the mid nineteenth century most were being made of glass. The teats were made of pickled calves' livers or India rubber. There are some superb names to describe the huge variety of shapes and designs available, such as banana, turtle, boat and banjo. Early feeders were hard to clean, earning themselves the frightening term 'murder bottles'. By the early twentieth century the word hygienic had thankfully entered people's vocabulary, and this was often embossed on the feeder itself, as were decorative illustrations and other information about the product.

Values Some of the more interesting feeders sell for between £15 and £30 each in mint condition, and earlier rare hand-blown shapes can command more, £50 to £75 perhaps. Very rare highly decorative blue and white feeders have sold for hundreds of pounds, and a salt-glazed feeder made to commemorate Queen Victoria's coronation would realise in excess of £1,000 in mint condition. There is also a market for tiny dolls' feeders.

Veterinary

There have been cures and potions available for animals – particularly dogs, horses and livestock – as well as humans. Look out for names such as Day & Sons, Thorleys, Benbows dog mixture, and Bronko's cough paste.

Values A rare 'Tippers Animal Medicine' bottle was recently sold to a US collector for $195 (about £100), and a unique Gaskell veterinary flask from the mid nineteenth century depicting an embossed cow is valued at £700. Rural dumps are good locations to search for these finds.

Poisons and inks

Poisons

Poisons are among the most collected types of antique bottle. Some poisons can be interpreted as chemist related, like the 'pox' (skin disease) bottle from Salford Hospital with panels stating 'poison not to be taken'. Interestingly, in 1908 the Poisonous Substances Act was introduced, which stated that bottles must be distinguishable by touch to take account of dimly lit houses and the illiterate. As a result poisons were often heavily embossed and were available in hundreds of interesting patented shapes and designs such as the wedge, triangle, submarine, skull and coffin.

Values The vast majority of poisons are only worth from just a few pence to perhaps the £25 mark, but collectors will pay anything up to £1,000 for the scarcest examples. A rare example of a British poison is the flat cobalt blue wasp-waist, so called because it has a narrowed mid waist. There are less than a dozen of these known, and they can realise up to £1,000 at auction. The highest price paid for a British poison was for an 1871 G. F. Langford coffin in cobalt blue. Only four of these bottles are known to exist and this was one of the best. The hammer came down at £9,570.

Inks

Generally speaking the category 'inks' refers to inkwells, but there are also collectors of master ink bottles. Most glass inks were clear, but occasionally coloured examples are found in ice and aqua blues, emerald greens and very occasionally amber. Inks were produced in a wide range of interesting shapes and designs including the barrel, turtle, pyramid, cotton reel, boat, octagonal, bell, tent and tipper, the latter so called because it has an angled base that enabled the writer to draw the last drop of ink.

Values Although inks are highly decorative they were generally cheap to produce and are therefore relatively common. Most finds only fetch £1 to £2 today. Penny inks, so called because they retailed for around 1d, were manufactured for sixty years from 1870 and are also common finds. They were usually cream or brown and very basic in appearance. Scarcer inks can be worth anything from £5 up to perhaps £30 to £40, with one-offs occasionally commanding twice that. Among the very rare examples is a late nineteenth-century ink that is shaped like a miniature cottage with the chimney acting as the well, worth £400. Another mid nineteenth-century embossed emerald green tea kettle-shaped ink has been valued at £500. Even Roman inkwells have turned up in Britain – one was found in Cannon Street, London, inscribed with the owner's name.

Other bottles and glassware

There are many other types of bottle and glass container that are sought after by collectors. People collect things as mundane as marmalade and fruit jars and even old sauce and pickle bottles. Listed below are examples of some of the other bottles and glass objects that people collect:

- Old **Bovril pots** can fetch £1 to £2 each, and a giant one with an intact label could be worth as much as £200.

- Old **pictorial milk bottles** have a value, as do old **oil bottles** like the early Esso bottles.

- Old **oil lamps** are worth a couple of pounds each if in reasonable condition.

- There are old **perfume bottles** from companies like Avon in a limitless range of shapes and colours, rare examples of which can command up to £25. Victorian examples of other commercial scent and decanting bottles are also collectable.

- The majority of **eyecups**, or eyebaths, which contained preparations for eye infections, are worth little but some of the coloured examples are very valuable. A cobalt blue reservoir variety from the late nineteenth century is valued at £100, and a particularly rare early nineteenth-century blue and white ceramic example is worth £1,000.

- **Smelling salts** and old **vapour inhalers** are sought after both in glass and stoneware, and are typically worth £20 each in good condition. A particularly attractive Boval Inhaler with instructions printed on the side, complete with both glass tubes, is valued at £200.

- **Soda syphons** can be clear or amber, blue or green.

- Old **coloured glass Christmas lights** came in a huge range of patterns and designs, and can now be worth anything up to £25 each.

- **Fire grenades** with interesting shapes and designs are considered to be very collectable. Glass fire grenades were deployed in public buildings and larger private homes before the onset of the modern fire service. They contained chemicals that exploded upon impact with a fire and consumed large amounts of oxygen, hopefully extinguishing the fire. Grenades were often displayed in racks of two or three and

were very ornate. Particularly rare sets can be worth several hundred pounds.

- A third-century **Roman glass drinking beaker** found in Britain was recently put on sale by an antique dealer for £185.

Collectable stoneware

Stoneware is a very broad term that I have hijacked to describe any kiln-fired non-glass container that has become watertight during its making process. A hundred or more years ago stoneware contained anything from drinks such as ginger beer, to foodstuffs, preserves, creams and ointments. There were also larger stoneware flasks, flagons, barrels and crocks that contained ale, porter, whisky, cider and vinegar, as well as dairy products. Early earthenware was often salt glazed, a technique that involved throwing salt into the kiln while firing, which produced a characteristic orange-peel effect. There has been a glazed stoneware-manufacturing base throughout Britain for around 250 years, although many of the techniques adopted were actually developed much earlier elsewhere.

Virtually all interesting pre-1920s stoneware has some value, but as a rule this will usually be less than £10. There are, however, some exceptional pieces that have sold for much more, in some cases for many hundreds of pounds, and even over £1,000. It is generally acknowledged by collectors that stoneware in mint condition is rare, and minor damage is sometimes accepted, but also reflected in the price. As in the case of bottles, categorising stoneware is a matter for conjecture – this is just my interpretation.

Creams, crocks and jugs

These contained butter, cream and other dairy-related products. They were manufactured extensively between the 1880s and

1930s, and often had a dairy's name and details of the product printed on the side. There is a limitless variety of this type of stoneware available in a wide range of interesting shapes and sizes.

Values Early examples with crisp prints and pictorials are particularly sought after, and are typically worth up to £30 each. A very rare Harris's clotted cream jar with purple print was recently on sale for £150, and a large Frame & Sons (Glasgow) butter crock could command several hundred pounds. A blue transfer-printed Andrew Cameron from the 1920s has been valued at £1,000, as only a few have been found and most were poorly struck.

Pots

In addition to bottled cures and potions, there were glazed stoneware pots that contained salves, creams and ointments as well as the usual foodstuffs. They were typically 75 mm tall and were manufactured in a variety of sizes and designs.

Values Once you get past the more common varieties these pots can be worth anything up to £100 each. Particularly rare examples like a Lee's Ointment (Paisley Sepia), or Dr Rook's Golden Ointment, both from the turn of the century, are each valued at £500. An extremely rare Johnson's ointment pot was recently offered to the US market for $1,350 (£675), and other examples have been known to change hands for over £1,000. There were also smaller versions of these pots and jars that contained foodstuffs such as chutney, potted meats, anchovy paste and caviar, which have been known to command similar prices.

Early stoneware

Early stoneware items such as crocks, barrels and flasks can be worth anything from less than £10 to several hundred pounds each. Collectors are particularly drawn to the famous name

Doulton, which actually began life in the 1820s as Doulton & Watts, producing salt-glazed jugs and flasks, as well as pipes for the London sewerage system, and becoming Doulton & Co in 1854.

Values A Doulton 'Votes For Women' inkwell was recently valued at £350, and a rare Doulton Colonel Bogey whisky jug would command over £500. Saltware bottles, tankards and flagons that contained whisky, cider, milk and vinegar are also collected. Highly ornate pub water jugs and whisky flagons can be worth anything from £50 to several hundred pounds. A mint Burslem jug made for Oakwell Brewery in Barnsley has been valued at £1,500.

Ginger beers

The manufacture of ginger beer began in Britain as early as the 1800s, and by the late nineteenth century the drink had became extremely popular. During the nineteenth and early twentieth centuries there were literally hundreds of ginger beer producers, ranging from large manufacturers right down to corner shop and even kitchen operations. Ginger beers were usually sold in glazed stoneware bottles to keep the contents cool, and manufacturers remained loyal to stoneware right up until the 1920s, by which time most other beverages were available in glass. Ginger beer bottles came in a wide variety of interesting shapes and sizes, with names like skittle and champagne, and were sometimes two-toned in contrasting shades like honey or white. Early examples had embossed lettering, the later ones transfer printed makers emblems, and the crisper these are the better.

Values Ginger beers are quite common, and the majority are only worth a few pounds at best, but some examples have sold for much more. A rare Gloucestershire Galtee More Patent ginger beer bottle was recently on sale for £70. Coloured tops

like the blues or greens are also sought after. A blue top with the highly descriptive title 'Bowens old fashioned non-alcoholic ginger beer like grandmother used to make only better' recently sold for £140. A very rare example like the blue-printed Buckler & Co or Fulham Pottery saltglaze from the turn of the twentieth century can command £300 to £400. An ultra-rare Thomson & Sons ginger beer in mint condition was recently sold at auction for £875.

Other stoneware

There are many other types of stoneware that collectors find attractive, particularly bedroom, bathroom and kitchenware. The most collectable types are listed below:

- Stoneware **foot warmers**, which were in use before central heating, are quite sought after, and in good condition most are worth £5 to £30, but prices in excess of £100 are not unheard of.

- Items like old **ceramic lavatory disinfectors**, **talc dispensers** and **laundry items** have all found buyers.

- Kitchenware such as **pie funnels**, **jelly moulds**, **rolling pins** and **water filters** are collected, and here again Dalton is a prominent and attractive manufacturer. Water filters began to appear in the late nineteenth century following a cholera epidemic, and contained filtration systems that incorporated ingredients as innocuous as carbon, cloth and even sand! Many water filters are very ornate and if complete and in good condition can be worth anything up to three figures.

Pot lids

Another category of collectable found in dumps is pot lids. Decorative glazed stoneware pot lids come from shallow glazed pots

that were manufactured around the mid to late nineteenth century and contained such commodities as preserved meat, fish pastes, toothpaste, powder, salves and creams. The lids were generally circular, and a uniform 75 mm, 100 mm or 125 mm in diameter, although there were exceptions. The lids often overhung the pot, and were displayed in a manner that gave the buyer the impression they were getting more product than was actually the case. Pot lids usually have the manufacturer's name printed on them, details of the product and sometimes additional information such as weight and a price, and occasionally an illustration.

Pot lids can be split broadly into two categories: black transfer-print on white glaze varieties, and coloured types. The coloured lids are often called 'Pratt lids' after Felix Edward Pratt, who was one of the pioneering manufacturers in the mid nineteenth century. Early coloured transfer prints were fiddly and time-consuming to apply, giving rise to yet another pot- and bottle-related phrase, 'pratting about'. Pratt lids and lids from other manufacturers who worked to an equally high standard are highly collectable. There are about 4,000 pot lid designs catalogued in the UK, and occasionally unique examples are still found. The lids themselves have the value, but this will generally be enhanced complete with the base.

Because there are so many different types of pot lid, collectors usually specialise in region or subject matter, or in coloured lids or just the black transfer varieties. Bears' grease for instance, a favourite with the Victorians, is particularly collectable. In its various guises, bears' grease was used for everything from skin creams to hair restorers and even in cooking. Bears' grease lids usually depict an illustration of a bear, of which thousands were sadly killed a century ago for the production of the grease. Many other themes are collected, such as portraits, floral designs, landscapes, sporting and hunting, animals, historical and geographical subjects.

Values Pot lid collectors value clarity, condition and scarcity above everything. Lids from even as late as the turn of the twentieth century can be worth anything from £5 to £50 if they are in good condition, and many rarer examples command in excess of £100. A black transfer Boots Cold Cream from the turn of the twentieth century is worth about £20, whereas a Bales Mushroom Savoury in sepia print is valued at £150. An undamaged oval tooth powder by T. Churlton & Co of Liverpool complete with the base was recently on sale for £350. Extremely rare coloured pot lids occasionally fetch over £1,000, but they need to be in perfect condition. A Clayton & Co's Real Bears Grease sold at a Sotheby's auction in 1980 for £2,700, and an exceptionally rare lid depicting an eastern lady with attendant went under the hammer recently for £3,600.

Other finds

Finally, in addition to bottles, pots and lids there is a myriad of other artefacts waiting to be found in dumps, many of which are of interest to specialist collectors. Returning to drinks, early beer cans from the 1930s shaped like 'Brasso' tins with screw tops are occasional finds that are highly sought after. They need to be in good condition, of course, but they can be worth as much as £50 each.

There are even match striker and match-related paraphernalia collectors, called phillumenists. Match strikers were common everywhere until they were virtually killed off by the matchbox. Strikers had a rough surface on the outside and a central recess for the matches. A particularly ornate Caley's match striker from 1905 is valued at £150.

Clay pipes are another highly specialised collecting area about which several books have been written. Other finds of interest include pressed tin and enamel signs, ashtrays, fly traps, bottle tops, china dolls and heads, and much, much more, not

forgetting the miniature versions of virtually everything mentioned so far in this chapter. That's the beauty of bottle digging – if it's old, looks interesting and is in reasonable condition, it will probably have a value to someone out there who collects it.

Locating dumps

It is generally accepted that the most difficult aspect of bottle digging is finding a dump in the first place. To get some experience you could consider joining a club and hope to get invited to an existing dig, but eventually you are going to have to go out there, do your research and find one yourself. Many of the larger inner city dumps – if not already uncovered – have now been built upon, but there are numerous smaller dumps still waiting to be found all around the UK.

Late nineteenth- and early twentieth-century dumps (or even a little earlier, if possible) are the ones you are looking for. It was the Victorians who began organising refuse disposal – collecting rubbish, carting it out of the towns to designated sites and eventually capping and grassing them over. Dumps earlier than 1860 are particularly rare because before then rubbish was first taken to collection depots where scavengers sifted through it, and anything of use found its way back into circulation. Later dumps, even up to as recently as the 1960s, do produce finds, but most are just worthless machine-made glass and other rubbish.

So how do you go about finding your first dump? Ideally you have to adopt a three-pronged approach and see what turns up.

1. **Ask around.** Ask anyone and everyone, particularly the older generation, and follow up every lead. Local knowledge is second to none, and it's often amazing what people can remember.

2. **Do your research.** Visit the reference section of your local

library and compare old maps with new ones. Look for old ponds, gravel pits or quarries that have been filled in, hopefully with household rubbish. Old minutes from council meetings regarding landfill sites are another source of information. Consider Victorian industrial sites that may now just be waste or common land. Old glassworks, breweries, brickworks, clay and lime pits, disused railway depots and embankments are other common areas where dumps have been found, as are tidal rivers, because bottles and other rubbish were often used as ballast.

3. **Keep your eyes open.** Builders removing topsoil from new sites deliver probably the most consistent supply of new dumps. It's also worth looking around canal towpaths, farms, hollows, coppices, woodland and even the countryside, because farms and estates also had to dispose of rubbish. Look for clues such as tall nettles and blackberry and elderberry bushes, which thrive on well-drained ground (ash), and also old tracks that appear to lead to nowhere. Even a glint of glass shining in the sunlight may lead you to an old dump. This suggestion could work much quicker than you think. An American bottle digger who came to Britain recently found a dump within days. Thanks to Jim Sears and Andy Goldfrank for the following story.

An American bottle digger in London
by Andy Goldfrank

The cold drizzle was incessant, night had fallen, the paths were muddy, the full moon was cloaked in fog, and yet there I was in my muck-caked shoes and water-soaked clothes walking through a farmer's overgrown field in England. There I was in that pasture after spending almost seven days seeing the sights of London, from Westminster Abbey to Shakespeare's Globe

Theatre. There I was meandering on a cold, dark evening, over bridges and into a tunnel, along highways, railways and waterways, through waist-high grass, thistles and brambles. Just an hour before, the only thought in my head had been returning to my sister-in-law's apartment, where dry clothes, hot food and a soothing drink awaited. On this wet, dark night, what was it that had pulled me to this place like iron filings to a magnet? Perhaps I am getting ahead of myself . . . let me start from the beginning.

Last month, my wife and I travelled to England for a holiday and to visit family living in Windsor. It was my intention to focus on family and perhaps attend a bottle show. Much had been planned, from touring Windsor Castle and trekking around London, to a trip to Stonehenge and the English Channel, leaving little opportunity for locating a dump site, let alone digging one. Accordingly, I had done no research and made no effort to contact local bottle diggers, and did not bring my metal detector or digging equipment. Over the first weekend, my sister-in-law and wife drove me to, and attended with me, the Alton bottle show. This event was quite an experience considering that, along with the hundreds of collectors packed into a tiny community centre, there were dozens of dealers, each with thousands of bottles, pot lids and other goods on their tables and laden in boxes nearby.

Somehow I managed to pick up a few bottles for digging buddies, and a few magazines for my personal edification, without smashing anything or offending anyone with inadvertent elbowing. My purpose in obtaining the magazines was to learn about the British bottle scene and to allow me to vicariously experience local digging through magazine stories. As I devoured the magazines over the next few days, it soon became apparent that the bulk of digging was done in 'tips' or dumps. It also dawned on me that there was a pattern to the location of these tips – not only were many of these dumps near waterways

or railways, but they were also wherever large-scale brick struc-
tures were built that required clay borrow pits for the brick-
making operations. Moreover, I realised that on my daily
sightseeing treks to and from London there were many places
that had all of these attributes.

Over the next few days, every time we departed from the
train station my eyes were fixed upon the passing landscape in
search of likely spots. It seemed there were plenty of locations,
but none readily accessible or identifiable to a tourist (without
a car or shovel) scheduled to leave shortly. On the second to last
day of our trip, much like the others in that it was cold and
rainy, we departed from a different train station because we
were going to a different part of London to see the British
Museum and Sir John Soane's home.

The ride into the city exposed me to a different landscape but
was otherwise uneventful (other than the bullet trains that whip
past at unbelievable speeds!). The day was spent meandering
through wet streets and mind-boggling museums, and at its
conclusion we ventured back to Windsor on the same line. My
faith in finding a digging spot long extinguished, I sat looking
out of the window examining the architecture and countryside
for amusement as I thought about changing my clothes and
eating some hot food. And then it happened ...

Out of the corner of my eye, I spotted some turned earth in
a field that had specks of white. Not even realising it, I said
aloud, 'I saw a tip, a real English dump!' My wife Joan, who is
incredibly supportive but also keenly aware of my obsessive
bottle-digging tendencies, looked at me as if I had seen a mirage
of a watering hole in the Mojave Desert. Without Joan even
asking, I explained to her that we had just passed an area that
was bordered by water on two sides (indicating a likelihood of
clayey soil), and a mile-long brick railway trestle on a third. This
spot was a prime location for temporary brick manufacturing
and therefore an ideal place for subsequent dumping to fill the

void left from the clay borrow pits. Within minutes we pulled into the station and parted ways: Joan off to the apartment to dry off and eat, and me off on a trek of an undefined distance to seek an inexact location if it existed at all.

Practically running along paths, roads and highways, I attempted to travel parallel to the railway tracks. My first obstacles were a dead-end street followed by a river that required a slight detour onto a highway bridge. Then, with the light fading, I walked along a narrow and muddy hiker's trail that stopped in a field. Straining to determine my location in relation to where I had thought I had spotted the dump, I finally noticed the brambles that had been a clue from the train. Also, up to that point the fields had all been flat, and this one was not only covered with thorny bushes but also rolling and uneven. There had been displacement of soil here, but the animal burrows failed to reveal any artefacts and no dump appeared to exist. Disheartened, I thought perhaps I had let my dreams and desires get the best of me.

Daylight long gone, I decided to walk into one last field that bordered the railway bridge. Breaking through a line of pine trees, I literally stumbled into a rabbit hole. Stepping away, I scanned the dirt and saw a pottery shard. Walking thirty yards further into the field, even with my eyes straining in the dark to see, it was evident that this was an old Victorian tip! Stumbling around for fifteen minutes, I managed to pick up a few shards of bottles and pot lids to show everyone back at the apartment (so that they would not think that I had gone on a wild-goose chase). As I retraced my steps back into town, my mind raced about the site with dozens of questions. Could I get a chance to dig before we left for the United States? Where could I get a shovel and digging stick? How old was this dump? Had it already been dug? Could I possibly find a pot lid?

Needless to say, I arranged to get up before 6 a.m. to return to the site and dig for a few hours on the day that we were

scheduled to depart for home. Purchasing a (terrible, flat-bladed) shovel and a broom handle, I trekked back to the site and saw that large portions of the tip had already been explored. Scouting around, I managed to isolate a spot that had not been dug. My goals were simple but certainly not easy: a ginger beer, a bottle embossed with London and a pot lid. The incessant drizzle did not bother me in the least. After taking off about 2 feet of overburden and ploughed soil in a small 3 foot by 5 foot rectangle, I finally broke into an undisturbed layer of ash. Almost immediately, bottles of all shapes and sizes started to pop out of the earth, including some utility bottles, sheared-lip sauces, a small green poison, a rich blue-green unembossed medicine and a squat amber 4 oz Bovril. This was nothing but fun, but I was in fast pursuit of more as time was running out.

Breaking past the ash, a 6 inch layer of coal-blackened soil that was void of artefacts needed to be removed. Shortly there-after more ash was exposed but it was starting to get wet in the hole at the 4 foot level. Careful not to get too dirty (since I did not have proper digging clothes in England), I started tossing out some sloppy, wet dirt. After a while of this heavy lifting, I jumped out to inspect the throw dirt and was surprised to find a brown pottery ginger beer stamped 'R. White London' with only a small lip chip! Next to that, there was a 4 inch tall, sheared-lip, ice-blue bottle embossed with the same name 'R. White' on one side and 'Sauce' on the other. Back in the hole, I started collapsing the sides and found that my excavation was directly beside someone else's digging efforts. Remarkably, I had managed to find one of the few untouched spots in the heart of the dump.

Finishing up, I poked around with my digging stick under a large rock that was in the side of the hole and recovered a beautiful sheared-lip aqua boat ink. These are quite common, but this was the first one that I had ever found and it will occupy a place of honour in my wife's collection of dug ink bottles. After

that find, there appeared to be nothing left to dig and I started refilling my pit. Looking at the soil while pushing the dirt in a paddling motion into the hole, I spotted the chipped edge of a pot lid. Not expecting much because this one was evidently damaged, I was delighted to find that the entire pot lid was sitting there in a clump from when it had been pitched from the earth. This was exactly what I was looking for, namely, a printed English pot lid. The pot lid once covered a container of Burgess's Anchovy Paste.

In rapid succession shortly thereafter, I pushed my shovel and digging stick into the loose soil that filled my hole, wrapped my artefacts in newspaper, placed them in my backpack, examined the architecture of the brick railway bridge with a smile and walked off to catch my plane home.

To share or not?

Once you have found a dump you need to decide whether you are going to keep it to yourself or share it with others. The answer to this might seem obvious, but there will generally be unforeseen circumstances to take into consideration. The main problem with new dumps is that they have a surprisingly quick way of becoming common knowledge, and before long your little gold mine might be considered fair game.

Engaging the help of another digger might offer a more profitable approach in the long run, enabling you to retrieve the finds quickly before word gets out. We are not talking archaeology here – once a dump is known about there will be plenty of others having a go. There may also be other considerations, such as safety, or perhaps in the case of a building site, time constraints. Of course, the one advantage of sharing your dump would be a reciprocal invitation.

Obtaining permission to dig

Gaining permission to dig a dump can often prove as frustrating as finding one in the first place. This is a common problem among bottle diggers. Who, for example, owns the railway network these days, and where exactly do you go to ask for permission to dig? Brownfield sites are another problem – they are large tracts of land that are often owned by a holding company.

How closely you stick to the letter of the law is a decision for the individual, but in most impossible cases bottle diggers tend to adopt the 'what they don't know won't hurt them' approach, and I think it would be fair to say if you've done your best to obtain permission, and work responsibly, what more can you do? If you can locate an owner, an offer to work quickly and responsibly, refill and even reseed a site after you have finished might secure permission. Having third-party insurance also helps, since it lifts responsibility from a landowner. Finally, you can always resort to that old chestnut – offer to share your finds.

Important note Some local authorities have recently taken legal action against bottle diggers, even to the extent of arresting and prosecuting individuals.

Digging techniques

Although the geography of each dump is different, once you have found a genuine Victorian or Edwardian dump there will be similarities no matter where it is located. Old dumps were generally made up of compressed ash because household rubbish was taken to sites mixed with fire ash. When full, organised dumps were capped with a layer of clay and then turfed over to prevent rat infestation. The geography of each dump will vary, but there are tried and trusted digging techniques wherever you are. Here, briefly, is the basic digging method:

1. Cut and carefully remove any turf, which should be stored separately on a plastic sheet or tarpaulin to prevent damage.

2. Begin digging shallow exploratory trenches to plot the geography of the dump, and of course establish whether or not there are any finds to be made.

3. Once you know that the dump has potential, dig down until you find a 'seam' of compressed ash.

4. Work inside the trench, collapsing the sides with a fork; bottle diggers refer to this as 'caving in'.

Although there will be a lot of broken glass and other rubbish around, good finds should begin to materialise. Bottles and pots will have survived intact not least because they were well made a century ago, and also because compact ash acts as packing. A good site can produce many dozens if not hundreds of finds.

Safety considerations

Sorry to be blunt, but people have died bottle digging. A few years ago a British bottle digger only survived a chest-high cave-in because someone was there to dig him out, and he still suffered broken ribs. The simple rule is never to dig anything apart from a few initial shallow trenches if you are on your own. It is also important to remember the safety of others. When you have explored a particular area always backfill the trench, and don't leave it open overnight. There will also be a lot of broken glass and sharp objects around, so make sure you have had tetanus injections and always wear sturdy boots and good gloves.

Bottle-digging tips

- If a site is turfed over, cut and remove the turf carefully and store it well away from the digging area. It can then be

replaced neatly when you have finished, leaving the site as you found it.

- Soil increases considerably in volume when dug. Make sure you have adequate polythene sheeting or tarpaulin to store it on. Three-metre strips should suffice.

- Bring boxes with you to store any finds recovered, and keep a record of what artefacts are found and where. Newspapers are also handy for packing finds and wrapping anything delicate.

- If possible use a fork instead of a shovel. This should result in fewer breakages.

- A small trowel can be useful for gently removing any finds from surrounding debris.

- Another handy tool is a probe rod, which is basically a metallic stick with a T-bar handle. A probe rod can be used to plot a dump and detect glass before digging.

- When digging, always wear sensible clothing such as overalls, good boots and a thick pair of gloves.

- Backfill your trenches regularly, and apart from exploratory trenches never dig alone (*see page 99*). Under no circumstances ever tunnel, no matter how tempting it may be.

Identifying your finds

At the beginning of this chapter I said that you probably wouldn't want to know what a Birch blue top or a slab seal porter was, but by now you will probably already have an idea. Being able to tell a Hamilton from a codd or a Warner from a seal will at best only get you halfway. The problem with bottles, stoneware, pots and lids is that being able to identify them

accurately by type is only part of the story because sometimes the plainest of finds can be very valuable simply because it is a regional rarity or an unusual patent. To identify your finds more accurately requires further investigation.

After initially identifying a find, the next stage is to date it. Some minerals and beers have dates embossed or printed on them, as do many flagons, but you should exercise caution because a date may just indicate when a company was established, not when the bottle was made, and could even just be a misleading batch number. Two quite accurate sources of information in this regard are the diamond registration marks that were employed between 1842 and 1883, and the system of registered design numbers that ran from 1884 until 1945.

Registration marks

From 1842 bottle manufacturers began to register their designs. The diamond-shaped registration mark on the bottle had the symbol *Rd* at the centre. Ignoring the letter or number at the very top of the diamond, which signified the class of material used, underneath was a letter that identified the year of registration. On the other three corners of the diamond were less important numbers and letters that related to the production dates and batches. Listed below are the years that relate to that top letter.

Note From three separate sources I failed to reach an absolute consensus on every date/letter combination. There may be an error or two, but I think this list is still well worth including.

1842 – X, 1843 – H, 1844 – C, 1845 – A, 1846 – I, 1847 – F, 1848 – U, 1849 – S, 1850 – V, 1851 – P, 1852 – D, 1853 – Y, 1854 – J, 1855 – E, 1856 – L, 1857 – K, 1858 – B, 1859 – M, 1860 – Z, 1861 – R, 1862 – O, 1863 – G, 1864 – N, 1865 – W, 1866 – Q, 1867 – T.

In 1868 the position of the letter changed from the top of the

diamond to the right-hand side. There is no danger of confusion here because before 1868 that position was held by a number. Here are the letters in the new position.

1868 – X, 1869 – H, 1870 – C, 1871 – A, 1872 – I, 1873 – F, 1874 – U, 1875 – S, 1876 – V, 1877 – P, 1878 – D, 1879 – Y, 1880 – J, 1881 – E, 1882 – L, 1883 – K.

A third system was introduced in 1884 that ran until 1945. A number was allocated for each design, and if you know the spread of numbers for each year you can calculate approximately when an item was first registered. Below are the first numbers allocated for that year. The numbers were usually prefixed by 'Reg No' or something similar. The year/number combinations vary slightly, but in any case should only be treated as a guide.

1884 – (from) 1	1885 – 19,754	1886 – 40,480
1887 – 64,520	1888 – 90,483	1889 – 116,648
1890 – 141,273	1891 – 163,767	1892 – 185,713
1893 – 205,240	1894 – 224,720	1895 – 246,975
1896 – 268,392	1897 – 291,241	1898 – 311,658
1899 – 331,707	1900 – 351,202	1901 – 368,154
1902 – 385,541	1903 – 403,012	1904 – 424,157
1905 – 447,615	1906 – 471,617	1907 – 493,532
1908 – 518,475	1909 – 534,978	1910 – 552,000
1911 – 575,855	1912 – 594,192	1913 – 613,209
1914 – 630,229	1915 – 645,055	1916 – 655,062
1917 – 659,164	1918 – 663,338	1919 – 666,476
1920 – 673,750	1921 – 680,289	1922 – 687,205
1923 – 695,061	1924 – 702,707	1925 – 710,199
1926 – 718,080	1927 – 726,393	1928 – 734,368
1929 – 742,740	1930 – 751,160	1931 – 760,589
1932 – 769, 675	1933 – 779,292	1934 – 789,035
1935 – 799,152	1936 – 808,793	1937 – 817,284
1938 – 825,246	1939 – 832,642	1940 – 837,520

1941 – 838,619 1942 – 839,283 1943 – 840,084
1944 – 841,071 1945 – 843,309.

When identifying a find, one of the best sources of information comes from being a member of a club, or at least being in touch with experienced bottle diggers and collectors through website forums or specialist publications. Bottle diggers and collectors pride themselves on the knowledge they have accumulated over many years, and 'what is it?' sections in magazines and on websites indicate that if they can help, they will.

Finally, in order to value a find you need to make an honest appraisal of its condition. Here is a guide:

1. **Mint** In perfect condition with absolutely no damage whatsoever. Bottles and pots rarely come out of dumps in this condition.

2. **Near mint** A mint condition example except perhaps for a light scratch or minor handling wear.

3. **Excellent** Light stain or scratches, but no nicks.

4. **Very good** Some scratches and staining. Minor nick(s) but no chips.

5. **Good** Scratches and heavy staining, minor chips but no cracks.

6. **Poor** Chipped and cracked.

Cleaning your finds

Old bottles and pots will often come out of dumps in surprisingly good condition, not least because they were so well made a century or two ago, but they will still need cleaning. The first thing to do is to leave any find to acclimatise for twenty-four hours, otherwise the shock during the cleaning process may

crack it. A note of caution here: old bottles can occasionally still contain potentially harmful, noxious or even poisonous chemicals that should be disposed of responsibly.

- To clean a bottle or pot, first soak it in warm soapy water and then give it a good wash.

- For tougher stains try rotating it in a bucket of sand or use a light scouring pad, but be careful not to leave any scratches. Under no circumstances ever use metal scourers, and at all times be aware that the neck is the weakest part of a bottle.

- Internally, a bottle or pot can be cleaned by using a brush – the type home brewers use is ideal – and if necessary left to soak overnight in a soda solution.

- Lighter stains can be removed using a rice/water solution (uncooked obviously!).

- For tougher stains try shaking vigorously with a mixture of coarse sand and water, but remember this might scratch a find and affect its value.

- To give bottles and pots that extra sparkle, a finishing touch can be achieved by applying a light coating of cerium oxide, used by lapidaries on gemstones. If you don't have access to this, light oil will do the trick but won't last as long.

- For interesting metallic finds vehicle rust remover can often do the trick, and for more valuable finds there are many specialist cleaning products available, and even experts who can do the job for you.

Valuing your finds

The first rule when selling finds, regardless of what you think you might have, is to try not to get too excited. One codd complete with marble stopper in excellent condition can look pretty

much like another. It may be worth £1,000, but it is almost certainly going to be worth more like £1.

I have already mentioned the clubs and websites that can help in valuation, and frankly this is the best approach because most valuation books only tend to deal with the higher end of the market. Another approach is to type the details of your find into an Internet search engine and see if anything comparable turns up. Again, price guides are one thing, but what people are actually prepared to pay is entirely another. Finally, there are some excellent specialist magazines, plus bottle shops, fairs and shows that you can visit to enable you to get an idea of prices.

Selling your finds

The pricing and selling of bottles, stoneware and pot lids is not a precise science. What might only be worth a few pence to one person might be worth a pound or two to another. At the other end of the scale, the value of a rare item might halve or even worse just because of a tiny amount of wear or damage, so valuations should at best only ever be treated as guides. It is also worth remembering that when selling reasonably common artefacts there is a fair amount of competition, so an inventive approach is required. Try a car boot sale, or filling odds and ends boxes at minor auctions. The next level is batching; putting three, five or more similar finds together and then attaching a price tag to the lot. The third level only applies if you have a find that would be of specific interest to a collector, and by now you will be talking about something that is worth at least £10.

There are many websites specialising in bottle and pot sales. You could try approaching one of these and ask to place an advert, and of course with modern technology it is not beyond the realms of possibility to create your own. Another way to reach the world market easily is through Internet auction sites. If you need a more targeted audience, try placing an advert in

one of the specialist bottle- and pot-collecting magazines. Finally, if you have something very special there are collectors whose names crop up all the time and who can easily be reached through the sources already mentioned.

An accidental digger

In the late 1980s, when I was a builder, I was contracted to build an extension to a pharmacy near my home in an industrialised area of the West Midlands. The pharmacy dated from the early part of the twentieth century, and the building certainly pre-dated that period. There were several pieces of vintage pharma-ceutical equipment on display in cabinets in the preparation area. The site was impossible to access with machinery so the foundations had to be dug by hand.

As I was digging I began finding the odd bottle. I ignored them at first, but as they started to mount up I removed them from around the trenches, at the time because I didn't want glass underfoot in what was a very restricted working environment. Within an hour I had accumulated a couple of hundred bottles. Most were intact, and the majority were clear, but there were also some really nice coloured examples and some interesting shapes. They were all definitely old and chemist related.

This is where bottle enthusiasts should turn away. Apart from the one or two more striking examples that ended up in the pharmacy, I threw the lot in the skip. It's pretty clear to me now that I dumped what would today probably be several hundred pounds worth of bottles, and these were just the ones that had been in the path of the trench – there were many others. What I can say is that I can't remember anything being coffin shaped or cobalt blue!

I mention this story simply to illustrate that anyone, any-where, at any time, can find a dump. I only wish I'd known then what I know now.

Sources of information

The best sources of information for bottle diggers are the two leading magazines *British Bottle Review* (*BBR*) and *Antique Bottle Collector*. These publications' names are a little deceptive, since they cover stoneware, pot lids and other associated finds as well as bottles. *BBR/Collectors' Mart* magazine is affiliated to many of the dozens of clubs throughout the UK, and both magazines will either carry or furnish you with full details of these, as well as keeping you in touch with the fairs and meets held around the UK throughout the year. For perfume and scent bottles try *Common Scents Magazine*. There are also bottle museums you can visit and specialist antique bottle shops. To get an instant taste of the world of bottle digging you can search the several websites built and run by enthusiasts in the UK, and hundreds more around the world. Finally there are several good books about bottle and pot collecting, details of which, together with other sources mentioned in this chapter, can be found in Further Information (*see page 276*).

CHAPTER FOUR

Searching for Gemstones

GEMSTONES ARE PRIZED throughout the world, and in the UK they are particularly rare. The highly sought-after gemstones like sapphire, opal and topaz are only found in Britain in tiny quantities, and some varieties are not found there at all. Described beautifully by Val Axel Firsoff in his book *Gemstones of the British Isles* as 'flowers of rock', a rare gemstone is that most elusive of finds for the British treasure hunter. There are a few specialist jewellers who make pieces from gemstones that genuinely originate in the UK, but the high street is predominantly serviced by other parts of the world.

Despite this, I make no excuses for including gemstones here. Outside the confines of mineralogical academia and the jewellery industry I am generally met by a mixture of surprise and disbelief when I tell people that gemstones are found in Britain. The fact is that people have found them in the past, and this indicates that they will continue to do so in the future.

The study of gemstones is called gemmology, and it is a fascinating but complicated subject. To understand gemmology you first need to study mineralogy, and to be able to hunt for gemstones you need to have some knowledge of geology. Mineralogy and geology are complicated subjects and I can only

really begin to scratch their surfaces here. This chapter therefore covers the basics, which include the definition of a gemstone, the various types found in Britain and where they can be found. Also recounted are some of the most interesting gemstone find stories from around Britain.

Not included here are the physical and chemical properties of gemstones, their complex formation processes, crystal structure systems, detailed optical characteristics and the processes gemmologists use to diagnose and grade gemstone species. Geology is also left almost entirely to the experts. If you would like to take a closer look at either of these subjects after reading this chapter, details of where to begin and some contact addresses are provided in Further Information (*see page 276*).

What is a gemstone?

Throughout history, gemstones have been defined in different ways by different civilisations. Thousands of years ago what were considered gemstones – coral, amber and pearl – were mainly organic. As well as being worn for personal adornment, these materials were often believed to have magical or healing qualities. More recently rarity has been the overriding factor, and today the majority of what we consider gemstones are mineral based.

Minerals are the naturally occurring chemical compounds or elements that make up the Earth. There are over 4,000 known minerals, each with its own properties, essential to our own physical well-being and even life itself. Of all the minerals known to exist, less than a hundred have the three basic qualities necessary to be classified as gemstones, which are beauty, durability and rarity. Of these mineral gemstones only around twenty are commonly used in jewellery, and some would argue that even less than that really count.

Gemstones were once classified in one of two ways, as either

precious (for instance sapphire and topaz) or semi-precious (jasper, zircon and so on) and taxed accordingly, but this is no longer the case. Today, whether gemstones are mineral, like sapphire or topaz, or organic, like pearl or amber, what they have in common is that they are all naturally occurring, hardwearing, beautiful and scarce. Put at its simplest, a gemstone today can best be defined as an attractive, rare, naturally occurring commodity that a jeweller can work with and mount into a desirable piece of jewellery.

Gemstone quality

The three main factors that define a gemstone can be summed up in one word – quality. Beauty is about colour, and in some cases degrees of transparency; it is also about how a stone's visual characteristics can be fashioned and enhanced by cutting and other processes. Durability is what defines a gemstone's hardness and resistance to damage through either scratching or breakage. Hard gemstones like diamonds are very durable, pearls much less so. As a rule gemstones are very durable, but even a diamond can break. Rarity is also an important factor, particularly nowadays, because many of the other characteristics can be replicated synthetically. Rarity is what distinguishes the highly desirable gemstones from the more common varieties, and the disparity in values can be startling. Whereas a particularly fine sapphire might be worth several thousand pounds, a comparatively common but equally beautiful stone may only be worth a few pence.

A mineral may qualify as a gemstone, but that doesn't mean all examples of that mineral are of gemstone quality. Azurite and malachite are classic examples of this. They are both minerals that are generally recognised as gemstones, and are common throughout Britain, but gem-quality stones, namely crystals of sufficient size and quality to actually be cut and

fashioned into jewellery, aren't found here. The most common reasons for this are flaws and inclusions – the crystals generally contain too many of these, making them unsuitable for cutting. Instances of the vast majority of the rarer gemstones found in Britain are usually tiny. In some cases they can be measured in terms of less than a millimetre, and whereas larger crystals are occasionally found, they are often badly flawed. Almost all gemstones from Britain that are of sufficient size and quality to be incorporated into jewellery are of the more common varieties, but there are occasional exceptions.

If a gemstone is of suitable quality for use in jewellery it is individually assessed by what is termed the 'four Cs': colour, clarity, cut and carat. Several different aspects within the definition of colour are used by gemmologists when evaluating gemstones both for identification purposes and for grading. Many of the complicated areas of gemmology relate to this subject, but sometimes it is just as simple as the fact that some gemstones are more desirable in certain colours than others. Similarly, clarity appertains to the presence of flaws and inclusions, which can again aid identification, but also affects durability and therefore a gemstone's suitability for the third of the four Cs, cut, which will be covered later. The fourth C, carat, is the measurement of the weight of a gemstone. People tend to be preoccupied with how many carats a gemstone is, but this is only one of the factors taken into consideration by gemmologists when determining a gemstone's quality and therefore value.

Carat

The weights of gemstones are measured in carats. *Carat* is an Arabic word meaning the seed of a Mediterranean fruit tree that was adopted as a measurement of weight for precious stones. One carat equals 0.2 grams. Carat is a term everyone is familiar with, particularly when buying jewellery, but it is completely

irrelevant when comparing like for like because some gemstones are naturally rarer than others. Even when comparing the same gemstone like for like, colour and clarity can affect value as much as weight.

Another popular misconception is that all gemstones of equal size are also of equal carats, but this isn't the case. The weight of a gemstone is determined by its density, which is measured by specific gravity. If you know a little about wine or beer making you will be familiar with this; if not this may be another of the relatively complex subjects you may wish to investigate further at a later date.

The Mohs scale

Another interesting aspect of gemmology is the Mohs scale, which is a formula devised to measure the relative hardness of gemstones. The durability of a gemstone is determined in many respects by its hardness, and the Mohs scale measures this. The Mohs scale was devised in 1912 by mineralogist Friedrich Mohs as a means of comparing the relative hardness of minerals. It works on a scale of 1 to 10, the diamond being the hardest at 10, while talc is 1. The principle is that each mineral cannot be scratched by the one that precedes it, and when you reach corundum that can only be scratched by a diamond.

The degrees of hardness between each mineral are arbitrary, but this is still a useful measurement. The traditional gemstones, which used to be called precious stones, all have a hardness of 7 or more, and the majority of gemstones still usually rate a minimum of 5 or 6, although there are a few exceptions. As well as being a measurement of durability, the Mohs scale can be useful as a crude tool of identification. A find that can't be scratched with a penknife (5 or 6 on the scale) would probably be worthy of further investigation. As a guide, window glass is about 5.

The Mohs scale

10 – Diamond	5 – Apatite
9 – Corundum	4 – Fluorite
8 – Topaz	3 – Calcite
7 – Quartz	2 – Gypsum
6 – Feldspar	1 – Talc

Gemstone classification

One of the most confusing aspects of gemmology is classification. People generally recognise gemstones by their individual evocative names such as ruby and sapphire, but this is misleading. Mineralogists classify gemstones by groups. There are several different groups of gemstone, and usually different varieties within each group.

The most common of all the gemstone groups is quartz. The quartz group is divided into two categories: crystalline and cryptocrystalline. Clear rock crystal is the most common variety of crystalline quartz. Amethyst and smoky quartz are coloured varieties of crystalline quartz, and are also relatively common, but there are others that are rarer. The second type of quartz is called cryptocrystalline quartz, which is a type of aggregate formed from microscopic crystals. Several varieties of cryptocrystalline quartz are also classified as gemstone material. Those found in Britain include agate and jasper.

Other gemstone groups include beryl, of which aquamarine is one variety, and garnet, of which pyrope is one of several varieties. Some gemstones, however, are single varieties, such as topaz and zircon. Each gemstone group can contain stones of similar colours to those in other groups, and different varieties within the same group can even be of similar colours. Gemmologists closely diagnose these gemstones by observing crystal systems and using other processes, but all you need to

remember is that each group of gemstones has properties unique to itself, but can contain gemstones of a wide and sometimes similar range of colours to others.

To illustrate why this is important we need go back to the ruby and sapphire example – they are both actually the same thing, corundum. Corundum in its natural form is colourless. Colour can occur due to impurities but the stones are essentially the same material – ruby is the red variety, sapphire the blue (or indeed any other colour but red). You can now understand why gemstones are given these easily recognisable names.

Gemstone occurrence

Geology is the study of the origin, structure and composition of our planet. It is an important aspect of gemmology because rocks are essentially composed of minerals, which are the source of gemstones. There are three basic groups of rock on Earth, igneous, sedimentary and metamorphic, and many different types within each group. Primary, igneous rock is solidified volcanic magma, of which all Earth was at one time composed of. Secondary, sedimentary rock formed when these pre-existing rocks were broken down by weathering, sometimes transported and then recompacted. Examples of sedimentary rock include sand that has become sandstone, and mud that has become shale. A third type of rock, metamorphic rock, forms when extreme heat or pressure changes the texture or mineral composition of either igneous or sedimentary rock.

Although the land mass of Britain is tiny, many different types of rock within the three groups are represented here. Gemstones are found in all three groups of rock, and knowledge of the formation and cooling processes of the different rock types within these groups can suggest the type of gemstone that may be present. Mineral crystals either grow from a melt or separate out from a solution, and in general terms igneous rocks are

the primary source of gemstones. Granite is an example of igneous rock that contains quartz, which as already mentioned is a group that contains the most common variety of gemstone. Gemstones are, however, also found in other types of rock. They can sometimes be washed away with the host material and resettle in sedimentary rock. Metamorphic rocks can also contain gemstones.

In order to identify possible gemstone-bearing areas, gem hunters need to familiarise themselves with the geological landscape of Britain. A geological map of the British Isles is a good place to start. Look for the red areas – an international colour for igneous rock. When in these areas keep a sharp eye out for exposed natural rock formations and on closer examination for cavities and veins. It's worth noting that conditions under which crystals grow are rare, particularly gem-quality ones, and natural gemstones can also be disguised for any number of reasons. Knowing exactly what to look for requires experience, and anyone new to gemstone collecting is best served by searching known areas with knowledgeable individuals, and allowing an understanding of geology and gemstones to develop from there.

Searching for gemstones

One explanation for the rarity of gemstones is that they hardly exist. A more accurate explanation is that they do exist, but recovering them in economic quantities is difficult. Commercial operations are aware of this. They know how gemstones form, and therefore the environments in which they are most likely to be found, but Britain like the rest of the world is constantly on the move and gemstones often aren't found where they were formed.

This is where knowledgeable individuals have the edge. A nonspecific approach to gemstone collecting, searching known

locations and having the experience to know what to look out for and what you might find is how some gem hunters build substantial collections. Don't be under any illusions, though – some gemstones are excruciatingly difficult to find.

Gemstones can sometimes be released into streams and rivers, where they are refined by weathering, which can sometimes make them easier to spot. They are also found on and around beaches, and again knowing what to look out for and having a sharp eye can deliver results. Other gemstone-collecting areas include on and around cliff faces, granite quarries, clay pits, the surrounding areas of mines and also man-made structural cutaways. A freshly ploughed field in close proximity to a known gemstone-collecting area might also be worth a look. Equipment is inexpensive: a chipping hammer (although a hammer and chisel can suffice), a hand lens (optional), goggles, gloves, sturdy boots and, of course, a plentiful supply of warm clothes and provisions.

If you want to learn more about gemmology, mineralogy and geology, and possibly search for gemstones yourself, there are several options open to you. By far the best approach is to join a club. Clubs conduct field trips that enable you to learn from knowledgeable and experienced individuals about the geological formations in Britain and the minerals they contain. You might also be able to safely access one of the best sources of gemstone material in Britain – some of the many disused mines around the country. It is also worth noting that there are many other types of mineral that are sought after by enthusiasts. People collect a whole range of interesting crystalline mineral samples, and in some cases they can be more valuable than gemstones.

When out searching for gemstones you should always take into consideration the issues of permission, including the right to remove material, and adopt a safe and common sense approach when visiting remote or potentially dangerous areas.

Gemstones in Britain

Finally we return full circle to the original question: which minerals actually qualify as gemstones? The truth is, there is absolutely no consensus – everyone has a different opinion. My interpretation, for the purposes of this book, is that if it is one of the generally recognised gemstones, and gem-quality examples – namely ones that could theoretically be fashioned into jewellery – of it have been recorded in Britain sometime in the past, then it is included. The only problem with this approach is that although many of the locations where gemstones have been found are on record, often the quality of the finds is not. I've tried to gather as much information as possible, and to read between the lines, but there may be some that should not have been included, and perhaps one or two others that should.

A word about locations. I've given a selection of locations where all the gemstones included have been found in Britain. Bear in mind that in some instances these locations may be where the gemstones have been found in the past, but are not necessarily still being found today, or at least in any quantity. Also, because many of the locations are associated with mines, quarries and private land, the issues of law, permission and safety must be taken into account, as they should be wherever you search. Finally, because of the constraints on space, the locations given are not particularly detailed or by any means complete – you need to do some further research yourself before setting out. Sources that can help in this regard are given in Further Information (*see page 276*). Also note that jet and amber are discussed in Chapter 5 (*see pages 145* and *173*) because of their associations with beachcombing.

Diamonds

Diamond clichés abound, and everybody knows at least one. Marilyn Monroe informed men very persuasively that diamonds are a girl's best friend, and most of us are aware that they are the hardest natural material known to man. But what isn't often properly understood is the true extent of their rarity. To give you some idea, even in the most prolific diamond-producing areas around the world – and there aren't many of those – it takes around 1,000 tons of processed rock to produce just one carat of diamond. Of that one carat, only one-quarter is of gem quality, namely suitable for use in quality jewellery. The other 75 per cent of production is consigned to industrial use. That is a hell of lot of work for very little return, and goes some way to explain the horrendous price of diamonds.

Diamonds are created many miles below the Earth's surface in a hostile environment of vast temperatures and pressures. They can rise to the surface in rare volcanic anomalies called kimberlitic pipes, which are conduits to the Earth's crust, and are only found in certain regions of the world. Diamonds are unique among gemstones because they are composed of one single chemical element – carbon. Carbon is one of the most common elements on the Earth but in diamond form the atoms are extremely tightly bound, which gives diamonds their hardness. Most people imagine diamonds as being colourless, but they are actually found in a wide range of colours, even black. Cut diamonds reflect light brilliantly, and this quality combined with their immense durability is what makes them the natural symbol of purity and love.

When talking about diamonds in the context of a British treasure-hunting book, you've probably already guessed that I won't be suggesting you grab a bucket and go for a casual stroll in the Scottish Highlands. Despite the general perception that diamonds do exist in Britain, and more precisely Scotland, there

is actually no conclusive proof of this whatsoever – but there are some great stories.

The Heddle 'Diamond'

For over a century a story circulated about a diamond that was recovered from a lake three miles northeast of Ben Hope in Sutherland, Ayrshire. It was found at the end of the nineteenth century by Matthew Forster Heddle, a chemistry professor at St Andrews University. The find was recorded in Heddle's book *Mineralogy of Scotland*, which was co-edited by his son-in-law, the geologist Alexander Thoms, and published posthumously in 1901.

Heddle described the sample thus: 'specimen of aventurine, from a lake three miles to the northeast of Ben Hope, Sutherland, contains, besides the red mica, red zircons, and other colourless garnets or diamonds'. In the book's appendix, however, Thoms appears to have reinterpreted this. He stated that Heddle had remarked that he felt confident that these small crystals were diamonds as they had certain optical characteristics that no other mineral he knew of possessed.

Whatever the circumstances surrounding the conclusions further scrutiny proved impossible because the sample disappeared. After reading Heddle's work many people organised searches around Ben Hope. All were frustrated by the fact that the area is just a marshy plateau, and there is not one single identifiable lake but a whole series of small lochans.

In the 1990s Dundee University's geological department closed and the faculty transferred to Glasgow. At Glasgow University, Dr John Faithfull discovered among other items Thoms's specimen collection, and being familiar with Heddle's work he decided to take a closer look. Everything was meticulously catalogued and all the specimens were in place except one, specimen number two, the Ben Hope diamond, which was missing. In 1998, while sorting through some old records,

geologist Dr Allan Hall noticed a specimen tagged 'Diamond' among mostly rubbish that was heading for the skip, and decided to put it to one side. He handed the specimen to Dr Jeff Harris, a diamond specialist, who examined it but decided it was of no interest and handed it back to Dr Hall.

The labelled specimen languished on a shelf in Dr Hall's room until once again Dr Faithfull noticed Heddle's familiar handwriting and realised that he had found the missing specimen at last. He decided once and for all to subject the sample to a full series of rigorous scientific tests, now with the benefit of modern instrumentation. Following the tests Dr Faithfull concluded that there was no diamond present, nor was there even a potential likelihood of there being diamond deposits in the Ben Hope area.

There was, however, a twist to the tale. The specimen contained microscopic traces of a mineral never before seen in Scotland, and more samples of the same mineral have since been found in the Ben Hope area. There is one final footnote in the story of the quest for a Scottish diamond. Dr Faithfull has been made aware of a completely new and separate line of investigation, which, if it has any validity, you can be certain he will be looking into with the same level of scientific rigour that he applied to the Ben Hope sample. So keep your eye on the headlines!

Other diamond finds?

This leaves us with just two other intriguing stories, the first of which, uniquely, originated across the sea in Ireland. In 1816 a diamond was reported to have been found in the Colbrooke River in County Fermanagh, which was thought to be the result of someone panning for gold. The diamond, a yellowish example, remained in the hands of the Brooke family and was subsequently cut and set into a gold ring. Unfortunately, nothing more of this story is recorded, and I have been unable

to locate its original source, so although it sounds interesting it almost certainly has no merit.

Returning to Britain, a slightly more plausible account concerned the discovery in the nineteenth century by John Smith, an Ayrshire geologist, of minute traces of diamond forming where magma had invaded a seam at a graphite mine at Craigman, 5 miles southwest of New Cumnock, again in Ayrshire. This story was fully supported at the time, but has also since been discredited, although it sounds the more credible of the two. Either way, there is no physical evidence whatsoever to support these stories, so you will have to draw your own conclusions.

Contemporary diamond searches

The only other information relating to diamonds in the UK has been the work carried out by Bristol-based Cambridge Mineral Resources, which has a licence to explore for diamonds and other gemstones in Ireland and the west coast of Scotland. Cambridge has reported that it is confident of the geology in northern Scotland and is currently conducting exploratory work in several areas including Moidart, Caithness and parts of Sutherland. The company has claimed to have identified several possible diamond-bearing areas.

Diamonds are the most elusive of gemstones, and the first person to find a specimen on UK soil will almost certainly prosper more from the notoriety than from any commercial value the diamond may have. The prevailing notion is that certain areas of Scotland do support diamonds, but whether a properly authenticated sample will ever be produced is entirely another matter. The good news is that plenty of other gemstones are found in Britain, and in some cases they are good enough to rival those from other parts of the world.

Topaz

Topaz is one of the original 'precious' gemstones, and quality crystals can be quite valuable. It is listed on the Mohs scale as having a hardness of 8. Topaz occurs in granite rock, and the crystals found in Britain are occasionally clear, but generally pale blue, and it can also be yellow, green, wine or honey coloured.

Distribution

The majority of topaz finds occurs in Cornwall, and one or two quality stones have been recorded. Several crystals up to 3 mm were recovered from the St Austell and St Agnes districts, and there is an early report of some exceptional crystals from Cligga Head. Several pale blue topaz crystals, including a 6 mm specimen, were found on a single sample from a quarry on the Isle of Lundy in the Bristol Channel in 1996.

Some of the finest gem-quality topaz crystals from Britain also occur in the Cairngorms, and topaz has been recorded at Devoke Water in Cumbria, the Isle of Harris in the Outer Hebrides and a couple of locations on the Isle of Arran.

Turquoise

Turquoise is a pale blue or green blue cryptocrystalline quartz gemstone. It has a hardness of 5 to 6 on the Mohs scale.

Distribution

Specimens of 10 mm to 20 mm have been found at Caldbeck Fells, Cumbria. Mineral samples have been found at Gunheath China Clay Pit, St Austell. Green turquoise is reported at Liskeard, Cornwall. There are no reports of turquoise in Wales or Scotland.

Amethyst

Amethyst is a striking pale to dark purple gemstone and another of the quartz varieties, with a hardness of 7 on the Mohs scale. Amethyst occurs quite commonly in the UK, particularly in the southwest, although quality stones are rare. One disadvantage of amethyst is that it often fades when exposed to prolonged sunlight.

Some particularly fine examples of amethyst have occasionally occurred around Britain. In 1882 Heddle recorded a single crystal measuring 80 mm by 35 mm. More recently a 90 mm purple crystal was found in Redruth, Cornwall. Another specimen with several 5 mm to 20 mm crystals was uncovered in Fylde, Lancashire.

Distribution

There are at least fifty known locations in Britain where amethyst has been found, including the Scilly Isles, Cambourne, Redruth, Liskeard, St Michaels Mount, St Austell and St Just in Cornwall. Amethyst is also found at Dartmoor and Sidmouth in Devon, Matlock in Derbyshire and Fylde in Lancashire. In Wales there is Taffs Well, Cardiff.

There are several amethyst locations in Scotland, including Bruxie Hill, Aberdeenshire; Kaim Hill, Ayrshire; Loch Morar, Invernesshire; Dumfries and Galloway; Fife, Kirkcudbrightshire; Mid and East Lothian; Renfrewshire; Rosshire and Esha Ness in the Shetland Islands.

Smoky quartz

A chapter about British gemstones wouldn't be complete without mentioning the traditional stone of Scotland – smoky quartz. Smoky quartz, or Cairngorm as it is more commonly called after the mountain range where it is often recovered, is as

its name suggests a deep orange or dark, smoky reddish-brown crystal from the quartz family.

Smoky quartz has been known about for centuries, and has even been traced back as far as the Druids. It is usually associated with the igneous rocks of the Cairngorm Mountains southwest of Banff in the Highlands, but is actually found in several locations throughout the UK, and indeed the world. Smoky quartz can also be found in river beds around the Cairngorms.

Smoky quartz has been popular in Scottish jewellery since Victorian times. It was mined near to the surface and traditionally mounted in brooches and worn on cloaks as mourning jewellery. It polishes to a beautiful finish and is still mounted in rings and bracelets today.

Smoky quartz is relatively common, and specimen stones can run into the hundreds of carats. The Invercauld Cairngorm, a single crystal weighing over 20 kilograms, resides at Braemar Castle. A piece of smoky quartz also features in the Scottish Sceptre.

Distribution

There are several locations where smoky quartz can be found in Britain. A nice 15-mm crystal was recovered from Ton Mawr Quarry, Cardiff, Wales, and crystals up to 35 mm have been found at the Florence Mine in West Cumbria. Another report of a crystal 75 mm by 20 mm originates from Meldon Quarry, Okehampton, Devon.

Other smoky quartz locations around the UK include, in England: areas of St Just and St Austell in Cornwall, Dartmouth in Devon and Cleator Moor in the Lake District, Cumbria; in Wales: Taff's Well Quarry in Cardiff; in Scotland: Killin in Perthshire, Luthrie, Argyllshire, Sutherland and several areas around Aberdeenshire.

Citrine

Citrine is a lemon yellow to golden-brown gemstone from the quartz family. It is almost indistinguishable from smoky quartz and particularly rare in Britain.

Distribution

Citrine has been found at Dartmoor, Devon, Caldbeck Fells in the Lake District and several areas of Cornwall including St Michael's Mount.

Apatite

Apatite's credentials as a gemstone are debatable, but it is recognised in the wider circle and occasionally used in jewellery. Apatite crystals found in Britain are most commonly green, but can also be shades of blue, yellow, cream and even pink. Apatite only has a hardness of 5 on the Mohs scale and is therefore unsuitable for hard-wearing jewellery like rings and bracelets, but it has been incorporated into earrings and brooches.

Distribution

Apatite is one of the few gemstones that is more widespread in England than in Scotland. The most impressive finds come from the Megilligar Rocks, Breage, Cornwall. A 30 mm crystal was found there in 1975, and another superb 25 mm pale pink specimen was also recovered from the same location. There have been many other examples measuring 4 mm upwards and more recently 1 to 5 mm blueish crystals again from the same location.

Other areas to look for apatite include, in England, Bodmin, St Michael's Mount, St Agnes and Land's End in Cornwall. There are over a dozen sites where apatite can be found in Cumbria,

including Shap Granite Quarry, Braithwaite, Caldbeck Fells, Ennerdale, Langdale and Mungrisdale. In Derbyshire, Calton Hill Quarry near Buxton contains apatite, as do a couple of areas in Ceredigeon, Wales. In Scotland try the Isle of Mull, the Isle of Eigg, Ardnamurchan and the High Prin Mine near Wanlockhead.

Pearl

Pearls are unique as gemstones because of their comparative lack of hardness, and the fact that they are organic, but pearls require minimal preparation for use, and are of course beautiful, rare and highly desirable. Most gemstones are incredibly hard, and even the so-called semi-precious varieties are much harder than pearl, which only rates about 4 on the Mohs scale. I have to put my hands up here immediately and tell you that pearl hunting has been illegal in the UK for several years now, so this section can only be read purely from an academic point of view.

The freshwater pearl mussel

The variety of freshwater mussel found in the UK, which for centuries has been hunted for its pearls, is called the northern European pearl mussel (*Margaritifera margaritifera*).

Mussels are living creatures (molluscs) that have hard exterior shells and soft inside bodies. Life begins for the European freshwater pearl mussel when 'spat' (free swimming larvae) are secreted from the female and carried upstream in mid to late summer on the gills of salmon or trout. The larvae are deposited the following spring and settle on clean coarse sand or gravel. They feed on organic food particles, and if conditions are right develop into tiny mussels. Less than one in a million spat survive to become adults, but those that do can reach 150 mm in length and can live for over 100 years. One of the factors that has contributed to the decline in the mussel population, besides

pollution, is that females don't become sexually active until the age of between ten and fifteen.

How pearls form

Pearls form in mussels when a tiny irritant such as a grain of sand or stone gets stuck inside the shell and a substance called nacre is secreted to protect the delicate mollusc. Layer upon layer of nacre encrusts the irritant over time, eventually creating a pearl. Only a tiny proportion of mussels ever create pearls, and these are of varying quality. Natural freshwater pearls are rarely uniform in shape, and can even be quite irregular. The layers of nacre that make up a pearl determine its iridescent qualities – a pearl appears to glow. Pearls can vary greatly not only in size and shape but also in colour, from traditional creams to pinks; they can even be quite dark.

Pearl fishing in Britain

People have fished for pearls in Scotland and Wales for at least 2,000 years, and possibly even longer. The Romans, who always had an eye for a valuable commodity, added pearls to their list of potential sources of income when planning their invasion of Britain. The Roman historian Suetonius wrote that pearls were one of Caesar's invasion objectives, and in the first century AD British pearls were mentioned by Pliny in his *Natural History*. Alexander I, a twelfth-century Scottish king, was said to have the most enviable collection of freshwater pearls in the world, and there is also a 1355 reference to Scottish pearls in a statute of the goldsmiths of Paris. In the sixteenth century, the Scottish monarchy continued its stranglehold on pearls by employing river bailiffs to ensure that the best finds went to the Crown and the remaining pearls were taxed.

During the sixteenth century, pearls continued to be extensively harvested from rivers around Britain. There are documents pointing to evidence that between 1761 and 1764

£10,000 worth of pearls was sent to London. In 1769 an English traveller named Thomas Pennant described pearl fishing as being 'exhausted from the avarice of the undertakers'. In the 1860s a German named Moritz Unger visited Scotland and offered to purchase all pearls found by local peasants, which resulted in a hunting deluge that eventually became unsustainable. By the mid to late nineteenth century there were many examples of pearls selling for between £1 and £20 each, a fortune back then. In 1870 a necklace containing 100 pearls was on sale at a Scottish jeweller's for £100.

Some of the pearls found in the UK, and Scotland in particular, have been of a very fine quality, comparable even to that of pearls found in the Orient. A very rare Scottish pearl was found in 1967 by professional pearl fisherman Bill Abernethy in a backwater of the River Tay. The pearl, aptly named the 'Abernethy', was the largest taken in living memory. It was perfectly round, white, 1.27 cm across and weighed 8.6 carats. It was purportedly worth £10,000, but it wasn't until 1992 that Cairncross Jewellers in Perth bought it for an undisclosed sum said at the time to be an even more unbelievable £60,000. Amazingly, another pearl almost as large was found in the same stretch of water just months later by Donald McGregor, which was also bought by a Scottish jeweller.

Even as late as the 1970s there were still independent 'pearlers' working Welsh and Scottish streams and rivers. They used adapted glass-bottomed buckets with handles to peer into the water for the dark brown or black shells. An ash pole split at one end was used to lift the mussels from the bed, and a knife with a heavy blade was employed to open them. Mussels aged between ten and fifty years old produced the best-quality pearls, and occasionally a pearl from an older mussel could be split to reveal a better one inside. Experienced pearlers learned to recognise certain pearl-producing characteristics in mussels before disturbing them, a skill that helped preserve stocks. A typical

harvest consisted of a few mixed-quality 'seed' pearls, but occasionally a find could be very valuable. Pearls of any quality were bought directly by top English, Welsh and Scottish jewellers.

Pearl fishing and the law

Pearl fishing had been a tradition among locals and travellers for centuries, but during the twentieth century the invention of the motor car enabled more people to access remote fishing grounds and opportunists began to arrive. Just a century ago, mature freshwater mussels were found in 160 rivers and streams throughout the UK, but today that figure is little more than a dozen. Since the 1970s pearl mussels have become extinct in an average of two rivers per year, and they are now considered a rare species. Pearls tend to be found in colonies, and it is estimated there are only around sixty of these left, distributed throughout rivers in Wales and Scotland.

Mussels are important to the life cycle of a stream or river. They filter impurities from the water and attract flies and insects which game fish feed on. Freshwater mussels need a pristine environment in which to survive, and have suffered considerably in recent years not only due to overfishing, but also because of the impact of chemical pesticides and fertilisers. Although the UK is still home to over half the world's freshwater pearl mussel population, it was estimated that had present levels of fishing continued they would have been extinct within twenty-five years. Freshwater mussels are living creatures, inedible and yet invaluable to the ecology of a river, and thousands were being killed needlessly each year by amateur pearl hunters.

In 1998 the authorities decided to take decisive action. A law was passed making it illegal to hunt, harm or trade in wild freshwater pearls from the UK – you even need a licence to study them. Anyone caught breaking this law now faces a fine of up to £5,000. The law is backed up by regular visits to known

fishing grounds and raids on suspected traders. Unfortunately there are still occasional cases of poaching and the illegal exporting of pearls. The legitimate industry now concentrates its efforts on developing techniques to increase cultured pearl production, and ironically more pearls are produced today than at any time throughout history.

An interesting childhood experience

When I was a young boy the annual family holiday consisted of a week by the seaside on the Dorset coast. Highlights of the holiday included regular trips to a tidal estuary famous for its salmon run. One day while I was playing at the water's edge something interesting caught my eye. I fished out a strange, dark jagged-shaped object which even at that age I could tell wasn't a rock, probably judging by its weight. I smashed it open, and what I found inside clearly warranted further investigation.

I have to be honest here – this was a long time ago and time does play tricks with memory. What I do remember was swirling my finger through a gooey substance and my attention focusing on something round and hard, which I scraped out. It was about 5 mm across, like a little marble, and creamy in colour. I played with it, bounced it off rocks – in fact I did everything a young boy does with this sort of thing until his attention span becomes exhausted – and then I threw it back into the water.

To this day I'm not absolutely certain what I found. It wasn't a freshwater pearl, but it could have been one of the saltwater varieties; it also could have been something else entirely, or just the figment of an overactive young imagination. Personally I prefer to put it down to a vague childhood memory, otherwise I would have to face up to the fact that I was not only one of the few lucky people to ever find a wild pearl, but also probably the only one in history to have thrown one back in the water.

Pearl jewellery

British freshwater pearls have historically been incorporated into many fine pieces of historical jewellery.

- A breastplate studded with native pearls was dedicated to Venus Genetrix by Julius Caesar, and Caesar himself was said to possess a corselet made from British freshwater pearls.

- The Kellie pearl, named after the burn in which it was found – a tributary of the River Ythan in Aberdeenshire – is the largest pearl ever found in Britain and is included in the Honours, the Scottish Crown Jewels that reside in Edinburgh Castle.

- A pearl from the River Conway, North Wales resides in the British Crown.

- Sir Walter Raleigh was said to have worn native pearl earrings.

- A sixteenth-century necklace that once belonged to Mary, Queen of Scots incorporates thirty-four exquisite freshwater pearls that were harvested from the River Tay in Scotland.

- In 1843 Prince Albert gave Queen Victoria a brooch shaped like a crown decorated with four Scottish pearls to celebrate their wedding anniversary.

There are many other beautiful pieces of pearl jewellery in private hands, like the pendant made from Scottish gold featuring a Celtic design that was mounted with a pearl from the River Brora. The Loch Buy Brooch, c.1500, which features several native pearls, once belonged to the MacLeans of Loch Buy and is now in the care of the British Museum. More recent examples include a Scottish pearl set in a gold ring that featured in an edition of the BBC's *Antiques Roadshow*. Even today there is a

brooch with a pink Scottish pearl from old stock on sale at a Scottish jeweller for £175.

Rhodonite

Rhodonite is a rose red gemstone with a hardness of 5.5 to 6.5 on the Mohs scale. The crystals are almost always badly flawed and generally only of interest to mineral collectors. In one form rhodonite is cabochon cut and used in ornamental jewellery.

Distribution

Rhodonite can be found at Meldon Quarry, Okehampton on Dartmoor, Greystones Quarry, Lezant and the Callington district of Cornwall, as well as Gwynedd in Wales.

Opal

Opal is a relation of quartz and has a hardness of 5.5 to 6 on the Mohs scale. Opal can be found in any one of a range of colours with corresponding tints and sheens. There are three main types of opal: precious, fire and common, and several sub-types. Common opal is typically green-yellow although it can have a blueish hue. Opal is usually cabochon cut for jewellery, although fire opal with sufficient transparency can be faceted.

Distribution

Some types of opal are found in Britain, particularly in the china clay pits of Cornwall located around the village of Trevisco. A 30 mm by 70 mm example was recovered from there in 1978 and there have been other similar finds in the area. A very rare 70 mm by 60 mm piece of orange fire opal was found at Botallack Mine, St Just, Cornwall. Other areas to look for opal include Okehampton in east Dartmoor, Wheal Gorland near St Day,

Cornwall, Kentmere in Cumbria and Talisker Bay on the Isle of Skye in the northwest Highlands.

Fluorite

Fluorite is another gemstone with debatable credentials, not least because it is considered too soft to be used in jewellery, being listed at just 4 on the Mohs scale. Collectors, however, like fluorite. The crystals are typically vivid and beautiful and found in virtually every colour imaginable, so specimens sell well. Fluorite is naturally colourless, but colourless crystals are rare and they are more usually yellow, amber, green, purple, blue or sometimes red. Occasionally if a crystal has few inclusions it may be suitable for faceting. One type of fluorite, known as Derbyshire Blue John, was once very popular in England and was carved into objects d'art. There are fluorite crystals as large as 50 mm on record from Britain, and fluorite is one of the few gemstones found in Britain that can compete internationally in terms of size and quality. Many examples from the UK grace mineralogical collections throughout the world.

Distribution

Fluorite crystals measuring 1 mm to 4 mm are commonplace throughout Britain, and examples measuring over 10 mm have been recorded, particularly from the Boltsburn, Frazers Hush, Redburn and Stotfield Burn Mines in the Pennines and at Weardale. Besides Cumbria, fluorite has also been found at other mining and quarrying locations throughout Cornwall, particularly Wheal Mary Ann. Fluorite finds have also been recorded in Somerset, Northumberland, Shropshire, Staffordshire, Gloucestershire, Leicestershire and County Durham.

The garnet group

Garnet is a generic term for a family of gemstones. There are several varieties of garnet, all of which vary in composition but share similar structures. At least six and arguably more varieties of garnet are found in Britain. Four on which there is at least some information available are highlighted here.

Almandine

Almandine is a brown to red-purple or violet garnet with a hardness of 7 to 8 on the Mohs scale. It is the most common garnet in the UK, and decent crystals are occasionally found. Heddle recorded a large sample from a railway cutting at Glensgaich, Scotland. Other areas to look for almandine include the western tip of Cornwall, Waberthwaite and Bramcrag Quarries in Cumbria and Huntly, Aberdeenshire.

Andradite

Andradite is a sherry-coloured or greenish-brown garnet with a hardness of 6.5 to 7. Crystals up to 2 mm have been found at Coatsgate Quarry, Beattock, Dumfriesshire, and 4 mm crystals at Okehampton, Devon. Other areas to look for andradite include St Austell and St Just in Cornwall, and one or two areas in Wales and Scotland.

Grossularite

Grossularite is a typically pale green garnet with a hardness of 6.5 to 7.5, and gem-quality crystals are sometimes found in the UK. Areas to look include Durham, Devon and Cornwall, Wasdale Head in Cumbria, Aberdeenshire, and Leac Ghorn near Balmoral in Scotland.

Pyrope

Pyrope is a deep blood-red crystal with a hardness of 7.5, and the most sought after of the garnet group. There are only one or two recorded locations where pyrope has been found in Britain. Gem-quality stones, albeit small ones, referred to as 'Elie rubies', have been found on the beach at Elie Harbour, two and a half miles southwest of St Marans, Fife, Scotland. True ruby, the red variety of corundum, has never been recorded in Britain.

Hematite

Hematite, a type of iron ore, is an unusual material to be classified as a gemstone. It has a hardness of 6.5 on the Mohs scale and polishes to a metallic-like sheen. There are several varieties of hematite, some of which can be carved into ornaments or incorporated into jewellery such as cufflinks, beads and cameos. Kidney stone is a reddish variety of hematite that resembles lumps of kidney and is found at literally hundreds of locations throughout Britain.

Distribution

Hematite is often found in large pieces, and particularly fine specimens have been recovered from Cleaton Moor, Cumbria. Hematite can also be found in Bristol, Cornwall, Devon, Derbyshire, Gloucestershire, Leicestershire, Somerset, Staffordshire, Warwickshire, Dumfries and Galloway, Lanarkshire, Renfrewshire and Tayside.

Sapphire

In the absence of diamond, by a country mile the Holy Grail for gemstone hunters in Britain is sapphire. To give you some idea of how rare sapphires are compared with smoky quartz, carat for

carat you can add several noughts to the value of a sapphire. Sapphire is second only in hardness to diamond, measuring 9 on the Mohs scale, and although sapphires are very rare in the UK, and gem-quality crystals even rarer, they are occasionally found in Scotland, notably on the Isle of Mull in Argyll and Lewis in the Outer Hebrides. In the 1980s blasting to make way for a farm track on Lewis revealed traces of sapphire, and some very fine examples have been recovered since, comparable even to those found in the traditional sapphire-producing countries around the world.

Rare finds in Scotland

In the early 1990s a flawless 9.7-carat sapphire was discovered on Lewis. It was by far the most valuable sapphire ever found in Britain. It was found by Linda Combe, who together with her husband Ian runs a business in Ullapool, Rosshire specialising in Scottish jewellery, and Ian in fact cut the sapphire. The stone was sold to a private collector from Dundee and is currently on loan to the Hunterian Museum.

The museum has one other significant piece of sapphire on display, again from Lewis. It is 2.5 cm across and originally formed part of a larger crystal. The rest of the crystal has never been found and presumably must still by lying out there somewhere. Other, smaller sapphires have been found on Lewis, but most are either too small or too thin to be cut, or contain flaws. Linda and Ian have cut many of the best sapphires from Scotland. Heritage jewellers in Pitlochry, Perthshire also offer jewellery incorporating Scottish sapphires.

The Isle of Mull is second only to Lewis for sapphires, with crystals of between 1 mm and 4 mm of varying quality being recovered from Port na Cloidheig, Loch Scridain and Nuns Pass, Carsaig Bay, although there is an older report of crystals up to three times this size.

Sapphires have also been found on the Isle of Arran at Glen

Rosa, near Brodick and further south, and at Glebe Hill, in Ard-namurchan, just north of Mull. There is also an early reference to tiny crystals being found at Clashnarae Hill, Glen Clova, Aberdeenshire.

Other possible British find spots

V. Axel Firsoff in his book *Gemstones of the British Isles* refers to millimetre-sized pale blue crystals that he discovered at Carrock Mine in the Lake District. He was investigating the site on the strength of another report but was unable to confirm whether the crystals were sapphire because they were damaged. Other locations where sapphire has been reported, although only as a trace mineral, are Lelant and the Carbis Bay area near St Ives in Cornwall.

Agate

Agate is another variety of gemstone from the cryptocrystalline quartz group. There are several types of agate. The sought-after variety features tight, regular or irregular, concentric coloured bands in a wide range of striking contrasting shades and colours. This variety of agate can be split to make particularly attractive pendants. Agate is rated 7 on the Mohs scale.

Since the early nineteenth century agate has been used extensively in jewellery. It can be fashioned nicely into pendants, particularly teardrop shapes that are often sympathetic to form. Some very fine examples of agate have been found in Scotland, including several up to 75 mm across from Barras Quarry near Bruxie Hill, Aberdeenshire. A nice 13 mm example was also found at Usan, Scotland.

Distribution

Rock hounds sometimes collect agate from streams and beaches, but very fine examples these days are rare. Areas to

look include, in England: the Mendip Hills in Avon, Somerset; Lyme Regis, Dorset; Budleigh Salterton, Devon; and Port Erin, Isle of Man, and in Wales: Llantrinsant, Glamorgan. There are dozens of known locations in Scotland, so do some research, choose an area, and try your luck.

Carnelian

Carnelian is included here simply because it's a name that is familiar to many. It is actually a translucent orange-pink variety of chalcedony from the cryptocrystalline quartz group, and has a hardness of 7 on the Mohs scale. Carnelians are usually cabochon cut for jewellery.

Distribution

Carnelians may be found in Whitehaven, Cumbria, the coast of Flintshire and Budleigh Salterton, Devon.

Jasper

Jasper is another variety of cryptocrystalline quartz that is represented by a range of rocks coloured by oxide impurities. Jasper is typically red, but can also be yellow, brown or even dark green, and is often found in a combination of more than one colour. Jasper has a hardness of 7 on the Mohs scale.

Jasper has traditionally been carved into decorative ornamental display pieces. On the Scottish Gemmological Association's website there is a delightful set of jasper carvings comprising a family of four frogs that shows precisely how contrasting colours can be used skilfully to great effect.

The Scottish jeweller Michael Laing, who created a baton in gold and silver for the Queen to commemorate the 1996 Commonwealth Games in Edinburgh, incorporated a piece of polished deep red jasper recovered from Campsie Fells in the baton.

Distribution

Areas to look for jasper include Greystones Quarry, near Callington, Wheal Cock, near St Just in Cornwall, Llantrinsant in Glamorgan, Wales, Campsie, Stirlingshire and King's Park, Lothian and a few other areas around Scotland including Montrose.

Tourmaline

The most common type of tourmaline is schorl, which is black and not considered gemstone material, but other varieties are. Tourmaline can be colourless, red, blue or green, and there may sometimes be a combination of several colours in one crystal, but gemstone-quality examples are very rare in the UK. There is an early report of green tourmaline at Okehampton, and of colourless stones at St Just, Cornwall, but most tourmaline found in Scotland is schorl.

Beryl

Beryl is another family of gemstones that contains several varieties, many of which are highly sought after, such as blue beryl, which is called aquamarine. Beryl can be colourless or white, but green, yellow, pink, red and mauve examples have also been found. Beryl has a hardness of 7.5 to 8 on the Mohs scale.

Crystals flawless enough to be classified as gemstones are rare in Britain. A couple of nice 3 mm and 5mm aquamarines have recently been uncovered on the Isle of Lundy in the Bristol Channel, and a 3 mm sample at St Michael's Mount, Cornwall.

The green variety of beryl is sometimes mistakenly referred to as emerald. This probably explains a report of an emerald being found in the River Caldew, Cumbria, in 1815. Although true emerald is actually a member of the beryl family, like ruby it isn't recorded in the UK. Green beryl lacks the dark green intensity of true emerald.

Distribution

There are several locations in which to search for beryl, including Cornwall between St Just and Land's End. In the Lake District try Derwentwater, the Carrock Mine at Caldbeck and Walla Crag, Keswick. In Scotland several areas of Aberdeenshire and the Cairngorms contain beryl, as well as Banffshire and elsewhere.

Zircon and sphene

Zircon and sphene (true name titanite) are not related as gemstones, but share similar characteristics in terms of being brilliant fiery gems when cut. Sphene has a hardness of 5 to 5.5, zircon 7.5, and both stones can be either clear or coloured.

Sphene is quite brittle and usually not suitable for jewellery, and in any case most of the crystals found in Britain are far too small. One of the larger recorded examples, a 1.5 mm yellow crystal, was found on Thurstaston Beach, Wirral, Merseyside.

Zircon was used as a substitute for diamond before it could be convincingly replicated, but it is now considered a gemstone in its own right. Zircon crystals can be clear, pink, yellow or red. The zircon crystals found in Britain are tiny, only up to 1 mm from Eas a Bradain on Isle of Sky.

Distribution

Other areas apart from Eas where zircon has been reported include Inverness and Sutherland. It can also be found at Twll Maen Grisial, Gwynedd, Wales, and both sphene and zircon have historically been reported at dozens of other locations throughout England and Scotland.

Gemstones in jewellery

Gemstones bear little resemblance in nature to the dazzling sparklers you see displayed in jewellery shop windows. Even diamond, that most brilliant of gemstones, is actually quite dull naturally. 'Rough' gemstones are often discoloured, and the natural shape of the crystal can be disguised for any number of reasons. Lapidaries use a variety of techniques to transform the appearance of gemstones ready to be incorporated into jewellery, one of which is cut.

All gemstones are basically cut one of two ways, en cabochon or faceted. Cabochon cuts are smooth, rounded polished finishes with no edges. Faceting involves precisely placing multiple symmetrical cuts onto the surface of a gemstone, and is the process we traditionally associate with quality stones, particularly transparent ones. Other processes for finishing stones include tumbling, inlaying and engraving.

Cabochon cutting

Cabochon cuts are suitable for opaque or translucent stones and also stones with inclusions, which may be unsuitable for faceting. Smoky quartz and carnelians are particularly suited to cabochon cuts. There are several styles of cabochon cut, including circles, ovals, domes and rectangular shapes. The technique involves roughly cutting and grinding a stone, then applying progressively finer abrasive grits until the desired shape is achieved. The stone is then finished with a polishing agent.

Faceting

Faceting is a highly skilled process designed to maximise the beauty and physical properties of a stone and enhance its optical qualities through the behaviour of light as it passes into the gemstone. A correctly faceted stone will reflect light brilliantly, while one faceted incorrectly will 'leak' light. An

individual design is selected for each stone to utilise its full potential. Multiple cuts are formed precisely on a faceting machine using special abrasives.

Other techniques

Common stones can sometimes be polished in tumbling machines, creating naturally attractive shapes. The machines are run at very slow speeds over several days and progressively finer grades of abrasives are added until the desired effect is obtained. Inlaying is another technique, which involves cutting a gemstone to fit the recess of another material. Some gemstones may be suitable for engraving. Cameos are designs in such a way that raised engravings can take advantage of different layers of colouration within a gemstone.

Selling gemstones

I'd love to be able to give you an approximate value per carat of all the gemstones covered in this chapter, but this simply isn't possible. Prices are on record, but they are world prices, and any gemstone found in Britain would always command more attention. There is a handful of reputable jewellers who do incorporate genuine British gemstones into their work, but apart from them it's hard to tell what is what. There is a lot of 'Scottish' smoky quartz about of dubious authenticity, for example. The vast majority of gemstones found in the UK are either too small or unstable to be fashioned into jewellery anyway, and by far the best approach is to collect them as mineral samples.

Collectors of mineral samples are interested not only in the crystals themselves but also in how they were formed, so a sample would typically include part of the host rock. Prices paid for samples depend on a number of elements, which again are impossible to formularise, but the following, based on what I've seen for sale, can be used as an approximate guide.

- Mounted fingernail-sized samples of minerals fetch 50p to £1.

- Fist-sized samples of minerals can fetch £10 to £25, rising occasionally to as much as £100.

- Exceptional mineral samples can command a higher price – even several hundred pounds in some cases. A 55 mm by 35 mm by 18 mm matrix with several apatite crystals recovered from Cornwall was recently on sale on an American website for $850 (£425), and a 600 mm by 400 mm specimen of rich gold on calcite recovered from the now-protected Hope's Nose in Devon recently sold for $3,250 (£1,625). Of course, should you ever come across a chunk of Scottish sapphire, you can perhaps think about a nice holiday.

Further information

If you are interested in collecting gemstones or becoming involved in gemmology, mineralogy or geology there are a number of avenues open to you. Rock and gem shows are held throughout Britain, and there are also clubs that you can join. There are also a few interesting websites, one or two of which list areas where gemstones have been found throughout the British Isles. If you wish to take things more seriously, Edinburgh University runs a reasonably priced nine-week course on gemmology, and the Gemmological Association of Great Britain offers both in-house and correspondence courses, together with various levels of membership. Details of everything mentioned here can be found in Further Information (*see page 276*).

CHAPTER FIVE

Beachcombing

As I SIT here writing it is the height of summer, and I, like millions of others, am turning my attentions to lying on a beach somewhere. Millions visit beaches each year, including holidaymakers, day trippers, and weekenders, often with their pockets stuffed with money and dripping in jewellery. Temporary facilities, suntan lotion, swimming, the changing in and out of clothes, and beachside attractions are perfect accomplices to conspire with billions upon billions of tiny grains of sand to permanently relieve anyone of anything carelessly misplaced. Inland detectorists may have the edge on large hauls, but beaches deliver far more finds on a day-to-day basis, and no other environment turns over a fresh layer with every tide. Welcome to the world of beachcombing.

Profiteering from the loss of someone's valued possessions might sound a little predatory, but let's face it, what's lost is lost. If you find an expensive piece of jewellery and the letter of the law gets the better of you, you can always hand it in at the local police station and leave it there for the mandatory three months before it legally becomes yours. Frankly, the chances of it being claimed by the original owner are almost zero. And that's just the valuables. There's cash, too, and many other

artefacts treasure hunters find on beaches. Once you have read this chapter you will look at beaches from a completely different point of view.

Besides cash and jewellery, this chapter contains one of two instances in the book where I've introduced the idea of live treasure. Don't worry – I'm not going to get you involved in sea fishing or anything like that, although at the time of writing have you seen the price of sea bass? Cockles, however, can be very lucrative. Did you know that some cockle pickers earn as much as £500 per day? There is a short section about cockles in this chapter.

Returning to inanimate objects, many historical artefacts have been found on beaches. I have already mentioned (*see page 92*) that Victorian bottles together with other refuse were once used as ballast on boats, and there are many other historical collectables that can be found on beaches.

Some treasure is specific to certain areas of Britain. Jet, for instance, is a highly collectable material with gemstone classification, which has been used in jewellery for centuries. It is unique to Whitby and still sought after by craftsmen and collectors.

Whitby jet

On the edge of the Yorkshire moors lies the port town of Whitby. Its popularity has been enhanced by its association with Bram Stoker's legend of Count Dracula. The churchyard overlooks the harbour, which contains Whitby's other lesser known dark secret – jet. Jet can best be described as being a solidified black resin. The Romans in fact referred to it as 'black amber'. Jet derives naturally from prehistoric *Araucaria* trees. Some 150 to 180 million years ago, dead trees were swept to the coast and settled beneath other decaying material. A complex process of heat and pressure occasionally

caused chemical changes in the timber, and over millions of years formed jet.

Jet is classified as gemstone material although it is relatively soft, measuring just 2.5 to 4 on the Mohs scale (*see page 113*). Jet feels warm to the touch and can be slightly magnetic. It will also burn, giving off an oily, coal-like smell. There are two different types of jet – hard and soft. Hard jet is sought after by craftsmen because it polishes beautifully to a near mirror-like surface. Although jet can be found at several locations throughout the world, arguably the finest comes from Whitby.

The history of jet

Jet's popularity grew during the early nineteenth century, and it was collected from the beaches around Whitby. Demand eventually outstripped supply, and mines sprang up both on the coast and eventually inland. Due to a buoyant market rewards were high, and miners were encouraged to take great risks. People were lowered down cliff faces to access seams, with obvious consequences, and inland mines were often unsupported, also causing fatalities.

Jet's popularity reached a peak during in the mid nineteenth century, when jet carvings featured in the Great Exhibition of 1851. An entire industry grew up in Whitby to feed demand, and by 1870 there were 1,500 men, women and children involved in the jet industry, and 200 workshops producing jewellery. By the 1880s the highest quality Whitby jet was selling for as much as £1,000 per ton – you can multiply that by thirty to see the value in today's money.

When Queen Victoria's consort Prince Albert died in 1861, she acquired a large quantity of jet both for herself and for courtiers to wear during her period of mourning. At one point it was said to be the only jewellery permitted in court. Although she relaxed this rule during her Golden Jubilee year of 1887, the import of inferior Spanish and French jet, and some would say

its association with death and mourning, caused jet's popularity to decline.

A resurgence of jet could have taken place during the Art Deco period of the 1920s, but artists instead took to onyx, and by 1936 there were only five craftsmen left working in Whitby. Today, however, there is again a thriving jet industry supplying predominantly tourists, and interestingly the Gothic subculture drawn to Whitby partly for the Dracula connection, and also for the fact that it is a beautiful town.

Collecting jet

It is thought that the Whitby coastline still contains a considerable amount of jet, but it is beyond commercially economical reach. Inland shale banks and cliff faces have long been worked dry, and what little remains today is once again recovered from beaches. Cliff-face erosion and the tide combine to occasionally reward collectors with what is known as washed jet, although quality pieces are rare. Jet has historically provided a subsidiary income for local fishermen forced to stay ashore due to bad weather, and this is still occasionally the case today. Good locations are closely guarded secrets – it's a question of knowing the coastline and being able to read the tides.

Although Whitby has always been at the centre of the jet industry, jet has also been found at other locations nearby both inland and on the coast. Jet has been found a few miles south at Robin Hood's Bay, and as far north as Saltburn. Between these two locations there are several other known jet-collecting areas dotted along the coast, notably at Kettleness, Runswick, Staithes and Skinningrove. Inland sites have included dozens of small abandoned mines on the Yorkshire moors, notably at Eskdale, Castleton, Bilsdale and Rosedale. There are several now abandoned mines alongside the A172, and a few spoil heaps are still visible. Jet mines should not be confused with the much larger open-cast mines in the

Whitby area that supplied chemicals for the clothing dye industry.

Most jet mines have now been extensively picked over, leaving little for the amateur collector. A couple of knowledgeable individuals claim to still have access to some inland jet, but an outsider would be unlikely to find any. Besides beachcombing, another technique known to locals is as follows: one hour before the very lowest tide each month, at the water's edge, a very heavy crowbar is jammed into the ground at an angle and sheets of shale are levered up ready to be split. The sheets are then inspected carefully for the familiar resin-like material. The process continues, moving along parallel to the waterline. There is usually enough time for a couple of hours work before the tide turns, and the upturned shale can then be inspected more carefully on the shore.

Whitby jet is still sought after not only by craftsmen but also by specimen hunters. Novices should beware, however. Other material, such as lignite, shale and bog oak, has been mistaken for jet in the past.

The value of jet

Like the value of any gemstone material, the value of jet depends on the quality of the individual sample. Jet often contains flaws and inclusions, and obviously the less there are of these the better. Grade A jewellery-quality jet appears to retail for around £1 a gram, although the finder would obviously be paid much less than that. As a guide, a 30 to 40 mm pebble-shaped piece weighs about 20 to 40 grams. Soft jet is inferior to hard jet but is occasionally of interest to collectors. Jet still showing the characteristics of wood also sells for much less.

Jet jewellery

Jet jewellery has been found in Bronze Age burial sites in Britain and other parts of Europe, and has been recovered from the

coastline around Whitby since at least 2500 BC. The Romans – particularly Roman women – liked jet, and the monks of Whitby Abbey carved jet into rosary beads. 'Jet black' is a familiar phrase, and Chaucer refers to followers of fashion wearing bright black stone from Yorkshire.

The range and diversity of jet jewellery created by the craftsmen of Whitby is simply staggering. Because jet is light it has often been carved into large, intricate pieces of jewellery. Historical examples have included keepsakes and lockets with ornate casings, and cameos cleverly incorporating contrasting ivory. Jet has also been carved into bar brooches, bracelets, bangles, necklaces, hair and hatpins, and there are even miniature carvings, busts and furniture. There is a plethora of jet religious paraphernalia, and jet has had practical applications in such things as candle holders, and knife and pen handles.

Some of the best examples of jet jewellery, together with a detailed history of jet in Whitby, can be viewed at Whitby Museum, the address of which is included in Further Information (*see page 276*).

Finds on beaches

Let me start by asking you a question. How much jewellery do you think the average family takes on holiday each year? To put it another way, how much jewellery does your family take? There are often two wedding rings, for a start, and an engagement ring, the latter often complete with a diamond or other precious stone. In addition there are decorative rings, worn by both men and women, and again often featuring gemstones (women) or measurable weights of gold (men). There are also chains, bracelets, earrings and necklaces, the majority of which are of sufficient size to register a signal on a metal detector. Increasingly these days there are piercings, and expensive watches of the Swiss persuasion. Even some designer sunglasses

are partially metallic. Virtually everything mentioned so far will be made of either gold or silver, and occasionally of platinum.

This isn't a terribly recent phenomenon, either. The Victorian middle classes were encouraged to visit the seaside, to take in the fresh air and bathe. During the nineteenth century beaches like Brighton, Weston-Super-Mare and Scarborough were crammed in the summer with upwardly mobile professionals flaunting conspicuous displays of wealth. Even when the great unwashed could afford to join them, they brought plenty of cash, if not jewellery, to spend on entertainment. Go back a century or two further and you have the merchants, traders, armies, and smugglers who all used the shores for their various enterprises, not to mention the thousands of ships that have come to grief along the shorelines.

People are generally careful with their valuables, right? Are they, heck! Can you honestly say you have never lost anything? There are literally tens of thousands of insurance claims each year for lost jewellery alone. Although we increasingly live in a society that uses plastic for purchases, for things bought on the beach, such as ice cream, snacks, rides and amusements, cash is still quite definitely king. Beach detecting is a relatively new hobby, and the vast majority of the treasure that has been lost over the centuries is still out there, and the tide constantly moves it around and turns it over. Land detectorists may have the edge on large hauls, but beachcombers make far more money on a day-to-day basis.

A rich field

Beach detecting done correctly in every respect can be mind-bogglingly lucrative. A group of detectorists has a website displaying an enviable haul of finds it has amassed over the years combing the beaches of Britain and other parts of Europe. The collection amounts to several thousand items. There are pages upon pages of 18-carat plus gold signet and display rings. Many

are very intricate, and some feature diamonds and other gemstones. There are also gold watches, bracelets, necklaces, pendants and numerous other associated gold finds. If that isn't eye watering enough, there are also literally piles of gold wedding bands which they say are their most common finds of this type. In one outing, admittedly in Spain, three of them claim to have found over a hundred gold rings in just one and a half days detecting. They barely even mention their silver collection, but you can imagine its size. Of course, this is an extreme example, and if living out of a van and risking the wrath of European police forces isn't for you, fair enough, but learning the basic techniques is easy, and anyone can have a piece of the action.

Beach detectors

Metal detectors have come a long way over recent years. When I did a little detecting twenty-odd years ago detectorists generally kept well away from beaches. Mineralised ground conditions caused by the reaction of salt and water made early detectors constantly register false signals, and as a result very little of the vast coastline of Britain ever got searched. The problem still exists, of course, but modern detectors are designed to counteract it, and there are even specialist machines that wipe the problem out altogether. Although search techniques are still the most important aspect of beachcombing, if beaches are going to be your mainstay you would probably be better off considering investing in a machine designed specifically for the purpose. Beach detectorists use what is called a pulse detector.

Pulse detectors use the pulse induction (PI) system, which in effect listens for echoes. The main advantage of pulse detectors is that they can penetrate deep into the sand and detect objects at far greater depths than normal detectors. Pulse detectors are also waterproof, and some of the more expensive models can

even be partially or completely submerged. It's worth noting that pulse detectors are also very useful for finding gold nuggets, although they have some disadvantages. The main one is that they are very ferrous sensitive, so not only will they detect all the metallic debris on a beach, but they will also register signals near to reinforced structures, and have no discrimination. PI detectorists learn to discriminate by ear – they 'hear' junk by listening carefully to the different signal tones.

All the major manufacturers produce a range of pulse detectors, and you should seek advice before deciding which one to buy. Some manufacturers are also developing detectors that are equally effective on land and beaches, with the advantages of discrimination and pinpointing. It's worth noting that owning a pulse detector is not essential as most modern detectors will work adequately on beaches with fine-tuning, but the pay-off will usually be loss of detection depth.

Regardless of which machine you choose, one piece of equipment no beach detectorist can do without is a decent set of earphones. Beaches are noisy places and signals need to be disseminated and faint ones heard. A good-quality spade is also useful because greater detection depths can mean a lot of digging.

How to search beaches

Before we get into the specifics of beachcombing techniques, how about a bit of a challenge? If you are baulking at the idea of forking out several hundred pounds for a detector, why not get one for free? Long before metal detectors were invented there were people who scoured beaches up and down the country using a sharp eye trained to spot small, disc-shaped objects. Remember that metal detectors only find valuables just below the surface, and that there is a huge quantity of valuables either on, or very near the surface.

Even today there are beachcombers who walk beaches with a brisk breeze behind them, together with the early morning or late evening sunlight, and it is said that the experienced ones can leave with a pocket full of money and the odd piece of jewellery. Many of the techniques employed by beachcombers also apply to beach detecting, so by the time you have saved enough money to buy your first detector you will already have accumulated enough knowledge to be considered among the higher echelons of the beachcombing fraternity. Just a thought.

Beach detecting is different in almost every respect from metal detecting on land, not least because the environment is constantly changing. Beach detectorists have developed techniques to exploit this, which to be honest can be a bit obsessive – studying complex tide charts, digging out historical maps, documents, books, even picture postcards. These are only of any use, however, if you live near a beach and need to maximise its full potential. Most people just need a few tried and trusted techniques that are effective on whichever beach you are searching, and the majority of these techniques are based on where to search and when the best time is to do so. Unlike vast acreages of land, if a beach is searched correctly no potentially lucrative area need be missed.

Some of the main beachcombing techniques are given below. They are in no particular order of merit, and quite simply the more of them you incorporate into any one search the better your results will be. Some are fairly obvious, others less so. Before you read them it is worth mentioning that there are a couple of events that are always outright winners for beach detectorists. One is a high spring tide, the other is the aftermath of a storm.

There are usually a couple of high tides every month, and if you can catch one just after a storm the only thing that may blight a lucrative day's detecting will be competition from other detectorists. I vaguely remember a story about a detectorist's

suitcase being completely filled under conditions similar to these. Not all storms are good, however, for if the wind is blowing in the wrong direction sand can build up on the beach, which is exactly the opposite of the effect you require.

Here are the basic beachcombing techniques:

- Observe the most populated areas of the beach. Don't detect when the beach is crowded, but wait until the end of a particularly busy day. Early evening is best.

- Search all the entrance points to the beach, such as pathways from caravan and camping sites, promenade steps, carpark access areas and the natural walkways above high tide.

- Search all areas around attractions such as deckchair pitches, the pavilion, bandstand, cafés, ice-cream and burger vans, amusement arcades, fairground rides, fishing, boat and ferry trips, and even donkey rides.

- Search under pier stanchions, groynes, sea walls, the promenade, landing stages and other solid structures. Finds will invariably become trapped around man-made structures. Rocks and rock pools are also coin and jewellery traps.

- Think of sand, shingle, pebbles and rocks not as separate material, but as the same material graded according to weight by tide and current. If coin-sized shingle congregates in a particular area it will sometimes contain, guess what? You've guessed it.

- Some beaches contain natural geological gullies that often reveal themselves as winding depressions at low tide. Use your eyes to follow these, since they are generally find traps.

- Search areas of the beach where the sand appears to be dark. 'Black' sand is heavy, and has settled naturally due to tide and currents, as will often be the case with valuables.

- Observe lugworm casts. If they are formed from black sand contrasting with lighter surface sand this means there is heavier material just below the surface.

- Search along the high tide mark. This is usually visible because of the line of seaweed and rubbish that accumulates.

- Search 3 to 4 metres on either side of the midway point between high and low tide. Search in a zigzag pattern along the length of the beach and then return, crossing your previous path.

- The depth of sand on beaches will vary at different points. Hard pack underneath the sand is often where finds will settle. Stripped sand where stones show at the low water mark are a good sign that you are close.

- Finds often group together, and once you have found a hot spot spend a little time in the area. If a beach is giving up good finds make the most of it, because conditions can change literally overnight.

Of course, not all finds are made up of cash, or necessarily take the form of modern jewellery. Seventy years ago the writer Leo Walmsley wrote about his experiences as a boy beachcombing, or 'scratting' as he called it, near his home at Robin Hood's Bay. The following is a list of the metallic objects he found just using his eyes, which should give you an indication of what else is in store on beaches:

- French, Norwegian, Spanish, South American and Chinese coins

- George II sovereign

- Silver groats

- Queen Anne florin

- Georgian bronze coins

- Gold watch chain

- Gold wedding ring

- Silver brooch

- Knives, forks and spoons

- Scissors

- Buttons

- Mail from a suit of armour

- Old pistol lock

- Cannon ball

- Head of a whaler's harpoon

- Crimean War medal

- Metal fastenings

- Brass lock

- Keys

- Nails

- Bolts

- Bits of brass

As you will have gathered, there's plenty to look out for. Below are listed some of the most popular beach resorts around Britain, along with tips about where to search and what you might find. There are, of course, many other beaches, and the usual techniques can also be applied to these and elsewhere.

Important note Always familiarise yourself with tides and other local hazards when out beachcombing. People drown with frightening regularity on British beaches.

Popular British beaches

Ayr A very popular Victorian resort. Search the sand area near the sea walls.

Barry Exposed rocks for modern finds. Whitmore Bay in winter and after spring tides.

Bawdsey Low-tide shingle. The tower area can deliver Victorian coins.

Beaumaris Sand and shingle beach.

Blackpool Around all access areas and piers.

Bognor Regis West of the pier, front of the promenade and also access areas.

Bournemouth Around the piers and sea wall for modern finds. All areas after storms.

Brancaster Landing stage for possible Roman finds.

Bridlington Areas to the north and south, the pier and access areas after a storm.

Brighton Between West and Palace piers on a busy day, particularly after a strong wind.

Brixham Beach for possible wreck finds after a storm.

Broadstairs Promenade and Viking Bay beach. Some good finds after a storm.

Budleigh Salterton Shingle, lumps and depressions for Victorian finds.

Burry Port Sands at low tide for Victorian coins.

Caister-on-Sea Access areas for modern finds. Roman coins found after winter storms.

Carlestown Noted for eighteenth-century coins.

Clacton Another popular Victorian resort. Search off-season for finds from that period.

Cleethorpes Promenade and under the pier for modern finds. Good after a storm.

Crackington Haven Best finds turn up after winter storms.

Criccieth Medieval coins around the castle. Shingle beach and depressions after a storm.

Cromer Sea wall, pier, rock pools and fine shingle areas. Good after a storm.

Dinas Head Plenty of wreck relics have been uncovered after strong storms.

Dover Beach next to the harbour after storms for old coins.

Exmouth A very ancient port. Rock pools and harbour at low tide.

Filey Brigg Rock pools below the cliffs.

Flamborough Head Caves cut into rock at North Landing.

Fleetwood A mile out from promenade for Roman finds. Mouth of Wyre after a storm.

Folkestone Early hammered coins have been recovered from Sandgate beach.

Grange-over-Sands Shingle and front of sea wall. Victorian finds turn up after storms.

Gravesend Popular resort with Victorians and renowned for finds from that period.

Great Yarmouth Dunes to the north and south. Both piers and sea walls for modern finds.

Happisburgh Water pools at low tide. Gold, silver and copper coins can be found.

Hartland Point Site of many shipwrecks. Worth searching after westerly storms.

Harwich Near to the sea wall and shingle inside the harbour for predecimal coins.

Hastings Pier and exposed rocks, and sand below shingle beach at low tide.

Hayle Footpaths near to Towan Sands, Porth Kidney Sands and the Hale tidal estuary.

Helmsdale Shingle beach picnic area. Nuggets where the River Kildonan joins the shore?

Hengistbury Head Celtic coins are known to have been recovered after winter storms.

Hoylake Wreck relics have been found on Wirral foreshore. Worth searching in winter.

Kessingland Shingle at Benacre Ness good for historical finds, particularly after a storm.

Leysdown Attractions on the beach for modern coins. End of sea wall for historical finds.

Llandudno Pavilion and bandstand. Also around the pier for Edwardian and Victorian finds.

Lower Upnor Particularly renowned for historical finds after storms.

Lowestoft North shore and harbour mouth for historical finds. South pier for modern finds.

Lyme Regis At low tide after storms for very early silver coins.

Manacle Point After storms finds can line the shore and become trapped between rocks.

Margate Sea wall, pier and access points. Coins are found all year round.

Mawgan Porth Good resort for modern finds. Storms have often revealed older finds.

Milford Haven Gelliswick Bay and shingle beach at Burton Ferry for historical finds.

Minehead Very popular resort. Quay area after storms and low spring tides.

Morecambe Front of main promenade, slope and steps, and south side of resort.

Mudeford Quay Around the beach huts across the tidal estuary.

Mumbles Around the pier and attractions. Jewellery found here can be of very good quality.

New Brighton Modern coins and jewellery found in shingle and sand. Good after storms.

Newlyn Medieval coins have been recovered from around the pier during winter.

Newport Rock pools for modern finds. Harbour mouth for historical finds.

Newquay Modern finds from all beaches, but particularly Watergate and Fistral Bay.

Padstow Areas of interest include the river entrance and boat-landing stages.

Penarth Shingle for recent finds. Also Victorian finds in sands after storms at low tide.

Perranporth Routes to Gear Sands, mouth of river for modern finds, beach after a storm.

Porthcawl Beach access areas, shingle and sand for modern finds. Rocks in winter.

Portmadoc Productive beach. Dunes can be glory holes. Also search Golden Sand Bay.

Prestwick Around the landing points and access areas.

Pwllheli The access areas can be excellent for modern finds, but beware of rubbish.

Ramsgate Modern finds next to the sea wall. Historical finds around rocks.

Rhossili Bay At low tide during the winter months for wreck finds.

Rhyl Where the River Clwyd meets the beach. Also water's edge and deckchair areas.

Ryde Great modern coin finds everywhere. Sea wall area after strong winds.

Sandown Good finds to the right at the end of short narrow bars of shingle.

Scarborough Victorian finds after storms. Blackrocks to the south can also be coin traps.

Seahouses Medieval coins have been recovered from Breadnell Bay after storms.

Seasalter Particularly worth searching after a storm for Roman coins.

Shanklin At low tide after a storm around the pier and exposed rocks.

Sidmouth Finds made below high tide. Also foot of esplanade and beach access areas.

Skegness Camping and beach huts for modern finds. North of pier for Victorian finds.

Southend Modern finds around pier and donkey ride areas. Top of beach after a storm.

Southport Wide area around the pier. Also beneath the promenade. Crosby after a storm.

Southwold Around the pier for modern finds. Also the harbour for historical finds.

St Donats High-tide line and natural depressions for Victorian finds.

St Ives Harbour at low tide during the summer. Elsewhere after winter storms.

St Mary's Island There are shipwrecks here. Searching after a storm can prove fruitful.

Sully Bay Sully Island has been renowned for Roman coins. Also foreshore after a storm.

Swansea Bay Good modern finds can be made during the summer. Historical in winter.

Teignmouth Great losses during the summer. River mouth. Shingle patches in winter.

Tenby Try promenade and sand dunes. Also Monkston Point for old coins.

Thorpeness Search productively around the low-tide line.

Tilbury Worth searching after storms. Napoleonic artefacts have been recovered.

Torquay Rock pools at low tide. Also Corbyn Sands area and Torre Abbey.

Traeth Lligwy Southern end and also any visible sand anomalies in winter.

Treanance Cove Rocky shores for early finds.

Trebarwith Strand Particularly around foreshore for older finds.

Troon Modern finds are made on beach. Beaches to the north and south after a storm.

Warren Mill Roman coins have been found around the landing stages.

Wells-next-the-sea Landing stages for Victorian coins. Also the harbour mouth.

Westward Ho Good for modern coins. Roman coins found in winter.

Weymouth Hot spot for Roman coins. Particularly good finds after a storm.

Whitby South of the swing bridge after high tide. Keep an eye out for jet.

Whitesands Bay Good modern finds and sometimes gold items, particularly after a storm.

Whitley Bay Low-tide shingle for predecimal coins. Front of sea wall for new finds.

Worthing Front of promenade. Shingle patches in winter. Good finds after a storm.

Cockle picking

I wasn't sure what approach to take with this subject, or indeed whether to include it at all. The remit of this book is searching for valuable treasure around Britain, and cockles fit that criteria in some respects. I would say that if you are ever in a cockle-picking location you should adopt a 'free lunch' approach rather than try to set up a commercial operation. People's livelihoods depend on cockle picking, and no one wants to see a deluge of amateurs taking food from anyone's table. Having said that, the money some cockle pickers make is astonishing. This, however, is only half the story.

The cockle – a bivalve mollusc – has been collected around Britain's shoreline since Roman times. Cockles were certainly an early staple food, probably even from as far back as the Stone Age. In Wales, cockle picking was a lifeline for women whose husbands were too ill to work in the mines. Today, demand for cockles is driven by the Continent, and cockles are exported to France, Spain, Holland and Belgium. In Britain the annual cockle harvest is estimated to be worth £20 million, of which £8 million alone is generated in Morecambe Bay. Other major cockle-picking areas around Britain include the Thames estuary, Burry Inlet in Wales and the Dee estuary in Scotland.

Gathering cockles is delightfully simple, although the technique is only half the story. The cockle picker's tools include a 'jumbo', which is a plank of wood with two long handles, a rake, a sieve, a bucket and sacks in which to store the cockles. The jumbo is placed on the sand and rocked backwards and forwards to loosen it and suck the cockles to the surface. A few centimetres of the sand are then raked off, placed in the sieve and shaken vigorously. The young cockles (spat) fall through the sieve to regenerate the species, leaving the adults for collection. The contents of the sieve are then emptied into the bucket and eventually the bags, and the process begins all over again.

That's the technique – but here's the reality. The cockle-picking season takes place during the winter, usually beginning in December, and can end arbitrarily at any time at the whim of the authorities. It is cold, wet, windy and back-breaking work. Cockle pickers work all day in all weathers for as long as the tides will allow, usually seven days a week during the season, often for little or no return. Furthermore, at Morecambe Bay the tide comes in literally at the speed of a galloping horse. Twenty-one Chinese immigrants recently drowned there while picking cockles. Licences are also required for both Morcambe Bay and the Dee, and permits at Burry are very restricted, with a quota system being imposed.

There has been a lot of talk about the amount of money cockle pickers can earn, and some of it undoubtedly has basis in truth. A little of each daily harvest is sold to local fishmongers and restaurants, but the vast majority is exported to the Continent, where the market is controlled from Holland. Wholesale prices have fluctuated wildly from year to year. In the past four years the price has varied from as little as £200 to as much as £1,300 a ton. In a rich fishing bed there can be as many as a million cockles per acre, and if conditions are right and the market is buoyant it is possible for an experienced cockle picker to make £500 a day. With a bad harvest and poor market conditions you can easily knock a nought off that.

So what are we to make of these delightful little orange molluscs sold by vendors in pubs and in fish and chip shops? Depending on your point of view, they are either the perfect accompaniment to a pint of beer or a bag of chips, or they may give you the impression that you are chewing rat gristle infused with fish brine and vinegar. Perhaps the answer is to get a little more adventurous. In Wales, cockles were traditionally cooked in bacon fat and served with bacon, leeks and larva bread. You could even take the Continental approach and eat them with fennel, garlic and onions and a splash of white wine. Whatever

your tastes, I think that's enough of the Delia Smiths for one treasure-hunting book – if you do decide to try your hand at cockle picking, just be very careful of the tides.

Sunken treasure

There is a huge amount of other treasure waiting to be found around the coastline of Britain. No one has as yet found a hoard of gold or coins on a British beach, but it's only a matter of time judging by the amount increasingly turning up on land. Shipwrecks and pirate treasure are a heady mix, not least because beaches regularly give up gold and silver coins, which obviously come from somewhere. The most productive way to recover this type of treasure is by diving for it, but as most people aren't qualified divers this is not included as an option here.

Beach detecting using pulse detectors has already been covered (*see page 151*), and fully submersible pulse detectors are one option that gives you that extra few metres of reach impossible even with the latest technology. You don't, however, need any of this equipment, and can make finds just by using your eyes. Below are examples of locations around Britain noted for their unusual historical connections, which are generally centred around old shipwrecks, pirate legends and places reclaimed by the sea. Some are just stories, others are fully documented, and any one of them may have something fantastic in store for the future. Next time you visit one of these resorts, take time to consider where the next 'Hoxne Treasure' could come from.

Isle of Wight

On 22 September 2002 Darren Trickey decided to go metal detecting on a beach near Bembridge on the eastern tip of the Isle of Wight. After just a few minutes his detector registered a signal that would change his life forever. Buried just a few

centimetres below the sand Darren recovered what turned out to be a solid gold Anglo-Saxon sword-belt fitting, which had been lying buried for centuries. He was quoted as saying, 'It glowed as if it was brand new when I dug it up.'

The sword-belt fitting had an octagonal base and sixteen panels divided equally into individual cells, each of which once contained a garnet, although only one now survived. The belt fitting was one of the most elaborate and valuable artefacts ever to be found on the island, and was certainly the best located with a metal detector. Other sword-belt fittings had been discovered before, but they were usually made of copper alloy or silver, and this was uniquely gold.

The artefact clearly once belonged to someone of exceptionally high rank, and could even have been the property of the brutal seventh-century King Caedwalla. The artefact was declared treasure, and its value was estimated at £30,000. Darren, who was twenty-one at the time, said that he wished the sword-belt fitting could remain on the island, and wants to put the reward money towards buying a house.

Beer

A shipwreck containing Spanish gold and silver coins is said to lie very near the coast at Beer, east of Sidmouth. Try searching between low and high tides. The caves nearby are also known find traps.

Berwick-upon-Tweed

The historical town of Berwick-upon-Tweed in Northumberland has changed hands more than a dozen times during conflicts between England and Scotland. It is noted for battle relic finds, and Scottish silver coins have been found by detectorists in the past. Areas to search include underneath Berwick Bridge, along the foreshores of the Tweed and around the Royal Border Railway Bridge.

Chesil Beach

Chesil Beach in Dorset has several outlying shipwrecks. Roman and medieval coins, as well as gold and silver bars, have been discovered there. In 1749 the pirate ship *Hope* floundered on Chesil Beach. Locals stripped her completely and recovered £50,000 worth of gold. Wreckers working the beach over the centuries are the source of numerous legends of hidden chests containing gold and silver coins from the Spanish Armada.

Cligga Head

The wreck of the *Hanover*, a packet ship that sank on route to Portugal from Falmouth in 1763, was discovered a few years ago off Cligga Head near Perranporth in Cornwall. The cove where she lies is now actually named after her. Some say the wreck still contains the original cargo of gold, estimated to be worth £50 million.

Dunwich

Dunwich on the Suffolk east coast is famous as the town that was claimed by the sea. Dunwich was once the capital of East Anglia, and an important coastal port, until a large portion of it slipped into the sea in the thirteenth and fourteenth centuries due to violent storms. All that now remains is a small village around the western fringe of what was the original town.

Ferriby

The south bank of the Humber near Winteringham has Celtic, Roman and Saxon connections. There was a Roman villa situated nearby which slipped into the river, and detectorists have found Roman and Saxon coins and artefacts there.

Fowey

Fowey near St Austell in Cornwall was a prosperous coastal port

throughout the Middle Ages, and was famous for pirate activity. Search around Lantic Bay and Polridmouth during the winter months, and also along the River Fowey.

Herne Bay

Fishermen have for centuries found pieces of Roman pottery in their nets believed to originate from a Roman shipwreck lying in Herne Bay, Kent. A total of 350 pottery vessels has so far been recovered, and it is thought that the boat was transporting thousands. Locating the wreck itself would be a considerable achievement, as no Roman shipwreck has yet been found on the British coastline.

Holme next the Sea

Two routes, the Roman Peddars Way and the older prehistoric Icknield Way, converge at Holme next the Sea, Hunstanton, in Norfolk. Roman and even older coins have often been found on the beach by detectorists.

Ilfracombe

Over the past twenty years, gold and silver coins have been found by detectorists around the coast at Ilfracombe, in Devon. They are thought to originate from the treasure ship the *London*, which sank on 9 October 1796 with the loss of the lives of dozens of prisoners of war. Search the sands in the summer months, and also the harbour at low tide.

Kettle Ness

Kettle Ness is a headland to the east of Runswick Bay on the east coast. The village is recorded in the Doomsday Book and was claimed by the sea, and this is also the site of the remains of a Roman lighthouse. It's worth searching between high and low tides following a storm or after spring tides.

Mablethorpe

Remains of shipwrecks have recently been sighted at low tide on the beach at Mablethorpe, Lincolnshire. Roman finds have been made by detectorists. Search the main beach area for modern finds, and also to the north of the promenade.

Marazion

Over the centuries there have been many stories of medieval losses by pilgrims making their way along the causeway from Marazion to St Michael's Mount in Cornwall. The causeway is revealed at low tide.

Mount's Bay

The Mount's Bay area of Cornwall has seen many shipwrecks over the centuries, some of which were carrying treasure. In 1526 the *St Anthony* was driven ashore at Gunwalloe and the locals spent all day and night salvaging silver. In the eighteenth century another ship broke in two and emptied bullion into a gully. Detectorists have often found gold and silver coins after storms. The coves are also worth searching, particularly between Gunwalloe Cove and the Lizard.

Pembroke

There have been several shipwrecks around the Pembrokeshire coastline over the centuries. In 1543 a Spanish ship carrying gold was wrecked when she was forced to shelter during a gale. It's also worth searching the shores around the castle after a storm for historical finds.

Penzance

Penzance in Cornwall needs no introduction. The Spanish arrived there in the 1500s and the fort dates back to the mid seventeenth century. Penzance was also besieged by pirates. Only

search the beach after a storm, as the sand is quickly replenished.

Porth Dwgan

The *Charles Holmes* sank off Porth Dwgan north of Aberbach beach in 1859 carrying pottery and reputedly a chest full of gold. It is uncertain whether the money was recovered or went down with the ship.

Prussia Cove

Prussia Cove, six miles east of Penzance, is said to harbour wreck treasure and was once a favourite with smugglers. Detectorists have found gold and silver coins at several locations.

Reculver

What was once a third-century Roman fort stands on the sea edge at Reculver on the Kent coastline. Many Roman and medieval coins have been recovered by detectorists from the shingle areas.

Salcombe

Salcome in Devon is home to several shipwrecks claimed by the sand bar that lies at the mouth of the estuary. Detectorists have also found Spanish gold at Bolt Head. Islamic gold worth hundreds of thousands of pounds was recently recovered in just 15 metres of water. Searches of the coves in the area have sometimes proved rewarding, particularly after a storm. Victorian coins are also found at Bigbury Bay after spring tides.

Seaton Carew

Scar Rocks at Seaton Carew have claimed several ships in the past, and detectorists have made occasional related finds. There is also a legend of a ship named the *Duck* that was reputed to have sunk on Seaton Carew beach laden with gold coins. The story goes that some fifty years later storms exposed the ship,

and that this started a mini gold rush.

South Shields

There are several shipwrecks located in the vicinity of South Shields, near Tynemouth. The Roman fort of Arbeia is also located nearby. Search the Marsden Bay and pier areas for Roman coins. The area is also worth searching during winter months.

St Brides Bay

On 1 November 1679, the *Santa Cruz* sank somewhere off the Pembrokeshire coast, quite possibly in St Brides Bay. She was carrying gold that has never been found.

West Mersea

Several smugglers' tales originate from the coastline at West Mersea in Essex. The shingle areas are worth searching carefully, as are any unusual anomalies in the sand.

Worms Head

Detectorists have found numerous Spanish coins at Worms Head near Rhossili Bay. In the second half of the seventeenth century a ship purported to be carrying the dowry of Catherine of Braganza was wrecked nearby. In 1807 and 1833 quantities of silver Peruvian dollars were revealed by the tide, some of which now reside in local museums. The area is worth searching after a storm or at spring low tide.

Shell collecting

This most obvious of all the beachcombing subjects is not included here except in passing for several reasons. Firstly, to be ruthlessly honest, there's very little money in it. Some of the more serious shell collectors in Britain do trade, but generally

the ethos seems to be to swap shells. Secondly, leaving aside the subject matter – which in itself is quite complicated – describing shells accurately in an unillustrated book is the stuff of nightmares. Finally, having looked into the subject a little, I believe – as the people involved seem to concur – that shell collecting should be done purely for pleasure. If you are interested in shell collecting I hope you will be as delighted as I was to discover that there is actually a British Shell Collectors' Club (*see page 276*).

Amber

Amber probably better belongs in either the gemstone or fossil-hunting chapters, but beaches are ideal environments from which to collect amber, so it is included here.

What is amber?

Amber is like jet in many respects. It is a type of fossilised resin that comes from the bark of prehistoric coniferous trees that existed tens of millions of years ago. Usually as the result of the tree fighting disease or becoming damaged, a sticky resin was secreted, and over a prolonged period of time, if conditions were favourable, the resin solidified. Given certain heat and chemical processes, this solidified resin can become the material known as amber.

Like jet, amber is light, very soft and warm to the touch. Also like jet, it is classified as an organic gemstone, rated at 1.5 to 2.5 on the Mohs scale (*see page 113*). Amber can be either transparent or cloudy – the cloudy variety contains millions of trapped microscopic air bubbles. Amber is generally a liquid honey colour, although it can be any one of several colours depending on where it originates. The appeal of amber lies in the fact that it often contains trapped organisms, usually plant based, which enable people to own and appreciate something tangible that existed millions of years ago.

Amber in Britain

Amber doesn't originate in Britain. The type of amber occasionally found here comes from the Baltic regions. The Samland Peninsula deposit is a former forest of ancient amber trees that was carried north from the Baltic and now resides under the sea only a relatively short distance from East Anglia. Because amber is light – in fact only slightly heavier than sea water – over millions of years pieces have drifted to shorelines in a number of locations around Britain.

The beachcombing technique mentioned earlier in the chapter, involving walking in the early morning or evening using the sun to catch a glint (*see page 153*), is probably the best-known technique for spotting amber. Areas to search include Norfolk and Suffolk, and in particular Southwold and Lowestoft. Other locations where amber has been found include Essex, Kent, Hastings, in East Sussex, Redcar, in Cleveland, Lincolnshire, Northumberland, Fife and the Isle of Wight.

The amber myth

Amber, like many other gemstones, is rarely found in Britain. Small pieces, usually no more than a centimetre or two and worth just a few pounds each, are typically what is found. Having said that, there is a report of someone finding a brick-sized piece a few years ago, which was sold for several thousand pounds. Pieces of amber that contain insects are rarer, and there is a report of such a piece being found on the Isle of Wight.

One myth that is often perpetuated is that pieces that contain insects are priceless, but although specimens with tiny insects trapped inside are uncommon, they are certainly not a rare phenomenon. It is said that one in a hundred pieces of jewellery-quality Baltic amber contains a tiny insect of one kind or another, and it appears the confusion lies not in the insects themselves, but in the size and type.

The resin secreted by amber trees was very sticky, and could easily trap plant matter and other tiny organisms. Small insects like gnats and flies of the type that are very common today were also common millions of years ago. Once caught in resin, they simply didn't have the strength in body mass to escape, and therefore were often trapped. These species of insect in amber are not as uncommon as you might think.

The very valuable amber specimens seem to be those that contain creatures which should have escaped, but for some reason didn't. Larger insects such as spiders and cockroaches, and even scorpions and lizards, have occasionally been found in amber. Finds of this type are phenomenally rare, and obviously of great interest to palaeontologists. Specimens of this nature have been known to trade for up to five-figure sums, although one has never been recorded in Britain.

Amber jewellery and specimens

Amber has been used in jewellery since the Stone Age, and this is still a very popular use for it. Worked beads that are 11,000 to 13,000 years old have been discovered in Cheddar, and in 1857 a cup carved from a solid piece of amber was found in the grave of a Bronze Age chief in Hove, East Sussex.

Amber values

Any specimen of amber found in Britain is of interest to the scientific community and is undoubtedly more valuable than amber actually found in the Baltic, but here is a small selection of Baltic amber specimens containing insects that were on sale by an American dealer:

- Amber containing a fungus gnat – $29 (£15).

- One large piece of amber containing several small gnats and one fly – $71 (£35).

- A piece of amber with a pair of mating midges, a rare, seldom-seen specimen – $238 (£120).

- Amber piece containing a very well-preserved millipede – $313 (£155).

- An amber piece with a large nymph, very rare in Baltic amber – $569 (£285).

Amber forgeries

There have been several cases of sharp practice and even outright fraud involving amber. Victorians heated and squeezed smaller pieces together to make larger pieces, which were called pressed amber. Copal, a material similar to amber also derived from pine resin but as yet not properly formed, is often passed off as the real thing. Insects have also been manipulated into amber, and plastics and a whole host of other materials have been passed off as the genuine article. Real amber is usually distinguishable by small, circular cracks and inclusions near to the surface, and amber will generally contain tiny hairs and other plant matter. Any insects trapped in amber will sometimes have a white coating as a result of partial decay, although unfortunately none of the above indicators is conclusive.

CHAPTER SIX

Fossil Hunting

PEOPLE DEVOTE THEIR entire lives to some of the more academic subjects this book occasionally touches upon. A good example is gemmology, a complicated subject in itself, but made more so due to the associated subjects of mineralogy and geology. Another good example is palaeontology, the study of the evolution and structure of extinct life. Palaeontology is a colossal subject, and a single chapter in a treasure-hunting book couldn't possibly begin to do it justice. Also, as in the case of gem hunting, geology rears its sedimentary head again. Here again, you will need to know the basics, but this book is about treasure hunting, so the more scientific aspects of the subjects covered are left for you to discover if you so wish.

What is a fossil?

Fossils are the records of previously existing life. They can be in the form of either fossilised organisms, called body fossils, or just evidence of extinct life, called trace fossils. Only a tiny proportion of organisms that die ever become fossilised because the process requires a rare combination of circumstances. There are several ways in which an organism can become fossilised.

Permineralisation occurs when an organism is replaced with the minerals in the environment in which it died. When an organism dies, if it isn't eaten or doesn't decompose, and the body is covered with sediment quickly enough, the harder parts can be replaced with minerals. Over time these form a rock cast or fossilised impression of the original organism – in effect a copy of it.

Other types of fossil include moulds and casts. Mould fossils occur when minerals dissolve an organism leaving a negative imprint. If an imprint is filled with mineral sediments it then becomes a cast. Trace fossils are evidence of extinct life such as footprints or burrows.

Fossils are heavier than the actual body part from which they are derived, and the colour, density and texture of a fossil will vary depending on the environment in which it is formed. Fossils will usually become compressed or distorted because of movements in the rock, and predators will generally ensure that only remains become fossilised. Fossils can be of any size. Even a single-celled organism can be fossilised, and these tiny fossils are called micro-fossils.

Some of the largest fossils ever found in Britain are those of marine dwellers. One species, *Leedsichthys*, an example of which was found in a brick pit in Peterborough in 2002, was estimated to have been 20 metres long. In Norfolk, the remains of several mammoths with 2 metre-long tusks have been found. In 1991 a brachiosaurus over 15 metres long was discovered on the Isle of Wight. It was thought to be just a juvenile, and had it survived it could have grown to 25 metres. Other organisms that can become fossilised include reptiles, birds, insects and plants.

Fossils are normally found in sedimentary rock, of which there are several different types. Examples of sedimentary rock include sand that has become sandstone and mud that has become shale. Sediment settles and compacts into rock over millions of years, trapping fossils in the process. Different types

of sediment settled throughout the various geological periods in history. The Carboniferous period, for example, during which large forests developed, laid down the organic material that formed Britain's vast coal reserves.

Fossils will often come to light when these natural resources are exploited – quarries in Oxfordshire have exposed fossils from the Jurassic period, for instance. Fossils also materialise as natural erosion occurs at many coastal locations around Britain. Sussex and Hampshire on the southeast coast, for example, are locations that yield material from the Cretaceous and Eocene periods.

All organisms, whether surviving or extinct, belong to one of three basic categories: invertebrates, vertebrates and plants.

- **Invertebrates** are animals with no backbone, and the vast majority of all creatures and therefore fossils found fall into this category. One of the most common types of extinct invertebrate are called ammonites, and these once lived in the sea. Ammonites had coiled shells that easily fossilise and are common in Britain.

- **Vertebrates** are animals that have bony skeletons and backbones, such as birds, reptiles and fish. Complete vertebrate fossils are very rare, and usually just parts of an animal survive.

- **Plants,** including seeds, can also become fossilised. In certain environments a process called carbonisation records an organism as a thin carbon film in the form of an imprint, such as a fern on a rock.

It is a sobering thought that 99.9 per cent of all organisms that have ever existed are now extinct.

The ages of the Earth

As our planet evolved, what we now call Britain went through several geographical and geological changes spread throughout colossal periods of time. Palaeontologists use eras and periods to make sense of these vast expanses of time and the changes that occurred within them. Many people are familiar with the Jurassic period, the time of the giant dinosaurs, which dates from 142 to 206 million years ago, and most of us also know about one of the mass extinctions that occurred at the end of the Mesozoic era 65 million years ago, but there were many other eras and periods, too. Listed below are the major geological eras and relevant periods and the approximate time frames they relate to, starting from when multi-celled organisms were first formed on Earth.

Era	Period	Date (millions of years ago)
Palaeozoic	Cambrian	545 to 495
	Ordovician	495 to 443
	Silurian	443 to 417
	Devonian	417 to 354
	Carboniferous	354 to 290
	Permian	290 to 248
Mesozoic	Triassic	248 to 206
	Jurassic	206 to 142
	Cretaceous	142 to 65
Cenozoic	Paleocene	65 to 54.8
	Eocene	54.8 to 33.7
	Oligocene	33.7 to 23.8
	Miocene	23.8 to 5.3
	Pliocene	5.3 to 1.55
	Pleistocene	1.55 to 0.1

- The earliest multi-celled organisms began to develop on Earth around 600 million years ago, during what is known as the **pre-Cambrian** period.

- The **Cambrian** and **Ordovician** periods saw the beginnings of marine life.

- During the **Silurian** period primitive land invertebrates began to develop.

- During the **Devonian** period fish evolved to be able to emerge onto land, insects began to appear and plant life took hold.

- The **Carboniferous** period saw the development of forests and with them, reptiles.

- At the end of the **Palaeozoic** era larger reptiles began to develop, as well as amphibians and marine life, but many were wiped out during one of the mass extinctions caused by climate change.

- New species began to appear during the **Triassic** period, including the first of the small dinosaurs.

- By the **Jurassic** period birds and many other species of dinosaur had evolved, including some carnivores.

- The **Cretaceous** period saw the large carnivores and the first mammals on Earth, but they were eventually wiped out by another mass extinction 65 million years ago.

- The beginnings of what we now recognise as life on Earth followed during the **Cenozoic** era. Mammals, birds and flowering plants flourished and eventually early man evolved from primates.

The history of early humans in itself spans over a million years. It is difficult to grasp that palaeontologists' area of study is generally at least sixty-five times further back than this, a time frame almost impossible to comprehend.

British fossils

The most common fossils found in Britain are those of marine dwellers, because these were abundant and their shells were easily fossilised. Ammonites, brachiopods and echinoids were three common marine dwellers, and there are numerous species of each. Later in this chapter these and other organisms are described, and this is where things get complicated.

Palaeontologists classify all organisms in an orderly fashion founded on similarities of structure, origin and so on. These are called taxonomic systems. Each species belongs to a genus, each genus belongs to a family, each family belongs to an order and so on. Ammonites, for example, which are a type of cephalopod (have a coiled shell), would be classified as follows:

- Kingdom – Animalia (self-explanatory, really)

- Phylum – Mollusc (a primary division of the kingdom)

- Class – Cephalopoda

- Order – Ammonoidea

This is followed by family, genus and species. It is the correct method of classifying fossils but it is also complicated, so for the purposes of this book I concentrate on the rarer, more collect-able fossils found in Britain, and try to describe them in an easily understandable manner.

Some of the rarest fossils are vertebrates. They can be of any animal, and take the form of teeth, bone, parts of bone, muscle or other body parts, occasionally a skull and very infrequently a complete or near-complete skeleton. One type of fossil that hasn't been mentioned previously is called an unaltered fossil, and it is phenomenally rare. Unaltered fossils are the frozen or mummified remains of an organism, and are usually found in arid or frozen conditions, which help to preserve body tissue.

Mammoths trapped in ice are one example of unaltered fossils.

In Britain, certain conditions can also preserve organisms in this way. Lindow Man, a 2,000-year-old body discovered in a peat bog in Cheshire in 1985, is a good example of this phenomenon. Other rare fossils include any previously unrecorded species, and fossils rare to a particular location. Even ammonites, which are relatively common, can be worth several hundred pounds each if they fall into either of these categories. Rare fossils are of interest to collectors, and even occasionally museums.

Invertebrate fossils

Below are descriptions of some of the more common invertebrate fossils that can be found in Britain.

Ammonites Molluscs that had coiled shells and were common during the Mesozoic era. They were carnivores and preyed on other sea creatures such as fish. Some ammonite shells are smooth, others ribbed or patterned. Ammonite fossils are generally the size of a hand, but have been known to be as small as a pellet or as large as a dustbin lid.

Belemnites Squid-like creatures that thrived from the Jurassic to the end of the Cretaceous periods. Like ammonites, they were predators. Usually the bullet-shaped tail guard is the part of a belemnite found fossilised.

Bivalves Bivalves (mussels, oysters and so on) are molluscs typically with mirrored upper and lower shells. Bivalves developed during the Cambrian period and have survived until today.

Brachiopods Shellfish that look similar to bivalves but are unrelated to them. The shells are not paired. Brachiopods developed around the same period as bivalves, but it is bivalves that have prospered.

Crinoids Also known as sea lilies, crinoids were a group of marine dwellers that had a crown of arms and were attached to the sea bed by a stalk. Crinoids were common from the Palaeozoic through to the Mesozoic era. Intact fossils are rare – usually just the stems survive.

Echinoids Echinoids (sea urchins) were a group of creatures that lived in the sea around the Jurassic period, although they date from much earlier. The most common types of echinoid, the irregulars, look like a hot-cross bun in fossil form.

Gastropods Fossilised gastropod (snail) shells are very common. Gastropods were originally marine dwellers that moved onto land. They date from the Cambrian period, and have survived until today.

Graptolites Colonies of interconnecting thin, tubular organisms that lived from the Cambrian to the Permian periods. Graptolite fossils look like pencil lines on rock.

Nautili Like ammonites, nautili were cephalopod mussels with coiled shells, but they originate much earlier, in the Palaeozoic era.

Trilobites Small marine creatures with segmented shelled bodies. They existed during the Palaeozoic era, and are highly collectable. To visualise a trilobite fossil think of an alien woodlouse.

Vertebrate fossils

Below are some of the extinct vertebrates found in Britain. Fossils of just individual body parts of these animals can be valuable. They are sought after by collectors and are much rarer than fossils of invertebrates.

Reptiles

Ichthyosaurus This group of reptiles (ichthyosaurus means fish lizard) roamed the sea throughout much of the Mesozoic era. They were typically 2 to 3 metres in length, although they could be much larger, and were dolphin-like, had four powerful paddles, a dorsal fin, tail, a long, toothed snout and enormous eyes. They were carnivores and were built for speed. Ichthyosaurus had lungs and breathed through nasal openings, which meant they had to surface periodically for air.

Plesiosaurus A group of large marine reptiles that lived during the Mesozoic era. They had four flippers, and depending on the species had a long neck, small head, strong jaws and teeth. Several fossils of plesiosaurus have been found in Jurassic and Cretaceous sediment. Plesiosaurus has often been described as looking like a snake running through a reptile, and is the type of animal that more often than not gives rise to the Loch Ness monster story.

Pliosaurus A sub-group of plesiosaurus, they differed in as much as they had large heads and short necks and were huge – some were 10 to 15 metres long, and quite possibly even longer. They were sea-dwelling carnivores alive during the Mesozoic era, and were predators right at the top of the food chain. Forget Tyrannosaurus rex: with a skull between 1.5 and 4 metres long, the biting power of the pliosaurus was simply colossal.

Pterosaurus Flying reptiles that lived throughout the Mesozoic era. There were several different species of pterosaurus – some had wingspans of less than one metre, others over ten. Pterosaurus were carnivores and it is believed that they lived on sea creatures and the remains of dead animals. Bones and other fossilised remains of pterosaurus have been discovered on the Isle of Wight.

Dinosaurs

Many dinosaur fossils have been found in the UK. In some instances several examples of the same species have been found, in others just a single bone or body part. Here are just a few of those that have been recorded.

Acanthopholis, Anoplosaurus, Baryonyx, Camptosaurus, Cetiosaurus, Dryosaurus, Eotyrannus, Eustreptospondylus, Hylaeosaurus, Hypsilophodon, Iguanodon, Megalosaurus, Metriacanthosaurus, Pelorosaurus, Regnosaurus, Sarcosaurus, Scelidosaurus, Stegosaurus, Thecodontosaurus, Yaverlandia.

Early fossil collecting

It wasn't until the nineteenth century that scientists started to take an interest in fossils and began to record them properly. Mary Anning was one of Britain's earliest and most famous fossil collectors. She was born on the south coast in 1799, and following her father's death, began to collect fossils in Lyme Regis with her brother in order to supplement the family income. At the age of only twelve she is credited with finding the first complete skeleton of an ichthyosaurus.

Mary Anning continued to collect fossils, and as her reputation grew she eventually came to the attention of a wealthy collector called Thomas Birch. He was so disturbed by the family's financial position that he sold his entire collection of fossils and gave the proceeds (£400) to the Annings. With a little financial security, Mary continued to collect fossils and went on to discover the first ever skeleton of a plesiosaurus in 1821. She continued to collect fossils throughout her life, and made many other important finds until her death in 1847. Just a few months before she died she was made an honorary member of the Geological Society of London, quite an achievement on two levels because women were ineligible for membership at the time.

Fossil collecting today

Fossil hunting is a hobby that can appeal to people of all ages, even children. There is no expensive equipment to buy, and fossils can be found at hundreds of locations throughout Britain. From a historical prospective it appears that many of the great dinosaur discoveries were made over a century ago, but there are some notable exceptions. In 1983 an amateur palaeontologist called William Walker unearthed a *Baryonyx* at Ockley brick works in Surrey. The *Baryonyx* ('heavy claw') was a carnivorous dinosaur and a unique discovery. The skeleton, which was over 70 per cent complete, was 9 metres long and 2 metres tall, had a long neck and tail, and a large body and rear legs, with slightly smaller front arms. The head of the *Baryonyx* resembled that of a crocodile's, the jaw contained dozens of small serrated teeth and it also had a small crest on its snout. The most distinctive features of the *Baryonyx* were the 30 cm-long claws on each of its thumbs, thought to be used for hunting fish. In recognition of the finder's extraordinary discovery, the dinosaur was named after him, and *Baryonyx walkerii* was donated to the Natural History Museum.

Fossil-collecting areas

The Midlands, southeast and east coast didn't get a mention in the gold or gemstone chapters, but they are among the most common places for collecting fossils. In the gold and gemstone chapters you will have read that the main sources for these resources are primary rock formations, but with fossils it is precisely the opposite. Fossils are not associated with primary rock at all, but are found in secondary, sedimentary rock. It follows, then, that the red areas on a geological map should be avoided.

The major fossil-collecting areas in Britain include Ayrshire, Cumbria, Derbyshire, Devon, Dorset, Durham, Essex,

Fife, Gloucestershire, Hampshire, Isle of Wight, Kent, Lincolnshire, Norfolk, Oxfordshire, Shropshire, Somerset, Suffolk, Sussex, West Midlands, Yorkshire and Wales. A more detailed list of the most popular fossil-collecting locations around Britain and what you might find in each is given later (*see page 191*).

How to look for fossils

The key to successful fossil hunting is knowing where to look, and using the most important tool of all – your eyes. Whereas the vast majority of people would walk past a fossil completely oblivious, an experienced collector will find them everywhere. Most people are vaguely aware of what fossils look like, and the best approach is to pick a known site and just start looking.

The most common place to search for fossils is on beaches, where you don't generally need permission. Look among the rocks and shingle, and the scree slopes – the piles of material that accumulate at the foot of a cliff. Fossils can also be found in the spoil heaps of quarries, on ploughed fields and in deep roadside cutaways. If there is nothing immediately obvious lying around, turn some rocks over and split them, and if you find something that looks interesting investigate further.

If you stick to a popular fossil location you will almost certainly find some fossils, and in some areas the most common varieties are very abundant, but finding a rare fossil is another matter. You might think that heading for sites where they have been found in the past would give you the edge, but of course that's what everyone thinks. The truth is, rare fossil finds are just occasional random events.

Like all treasure, the vast majority of fossils won't be of any great financial value. But also like other forms of treasure, the fun is in the anticipation that the big one is just around the corner. There are no special locations or search techniques

known only to a chosen few: important finds can happen to anyone, anywhere, at any time, even on their first outing.

A beginner's extraordinary find

Several years ago, a retired insurance salesman thought he'd like to try his hand at fossil hunting after reading about the subject in the library. There was a quarry about ten miles from where he lived in Edinburgh, and knowing a little about fishing he concluded that as fossilised plants had been found in the area it might also have once been a food supply for herbivores. He set off on his bike with a hammer and chisel and began chipping away at the rocks. After a few hours he took a break, picked up a flat rock to rest his cup on and turned the rock over. To his amazement, staring up at him was a complete fossil of a dinosaur about the size of a rabbit. The National Museum of Scotland identified it as a rare species, and it was eventually sold for £8,000.

Safety considerations

I know I have already banged on a lot about safety in this book, but I can't over-emphasise the need to be vigilant when fossil hunting, particularly when working alone in remote areas and on beaches. Always tell someone where you are going and when you expect to return, take a mobile phone, check the tide times, listen to advice about local hazards and keep away from cliff faces.

Equipment for fossil hunting

In order to go fossil hunting you will need some basic equipment, the vast majority of which can be found in any household. Correct clothing appropriate to the conditions is essential, of course, as are boots, and eye protectors if you are going to use a hammer and chisel. If you intend working anywhere near a

cliff face a hard hat should also be worn, and a fluorescent jacket is a legal requirement in quarries.

As for tools, you can get away with just a bricklayer's or geologist's hammer and a trowel or a knife, but fossil hunters will usually take a lump hammer and some chisels, and even a pick because certain rock types are quite hard to split. Gloves are also handy as chalk can irritate the skin.

You will need a plentiful supply of paper to wrap finds, and some strong bags or containers to carry them in. A camera, pen and paper are also handy for recording fossils as they may turn out to be of scientific importance, and doing so might even help with value. You should also include a good supply of provisions, first-aid supplies and a mobile phone for safety.

Fossil-hunting locations

Listed below are some of the better known fossil-collecting locations around Britain. These are just a few of the more popular sites – there are many others, and your local library or museum should be able to help in this respect. Also included are tips about where to search and what you might find, and highlights of some of the more interesting and rare discoveries that have been made.

As mentioned earlier, the descriptions of fossils have been simplified to make the subject easier to understand, and it is worth mentioning that this also applies to geological time periods. Palaeontologists subdivide geological periods further to give more accurate time indicators, and these are also associated with detailed descriptions of geological formations. Such subdivisions are not included here, since for the purposes of this book there is no point in getting bogged down with information that is irrelevant to treasure hunting (and I can't pretend to know that much about the subject anyway!).

Important note Permission may be required to search some of these locations, particularly quarries. There are also both local and national restrictions on what you can hunt for and the techniques you can use.

County Durham

In 2002 a twelve-year-old schoolgirl found a rare fossil of a type of fish, a coelacanth, on a field trip to **Thrislington Quarry**, near Ferry Hill. Another fossilised fish, a janassa, has also been found at the quarry. Both specimens were donated to the Hancock Museum.

Cumbria

The now-disused **Hodgson How Quarry** dates from the Ordovician period. The quarry is rich in graptolite fossils, and some of the most unusual species from there can be seen at Keswick Museum. Graptolites can also be found in **Stockdale Beck** and occasionally **Stair Stream**.

The Carboniferous beach at **Whitehaven** is one of the few coastal locations where plant fossils can been collected. Try splitting some rocks on the foreshore – occasionally some superb specimens come to light. Ammonites and starfish are also found here.

Derbyshire

There are several locations in Derbyshire where fossils can be found. **Buxton**, **Dovedale**, **Matlock**, **Bath** and in particular **Castleton** are primary locations among the white limestone. Crinoids, brachiopods some nice nautili and small trilobites can be found.

Devon

Budleigh Salterton has Devonian and Triassic geology, and is particularly noted for the pebbles on the foreshore that

occasionally contain fossils. Split these with a hammer to reveal bivalves and brachiopods.

Hope's Nose is one of the best fossil-hunting locations for trilobites, bivalves and corals in Britain. The Natural History Museum in London has specimens found in the area. Search the slate and limestone rocks around the slopes and foreshore.

Dorset

The foreshore at Jurassic **Bowleaze Cove** has yielded many interesting fossil specimens over the years, including some good ammonites and ichthyosaurus bones. In 1974 a crocodile jawbone was found on the beach, which was subsequently donated to Dorset County Museum. Ammonites, echinoids and molluscs are also found at nearby Osmington Mills.

Good occasional rock falls from the vertical Jurassic cliffs at **Burton Bradstock** can deliver a bonanza for fossil hunters. It is said that if you are quick, corals, shells and little belemnite guards, as well as ammonites, can be taken home by the bagful.

The cliffs and foreshore at **Charmouth** are known as one of the best fossil-hunting locations in Britain. They contain marine organisms such as ammonites, and occasionally fish and reptile remains. A complete 5-metre-long ichthyosaurus was found here in 2000, and another ichthyosaurus was discovered 100 metres away in 1997. For newcomers, the Heritage Centre has local finds on display. Charmouth is very popular with fossil collectors so it is better searched after the spring or autumn high tides or during the winter months.

Eype has Jurassic clay below hard Cretaceous rock. Numerous shells and belemnites are found, as are starfish and ammonites, and occasionally some very good specimens. A hammer and chisel are required to split the hard rocks on the foreshore.

Both shells and ammonites are found at **Kimmeridge**, and occasionally the bones of pterosaurus, plesiosaurus and

ichthyosaurus. The cliffs and foreshore should be searched at low tide. No hammers are allowed at Kimmeridge, and the tides can be very dangerous.

No hammering is permitted on the cliffs at Cretaceous **Lulworth Cove**, and fossils are generally collected from the beach. Unusual large bowls over 1 metre across are found here, created by algae around tree trunks. Fossils are not found as frequently as in nearby locations, apart from bivalves in Fossil Forest.

Lyme Regis is probably the best known of all the fossil-collecting locations in Britain, and a whole industry has grown up around it. The best place to look is at the foot of the cliff – the rock contains thousands of marine dwellers, and ammonites in particular. Occasionally, ichthyosaurus and other bones turn up, but they are rare these days. Here you are up against commercial collectors, so Lyme Regis is best searched during the winter.

After rock falls, Jurassic **Monmouth Beach** can be good for cephalopods, brachiopods, fish and reptile remains. Huge ammonites up to half a metre across have also been recorded in the locality, and there is even a report of one a metre in diameter.

Jurassic **Portland** is famous for the stone quarried in the area. Ammonites are found here, and occasionally the remains of early turtles. Permission is required to enter several of the nearby quarries, but you are permitted to search on the foreshore. A hammer and chisel are necessary.

Ringstead is an excellent fossil-collecting location. Split shale rocks on the foreshore for ammonites. Corals are also present, and occasionally rare species can be found.

What is now **Seatown** was a warm tropical sea during the Jurassic period. Storms and strong tides release fossils that can often be found just lying around on the foreshore. Ammonites are everywhere, but they can be delicate. Belemnites, crinoids and nautili are also found.

A hammer, chisel and gloves are required to work the Cretaceous chalk cliffs at **Swanage**. Echinoids, brachiopods and ammonites are quite common, and dinosaur footprints have been recorded in the vicinity.

Essex

Maylandsea was a marine environment fifty million years ago. Fragments of fossilised crab and several species of lobster have been found on the foreshore. Sharks' teeth are also found.

Walton on the Naze is an area known for plant fossils, and the beach is popular for sharks' teeth. Several fossilised bird remains have also been found here, but you have to scavenge.

Gloucestershire

The Triassic beach at **Aust** is very popular with fossil hunters. Bones and teeth have been found, and even the remains of ichthyosaurus and dinosaurs. The bone beds are at the top of the cliff so it is best to search on the foreshore after winter storms.

The beach at **Hock Cliff** is Jurassic and contains ammonites, brachiopods and bone fragments. Star-shaped cross-sections of sea-lily stems are also sometimes found in the gravel. The use of hammers is not permitted on the cliffs, and fossils need careful handling.

Hampshire

The geology at **Barton-on-Sea** and nearby **Milford** dates from the Eocene period. Sharks' teeth, mussels, oysters and hundreds of species of shells plus bones are all found on the cliffs and foreshore. Fossils are also found in the older Carboniferous rocks of the imported sea defence. Only surface collecting is permitted, it is muddy and the fossils are fragile.

Isle of Wight

Lobster, coral, brachiopods and fossilised plants such as ferns are all found at **Atherfield**, and the location is particularly renowned for giant ammonites. An iguanodon, a large herbivorous dinosaur that grew to up to 7 metres in length, was also discovered here in 1917. Other rare fossilised skeletons have occasionally been found, such as pterosaurus.

The cliff at Cretaceous **Blackgang Chine** is difficult to access but worth the effort because trace fossils and very occasionally rare dinosaur bones have been found here. (Incidentally, 'chine' is a regional term used to describe the remains of a river valley that led to the sea.)

Typical finds at Cretaceous **Hanover Point** include gastropods, bivalves and fish teeth. Dinosaur bone fragments have also been found, and occasionally more complete specimens. Trace dinosaur footprints are visible, but protected by the National Trust.

Sandown is worth a visit for the fossil museum alone. There are numerous dinosaur skeletons on display, and many of the creatures once roamed Sandown Bay. More likely finds these days include coral and oyster fossils and occasional bone fragments. A very rare footprint of an iguanodon was recently found by a schoolgirl. A partial skull of another unique dinosaur species was discovered at **Yaverland**.

In **Shanklin** it is worth searching among the pebbles and shingle at the foot of the Cretaceous Knock Cliffs for ammonite fossils, brachiopod nests and plant remains.

With its chalk cliffs and succession of geological periods from the Cretaceous, **Whitecliff Bay** is one of the best fossil-collecting locations on the Isle of Wight. Sponges, bivalves, belemnites, gastropods and sharks' teeth are just a few of the finds that are made.

Kent

The Cretaceous grey clay at **Folkestone** is full of ammonites, some of which are very well preserved. Search areas around the beach at the foot of the cliffs. Sharks' teeth and fossils of other sea creatures can also be found.

The Thames estuary around the **Isle of Sheppey** contains a wide variety of fossils, and there is usually something for everyone. The shingle beach contains sharks' teeth, and the Eocene clay has crocodile, turtle and fish remains. Very occasionally, a near-complete turtle specimen or fish skull will turn up.

The near-complete skeleton of a large herbivore was recently discovered at a clay pit near **Maidstone**. The 4-metre-long, heavily armoured nodosaurus dates from the Cretaceous period. It was the first discovery of this type since a similar one by Thomas Huxley in 1860.

Lincolnshire

South Ferriby contains both Jurassic and Cretaceous geology, and virtually the entire range of common marine fossils is found here. Another Lincolnshire site, **Ketton Quarry**, contains ammonites and brachiopods, and there are some fish and reptile remains. Collector-quality ammonite and bivalve specimens have also been reported from **Scunthorpe**.

London

Abbey Wood dates from the Eocene period. The most productive form of fossil collecting here is sieving, and large quantities of sharks' teeth can be found in this way. Other finds in this area include fish vertebrae, and bird, reptile and mammal remains.

Norfolk

The famous red limestone and white chalk cliffs at **Hunstanton** date from the Cretaceous period. Search the rocks on the foreshore for brachiopods, sea urchins, ammonites and fish remains.

Mammal and fish bones and other remains, as well as echinoids and coral, are all common on the cliffs and foreshore at **West Runton**, but can be fragile. In 1990 a fossilised elephant skeleton was found embedded in the cliff. At 4 metres high and weighing 10 tons, it was larger than its modern descendant.

Shropshire

There are several quarries in Shropshire dating predominantly from the Silurian period. Some are disused, others open, but permission may be required. **Farley Quarry**, for example, contains coral, cephalopods, trilobites and brachiopods. Mammoth skeletons have also been found at **Condover** in central Shropshire.

Somerset

An exceptionally rare fossil of a complete 1.5-metre-long plesiosaurus was recently found at Jurassic **Bridgwater Bay**.

Famous for its ammonites, Jurassic **Doniford Bay** is a fossil-collectors' paradise. Superb white, green and pink ammonites are sometimes found, as are some nice brachiopods and bivalves. A hammer and chisel are required to split the rocks on the foreshore. The beach is very muddy, and beware of the tides, which are very fast.

Some superb and often quite large ammonites, nautili and shells have been found at Jurassic **Quantoxhead**. Look out for recent cliff falls for opportunities, but beware because they are unstable. Dinosaur and ichthyosaurus bones have also been found here in the past.

Bivalve fossils and ammonites, casts of which can be seen at low tide, can be found at **Watchet**. Plesiosaurus and ichthyosaurus bones have also occasionally been found.

Suffolk

There are at least a dozen good fossil-hunting locations in Suffolk dating from the later geological periods. **Pakefield** has

yielded ichthyosaurus fossils, and **Levington** and **Nacton** have each given up at least one complete skeleton of a reptile, as well as many other individual body parts. Finds from **Ramsholt**, **Bawdsey**, **Easton** and **Dunwich** include fish and shark remains, and bird, mammal and mammoth fossils, as the traditional finds usually associated with the coastline.

Sussex

Fossils litter the sea bed at Eocene **Bracklesham Bay**, and there are fresh deposits after every tide. Shark and ray teeth, plates, turtle remains, fish bones and many fossils of shellfish are found. The fossils are pale in colour and can sometimes be mistaken for modern finds.

A hammer and chisel are required to work the chalk boulders and cliffs at Cretaceous **Eastbourne**. Ammonites, cephalopods, nautili, echinoids, gastropods and sharks' teeth are all found. Beware of falling rocks from the cliff.

If you can't make it to the Isle of Wight, try Cretaceous **Fairlight** or **Hastings**. Iguanodon footprints and dinosaur and mammal bones have all been recorded here. Fish, shark and reptile remains and crocodile teeth are also found, as well as plant fossils such as ferns.

West Midlands

The limestone Wren's Nest and Castle Hill areas of **Dudley** contain among the best-preserved Silurian fossils in Britain. Over 600 marine species plus rare plant remains have all been recorded in the area, and many specimens grace museums throughout the world.

Yorkshire

In 2001 a landslip at **Filey Bay** revealed an almost-complete skeleton of a 4-to-5 metre-long plesiosaurus. The specimen was found by fossil collector Nigel Armstrong and was spectacular in

itself, but particularly important in this case because it was previously unrecorded.

A sharp chisel blow to rocks on the scree slopes and foreshore at **Kettleness** can reveal nice ammonites and belemnites. Jurassic reptile and dinosaur remains are also found, and several part specimens of plesiosaurus have been recorded in the past.

Whitby is one of the best and most popular fossil-collecting locations on the east coast. The Jurassic sandstone contains plant fossils, and the clays contain ammonites, belemnites and bivalves. Crocodile, ichthyosaurus and plesiosaurus remains have also been found.

Wales

In southwest Wales **Fishguard** and **Abereiddy** are two locations dating from the very early Ordovician period. Graptolites and some nice trace fossils have been recorded at Fishguard, but they are rare and hard to find. Areas of the foreshore and cliff connected to the abandoned quarry at Abereiddy yield molluscs and trilobites.

Llantwit Major and **Lavernock** are two locations in South Wales where Jurassic and Triassic fossils can be found. Giant gastropods and brachiopods are present at Llantwit Major, and there are ammonites, fish bones and reptile remains at Lavernock.

Scotland

Many of the Devonian flagstone quarries in **Caithness** are quite rich in high-quality fish fossils, but unfortunately collecting is restricted and permission very difficult to obtain. **Achanarras Quarry** has been one of the more accessible locations, and still occasionally yields complete fish specimens.

The **Isle of Skye** is known as Scotland's 'dinosaur island' because of the number of bones and other remains that have been found there. Fifteen dinosaur tracks were recently restored

from the Middle Jurassic period, and judging by their size the creatures were around 10 metres tall and probably carnivores. Nice ammonite specimens are also found.

A plesiosaurus backbone was recently found by a passer-by lying on the banks of **Loch Ness**, feeding the monster story again. Two problems: firstly, the specimen dates from the Mesozoic era, whereas the loch is only 10,000 years old, and secondly, the fossil was extensively drilled with marine organisms, whereas Loch Ness is a freshwater lake. Evidently a hoax, and a fairly elaborate one at that, but what price tourism, eh! The good news is that there are plenty of genuine fossil-collecting locations throughout Scotland apart from those mentioned above, including **Brora**, **Golspie**, **Portgower** and **Thurso**.

Removing and preparing fossils

Recording fossils and the locations in which they are found accurately is very important. Not only does it add to science, but if a fossil turns out to be saleable such information will give it provenance. Issue each fossil with a reference number and date, and photograph it; gather as much information as you can about what the fossil is, the location and the rock type in which it was found. If a fossil appears important, record its location, leave it in situ and take advice from an expert.

When removing a fossil from the surrounding matrix do so carefully, as some fossils can be very delicate and being too hasty may damage or destroy them completely. It's worth noting that removing a fossil entirely from the matrix is not always desirable, and in fact may even detract from its value.

Preparation is designed to enhance the presentation of a fossil ready for display. Beach fossils often require soaking in fresh water for several days to remove the salt content. There are several techniques that can be employed to clean, enhance and even repair fossils, involving air tools, glue and other chemicals.

Without any experience you should restrict yourself to just a penknife and brushes. In some instances the minerals that formed the fossil can contain colours which may be enhanced by applying a thin coat of liquid paraffin. For more important and valuable finds you should seek the advice of an expert who may not only advise you on the best way to proceed, but also even prepare the fossil for you.

It is possible to roughly identify fossils from the basic groups described earlier, but identifying a fossil precisely and dating it are more complicated. Two of the most common methods employed are stratigraphy and index fossils. Palaeontologists can approximate the date of a fossil in relation to the layer of sediment that forms the stratum in which it is found. Index fossils are recorded fossils that were known to exist only during a certain period, and fossils found in proximity to these can be assumed to be from the same period. These two principles can also aid identification of some species.

Fossil valuations

The commercial exploitation of rare fossils is unethical in Britain. In 1997 Sotheby's auctioned the fossilised skeleton of a *Tyrannosaurus rex* for $8.4 million (some £4.4 million). Admittedly it wasn't found in Britain, but even so. Several other exceptional fossil specimens have been sold for huge sums, hundreds of thousands of US dollars in some cases. During my research I came across several for sale in the ten, twenty, even thirty thousand dollar price brackets. Finds that realise this sort of money are phenomenally rare, so it is not a dilemma likely to trouble most of us. Nevertheless, it's important to bear in mind that if a fossil is of scientific importance it should not be considered a commodity. Also don't collect more than one or two examples of any fossil in any given area.

The good news is that there is a thriving commercial market

for fossils in the lower to mid price range – by this I mean fossils worth from a few pounds up to a couple of hundred, and occasionally over £1,000. As mentioned earlier, rare finds are precisely that – rare – and some of the examples given below certainly aren't frequent finds even for experienced collectors. Knowing exactly what you have, even if it is in the right condition and prepared properly, is a matter that will affect value and require further investigation. But to give you a flavour of what fossil hunters do occasionally find, listed below are some of the rarer specimens that have been found in Britain which are commercially available, along with prices currently being asked for by dealers.

Like valuations of all types of treasure, fossil valuations are open to interpretation. Recently, an avid sharks' teeth collector spoke of some of the bargains he found on websites compared with the prices being asked for by dealers. He was looking for a tooth of a megalodon, a giant shark, and the shops wanted £160 but the teeth were a third of the price online. Global Internet sites will almost certainly be the place where the majority of fossils are traded in the future. I increasingly hear the phrase, 'Why not see what's on eBay?' When I looked recently there were thousands of fossils being auctioned, and the market seemed buoyant, so bear that in mind when pondering these prices.

Ammonites

- Selection of ammonites, Jurassic, prepared on cut bases, from Charmouth, Dorset – £5 to £15.

- Jurassic ammonite, nice colouring, from sought-after locality, 33 mm, found at Illminster, Somerset – £15.50.

- Multi-ammonites on matrix, nine specimens, 15 mm to 21 mm, found at Bearreraig, Isle of Skye – £42.45.

- Perfect example of a popular ammonite, gorgeous lustre, great display item, 120 mm, found at Whitby, Yorkshire – £48.50.

- Rare ammonite specimen from an unusual location, 70 mm, found at Bearreraig, Isle of Skye – £50.

- Pair of quality ammonites side by side on matrix, 60 mm and 46 mm, found at Bearreraig, Isle of Skye – £87.

- Two stunning ammonites on attractive matrix, display piece, 85 mm and 72 mm, found at Charmouth, Dorset – £255.

- Two ammonites, 350 mm and 200 mm, large display piece, found at Burton Bradstock, Dorset – £450.

- Ammonite, stunning display piece – £1,500.

- Very large ammonite with fantastic colouring, freestanding on matrix, 340 mm, found at Scunthorpe, Lincolnshire – £2,200.

Bivalves

- Cretaceous bivalve, scarce specimen, 25 mm, found at Shanklin, Isle of Wight – $4 (£2).

- Cretaceous bivalve, scarce specimen, 42 mm, found at Atherfield, Isle of Wight – $7.50 (£3.75).

- Three bivalves with dense shell walls, found at Bracklesham Bay, Sussex – £10.

- Matrix-free bivalve, exquisite detail, draw specimen, 38 mm, found at Charlton – £10.

- Rock specimen covered with Jurassic bivalves, 120 mm x 90 mm, found in Whitby, North Yorkshire – £12.50.

- Bivalve cluster on matrix, found in Dorset – £18.20.

- Jurassic bivalve, approximately 60 mm, found at Osmington Mills, Dorset – £20.

- Large Jurassic bivalve with superb colouration and detail, 140 mm x 60 mm, display piece, found at Scunthorpe, Lincolnshire – £58.

- Gorgeous bivalve fossil, Jurassic, 108 mm, polished to reveal green and white colouration, also other fossils on matrix, found in Scunthorpe, Lincolnshire – $149 (£75).

Crinoids

- Eleven small crinoid segments, Jurassic, a variety of species from same location, found at Seatown – £10 (all eleven).

- Quality pyritised crinoid head, draw specimen, 25 mm x 24 mm, found at Charmouth, Dorset – £12.50.

- Crinoid, showing mainly stems, preserved in iron pyrites, nice specimen, 85 mm x 56 mm, found at Lyme Regis, Dorset – £24.95.

- Crinoid preserved in iron pyrites with half-complete head, 134 mm x 100 mm, found at Lyme Regis, Dorset – £38.50.

- Nice pyritised crinoid fossil, scarce locality, display or draw specimen, 170 mm x 102 mm, found at Charmouth, Dorset – £42.50.

- Rare crinoid, Jurassic, fine detail, two heads visible, 145 mm x 70 mm, found at Whitby, North Yorkshire – £55.

- Sought-after crinoid from an unusual location, 100 mm x 70 mm, found at Whitby, North Yorkshire – £95.

- Scarce Jurassic pyritised crinoid, three-dimensional with thick stems, display specimen, 126 mm x 110 mm, found at Lyme Regis, Dorset – £95.

- Crinoid with fantastic detail, well preserved and pyritised, beautiful display specimen, 210 mm x 129 mm, found at Lyme Regis, Dorset – £118.

- Beautiful complete crinoid specimen from the Silurian period, 90 mm, found at Wrens Nest, Dudley – £250.

Dinosaurs

- Jurassic sauropod vertebrae, 60 mm, found at Abingdon, Oxfordshire – £30.

- Dinosaur tail vertebrae, some beach rolling, possible bite marks, Cretaceous, 50 mm, found at Yaverland, Isle of Wight – £40.

- Iguanodon tail vertebrae, 73 mm, found at Waveland – £48.50.

- Cretaceous iguanodon vertebrae, found on Isle of Wight – £200.

- Jurassic megalosaurus vertebrae, 120 mm, found in Oxford-shire – £233.83.

- Vertebrae from unknown large carnivore, found on Isle of Wight – £250.

- Cretaceous iguanodon neck vertebrae, 120 mm x 90 mm, found at Bexhill-on-Sea, Sussex – £295.

- Iguanodon bone from chest region, 170 mm x 150 mm, Cretaceous, found in Sussex – £345.

- Brachiosaurus foot claw, 62 mm, Cretaceous – £450.

- Dinosaur bones, found in landslip on the Isle of Wight – £5,000.

Echinoids

- Fine complete echinoid, 28 mm, good collectors' specimen, found at Beaminster, Dorset – £8.95.

- Well-preserved echinoid fossil from the Cretaceous period, 48 mm, found at Lyme Regis, Dorset – £10.50.

- Nicely preserved echinoid specimen showing plenty of detail, 50 mm, found in Dorset – £15.

- Important Cretaceous echinoid, part of shell is missing but still a good specimen, 75 mm x 59 mm, found at Folkstone – £16.50.

- A fine draw specimen echinoid with good detail, Cretaceous, 45 mm x 42 mm, found at Seaton, Devon – £17.50.

- Gorgeous complete echinoid, superb draw specimen, 52 mm x 50 mm, found at Mere, Wiltshire – £19.75.

- Large as they get for this type of echinoid from this area, 62 mm x 58 mm, collectors' draw specimen, found at Lyme Regis, Dorset – £24.95.

- High-quality echinoid specimen, Jurassic, 110 mm, found at Wyck Rissington, Gloucestershire – £27.

- Quality Jurassic echinoid specimen from a sought-after locality, 98 mm, found at Stow-on-the-Wold, Gloucestershire – £45.

- Three echinoids on one block, two nice size (120 mm) and one partial (85 mm), nice display piece, found at Stow-on-the-Wold, Gloucestershire – £117.50.

Fish

- Disarticulated Cretaceous fish skeleton in matrix, 90 mm, found in Sussex – £7.50.

- Popular fish fossil, nice example, almost complete, 60 mm, found at Lyme Regis, Dorset – £60.

- Complete fish specimen, superb little display item, 57 mm, found at Lyme Regis, Dorset – £78.25.

- High-quality fish jaw with good teeth detail, draw specimen, 80 mm, found at Brockley, Gloucestershire – £95.

- Rare primitive prickle shark fossil, Devonian, 74 mm, found in Orkney Islands, Scotland – $290 (£145).

- Devonian lungfish fossil, 205 mm, found at Caithness, Scotland – £225.

- Partial fish body with detailed scales, three-dimensional fin and internal bones, 160 mm x 120 mm, found at Whitby, North Yorkshire – £300.

- Fish skull with excellent detailing including gill covers, shell-crushing teeth and diamond scales, 160 mm x 100 mm, collectors' piece, found at Whitby, North Yorkshire – £650.

- Complete lungfish, very rare species, good detail on overlapping scales, 150 mm, found at Caithness, Scotland – $1,400 (£700).

- Very rare armoured fish, Devonian, 350 mm, found in Orkney Islands, Scotland – $2,970 (£1,485).

Gastropods

- Gastropod, nice specimen, 25 mm, found at Headon Hill, Isle of Wight – $4 (£2).

- Rare complete Jurassic gastropod shell, 38 mm, found at Long Itchington, Warwickshire – £10.

- Gastropod, Eocene, 190 mm x 60 mm, found at Barton-on-Sea, Hampshire – £10.80.

- Large Eocene gastropod shell, 130 mm, found in Hampshire – £14.10.

- Beautiful Eocene gastropod shell, 60 mm x 30 mm, found at Barton-on-Sea, Hampshire – £17.50.

- Gastropod, Eocene, 120 mm x 55 mm, found at Barton-on-Sea, Hampshire – £20.25.

- Beautiful gastropod, white opalescent shell, perfect specimen, 50 mm x 50 mm, found at Brockley, Gloucestershire – £24.95.

- Rare detailed ornamental gastropod shell, Silurian, 47 mm, found at Wrens Nest, Dudley – £38.75.

- Gastropod, average specimen but very rare from this location, 80 mm x 70 mm, found at Scunthorpe, Lincolnshire – £55.

- Stunning gastropod on freestanding matrix, highly polished, 40 mm x 35 mm, excellent display piece, found at Scunthorpe, Lincolnshire – £160.

Ichthyosaurus

- Single ichthyosaurus vertebra, 35 mm, found at Whitby, Yorkshire – £5.

- Ichthyosaurus paddle digit, 26 mm, draw specimen, found at Lyme Regis, Dorset – £1.

- Ichthyosaurus rib in matrix, found in Dorset – £30.

- Six disarticulated ichthyosaurus vertebrae on shale, 21 mm each, found at Watchet, Somerset – £42.25.

- Jurassic ichthyosaurus paddle bone, found at Port Mulgrave – £200.

- Full ichthyosaurus paddle, 150 mm x 120 mm, found at Whitby, North Yorkshire – £280.

- Section of ichthyosaurus jaw, collectors' display piece, 100 mm x 60 mm, found at Whitby, Yorkshire – £450.

- Articulated ichthyosaurus vertebrae, 260 mm, found at Lyme Regis, Dorset – £500.

- Well-defined section of ichthyosaurus skull with possible bite marks, 330 mm, found at Whitby, North Yorkshire – £800.

- Ichthyosaurus skull, vertebrae and ribs, found in Somerset – £2,400.

Nautili

- Small but complete nautilus, 35 mm, found at Burton Bradstock, Dorset – £15.

- Neat little nautilus specimen, 55 mm, found at Whitby, North Yorkshire – £25.

- Rare nautilus specimen, Cretaceous, 90 mm, found at Uplyme, Dorset – £42.50.

- Nautilus, Jurassic, yellow and clear, with belemnite fragment in aperture, well preserved for locality, found at Sherbourne, Dorset – £52.75.

- Beautiful polished rare brown nautilus, 80 mm, found in Wiltshire – £69.33.

- Superb nautilus specimen in relief, 175 mm, found at Radstock, Somerset – £74.50.

- Very nice nautilus specimen, 150 mm, found at Sherbourne, Dorset – £99.95.

- Very rare and decorative nautilus, highly polished, Carboniferous, very unusual from this area, found at Castleton, Derbyshire – £129.50.

- Very rare nautilus and ammonite, nautilus 112 mm, ammonite 105 mm, found at Sherbourne, Dorset – £145.

- Very rare nautilus, one of only a few from this location, 170 mm, highly polished, green, pink and brown colouring, found at Scunthorpe, Lincolnshire – £650.

Plants

- Large Carboniferous seed fossil, 18 mm, found at Wigan, Lancashire – £7.50.

- Seed fern fossil, Carboniferous, 50 mm x 30 mm, found at Wigan, Lancashire – £8.

- Fossilised fern with plenty of detail, 67 mm, found at Wigan, Lancashire – £12.50.

- Fern stem fossil, nicely sized and clearly detailed, Carboniferous, 122 mm x 70 mm, found at Wigan, Lancashire – £15.25.

- Stunning Carboniferous fern fossil, collectors' draw or study specimen, 60 mm, found at Wakefield, Yorkshire – £25.75.

- Superbly preserved Jurassic leaf and stalk, 56 mm, found at Scarborough, North Yorkshire – £30.

- Beautiful Carboniferous fern fossil, 105 mm long, found at Wakefield, Yorkshire – £42.25.

- Fossilised wood, Jurassic, 600 mm, found at Portland, Dorset – £75. Carboniferous pine cone in nodule, very rare, 100 mm x 50 mm, found in the Midlands – $155.

- Superb representation of a very primitive Devonian plant fossil, 40 mm – $195.

Plesiosaurus

- Selection of plesiosaurus bones, found at Portland, Dorset – £5 to £40.

- Complete Jurassic plesiosaurus paddle bone, 40 mm x 38 mm, found at Lyme Regis, Dorset – £19.95.

- Plesiosaurus pubis bone, Jurassic, 125 mm x 90 mm, found at Weymouth, Dorset – £27.

- Plesiosaurus vertebrae, Jurassic, water worn but well preserved, 65 mm x 45 mm, found at Whitby, North Yorkshire – £38.

- Two plesiosaurus pelvic ribs and two paddle bones, specimen 100 mm x 88 mm, found at Lyme Regis, Dorset – £42.25.

- Nice plesiosaurus bone specimen, 105 mm x 125 mm, found at Lyme Regis, Dorset – £68.50.

- Plesiosaurus bone, matrix free, 165 mm, found in Oxfordshire – £120.

- Four fully articulated plesiosaurus tail vertebrae, 100 mm, found at Lyme Regis, Dorset – £120.

- Large plesiosaurus bone, Jurassic, small repair but superb and rare specimen, 300 mm, found at Lyme Regis, Dorset – £160.

- Pair of plesiosaurus bones, very rare indeed, 230 mm in length, found at Lyme Regis, Dorset – £195.

Starfish

- Fine incomplete starfish, attractive rock, 80 mm, found at Eype, Dorset – £42.50.

- Starfish, good example, found at Eype, Dorset – £85.

- Two starfish with scattered arms, rare fossil, specimen 210 mm x 135 mm, found at Eype, Dorset – £90.

- Small and large starfish entwined, stone 130 mm x 130 mm, found at Eype, Dorset – £149.50.

- Very good complete starfish, found at Eype, Dorset – £150.

- Spectacular complete starfish, rare for this area, 80 mm, found at Eype, Dorset – £210.

- Starfish, very nice specimen, found at Eype, Dorset – £400.

- Very large starfish specimen, complete and rare, found at Whitby, North Yorkshire – £700.

- Starfish from a very rare group, found at Eype, Dorset – £2,000.

- Complete starfish from a very rare group, found at Eype, Dorset – £3,000.

Teeth

- Sharks' teeth, Eocene/Oligocene, various species, good condition, found at Highcliff – £25 for four.

- Shark's tooth, Eocene/Oligocene, good condition, no beach rolling, found at Highcliff – £10.

- Rare shark's tooth, unusual location, root missing, 20 mm, found at Uplyme, Dorset – £12.50.

- Shark's tooth, perfect condition, Eocene, 28 mm, found at Barton, Hants – £18.50.

- Ichthyosaurus tooth, Jurassic, good example, 40mm x 20mm, found at Lyme Regis, Dorset – £28.

- Pliosaurus tooth, internal mould, quite rare, 49 mm, found at Peterborough, Cambs. – £40.

- Rare shark's crushing tooth, Jurassic, 70 mm, found in Cambridgeshire – £45.

- Selection of 11 pliosaurus teeth, 80 mm to 145 mm, found at Charmouth, Dorset – £25 to £75.

- Extremely rare thecodont tooth, Triassic, serrated cutting edge, one-off British fossil, 22 mm, found at Budleigh Salterton, Devon – £165.

- Plesiosaurus tooth, extremely rare, 52 mm, found at Lyme Regis, Dorset – £295.

Trilobites

- Nice trilobite specimen, Ordovician, 15 mm, found in Shropshire – £28.20.

- Small complete trilobite, light against dark rock, Ordovician, 10 mm x 10 mm, found at Powys, Wales – £29.25.

- Rare intact Ordovician trilobite, 18 mm, found at Minsterley, Shropshire – £50.

- Large Orovician trilobite, found at Powys, Wales – £64.80.

- Rare Silurian trilobite with excellent detailing, 24 mm x 19 mm, found at Rushbury, Shropshire – £92.75.

- Scarce, well-preserved and articulated Ordovician trilobite, nicely positioned on shale, 22 mm, found at Leigh, Shropshire – $129 (£65).

- Top-quality example of a classic trilobite, three-dimensional, entire exoskelton clearly defined, good natural colouration and contrast with matrix, found at Betton, Shropshire – $199 (£200).

- Very scarce complete Ordovician trilobite specimen, beautifully centred on block of dense shale, 20 mm, found at Powys, Wales, $295 (£150).

- Rare Ordovician trilobite, outstretched and inflated, centred nicely on rectangular block, 45 mm, found at Minsterley, Shropshire – $389 (£198).

- Extremely rare Silurian trilobite, amazing detail, showcase condition, 22 mm, found at Shadwell, Shropshire – $1,295 (£650).

Other fossils

- Brachiopod, Carboniferous, 23 mm x 17 mm, found at Castleton, Derbyshire – £3.

- Fossilised sponge, Cretaceous, 37 mm, found in Flamborough, Yorkshire – £12.50.

- Lobster fossil, Cretaceous, 75 mm, found at Atherfield, Isle of Wight – £15.

- Superb belemnite guard, calcified, 125 mm, found in Peterborough, Cambs. – £15.50.

- Coral colony, Jurassic, good detail and definition, 60 mm x 55 mm, unknown location in Britain – £24.50.

- Rare crab, Eocene, 50 mm, found at Isle of Sheppey, Kent – £45.

- Millipede in split nodule, Carboniferous, 50 mm, found in Wigan, Lancashire – £169.50.

- Large pliosarus vertebrae, perfect condition, 120 mm, found in Abingdon, Oxon – £182.50.

- Large slab with several dozen primitive Carboniferous

shrimp, superb leg and antennae detail, rare for this location, shrimp 12 mm to 22 mm, found in Scotland – $590 (£300).

- Crocodile skull, Jurassic, almost complete, teeth marks from attack, 160 mm x 140 mm, found at Whitby, North Yorkshire – £1,600.

Fossil-collecting code of good practice

There is a whole host of regulatory and voluntary codes governing fossil hunting in the UK. They are generally there to ensure that people adopt a responsible approach to what is, after all, a diminishing resource. Your local library or museum should be able to provide you with the relevant information for your area. Below is the fossil-hunting code of practice issued by English Nature.

- **Access and ownership** Permission to enter private land and collect fossils must always be gained and local by-laws should be obeyed. A clear agreement should be made over the future ownership of any fossils collected.

- **Collecting** In general, collect only a few representative specimens and obtain these from fallen or loose material. Detailed scientific study will require collection of fossils in situ.

- **Site management** Avoid disturbance to wildlife and do not leave the site in an untidy or dangerous condition for those who follow.

- **Recording and curation** Always record precisely the locality at which fossils are found and, if collected in situ, record the relevant horizon details. Ensure that these records can be directly related to the specimens concerned. Where necessary, seek specialist advice on specimen identification and

care, for example from a local museum. Fossils of key scientific importance should be placed in a stable repository, normally a museum with adequate curatorial and storage facilities.

Further information

In the opening paragraph I said that it was not my intention to go into too much detail about many of the more complex aspects of palaeontology. My primary aim was to keep this chapter entertaining, and to just give you the basic knowledge and encouragement necessary to go out and look for fossils. Because this book is specifically about Britain, some of the other chapters have included quite detailed information, which in some cases has been difficult to obtain. I have included it because I feel this is necessary and in some cases even essential if you are going to stand any chance of finding the relevant treasure.

With fossil hunting it is quite different. Getting additional information is easy – there are literally hundreds of books, guides and maps relating to virtually every aspect of fossil hunting in Britain. If you have decided that you want to take fossil hunting seriously, and that you would like to get some local information and stay within the law, simply go to your local library. Libraries can furnish you with the books relevant to your area, and also provide details about museums and collections. These in turn can put you in touch with geological societies and clubs in your locality. There are also some good sources online, a couple of which I've mentioned in Further Information (*see page 276*).

CHAPTER SEVEN

Treasure Finds and Folklore

THIS CHAPTER CONTAINS stories that don't fit easily anywhere else in the book. They range from a few folklore tales, through to actual events and finds that have been documented over the centuries. The main point of this chapter is to inspire. Britain is a relatively small island yet there are tens of thousands of treasure finds on record, and plenty more waiting to be discovered.

Here is an example of a type of treasure I once found myself. It was the closest I ever got to finding anything like a hoard and it happened during the 1980s while I was renovating a house. I discovered some old one-pound notes that had been hidden behind a vent on the stairwell. They weren't of any use to me or to the owner, who was long since gone, but they were obviously savings equivalent to a couple of weeks' wages for whomever had hidden them there all those years ago.

To have any chance of finding a hoard, a bit of lateral thinking is required. Here are some suggestions for places where you could look:

- It is thought that the Celts made offerings of tools, weapons and coins near to springs, so boggy areas are worth searching.

- Another tip is to follow old finds; you would be amazed at how many separate hoards are found in close proximity.

- Consider ancient stones or markers, which can act as reference points for someone burying treasure.

- Almost every battle scene in British history has yielded a hoard or important find somewhere nearby.

- There is a lot of treasure associated with religious buildings, which was usually hidden to avoid confiscation, and during the English Civil War it is reported that the level of hoarding actually caused an acute shortage of money.

Here I thought it might be nice to take a hypothetical walk around Britain, starting with Scotland, then going through the central regions, into Wales, and on to the furthest reaches of southern England. Stories of finds (or potential find spots) are provided for each area.

Fife

A Bronze Age cairn at Largo in Fife was once said to contain so much gold that the fleece of sheep turned yellow just because they ate the grass that grew upon it. The story that treasure was hidden in the area was confirmed in 1819 when silver objects were unearthed at the cairn.

Ruins of the fifteenth-century Lordscairnie Castle, near Cupar, have a treasure story attached to them. It is said that the original owner, the Fourth Earl of Crawford, was partial to a bit of plundering and stealing, and that he buried his ill-gotten gains in the grounds of the 30-acre estate.

Aberdeenshire

The Grey Stone of Corticram at Old Deer in Aberdeenshire is a megalith that is purported to guard an ancient hoard. The leaning position of the stone is said to serve as a warning to any treasure hunter foolish enough to work beneath it.

In 1802 workers digging in Union Street, Aberdeen, found a large hoard of fourteenth-century coins, and in 1886 another gang working in Upper Kirkgate found 12,000 medieval coins in a bronze cooking pot.

A pair of massive first- or second-century bronze armlets, each weighing over 1.5 kg, were discovered in 1854 at Castle Newe, Strathdon. Other armlets have been found in Scotland, such as a brass example from Pitkelloney Farm, Perthshire.

A cache of Bronze Age arms including three swords was found on Ythsie Farm, Tarves.

Caithness

About 4 miles west of Thurso lie the ruins of Brims Castle. There is a story about treasure that lies buried somewhere in the vicinity. It is documented that fishermen actively spent time searching for it a hundred years ago.

Shetlands

In 1958 a hoard of treasure was found at the ruins of a medieval church on St Ninian's Island. The hoard comprised twenty objects, including brooches, bowls and a sword pommel. It is thought they were buried in the eighth century during Viking raids.

Isle of Lewis

In 1831 a crofter working on the shores of Loch Resort on the Isle of Lewis found a wooden box secreted in a drystone wall. Inside the box were seventy-eight miniature chessmen and other pieces, all beautifully carved from walrus ivory. It is thought that the carvings were Scandinavian, and dated from the twelfth century.

Western Isles

In the early ninth century AD, Abbot Blaithmac and the monks of Iona, a tiny island off Mull, faced an attack by Norsemen. They hid the abbey's treasures, and it is said that they refused to reveal its whereabouts despite being put to death one by one. Cairn na Burgh, one of the five Treshnish Isles, a group near Mull, are where the monks of Iona are thought to have buried their priceless library during the sixteenth century. If the beautiful collection of illustrated monastic books ever came to light it could be worth over a million pounds.

In 1813 a hoard of several thousand medieval coins was found at Ascog Bank, Millbank, on the Isle of Bute.

Ayrshire

In 1955 a hoard of 578 coins was found on a farm in Girvan, Ayrshire. In 1966 another hoard of 1,887 coins was found on the east shore of Loch Doon.

Kirkcudbrightshire

In 1911, during ploughing, a hoard of 2,000 silver coins was found on a farm near Parton, Kirkcudbrightshire.

Dumfriesshire

Dozens of treasure finds have been chronicled in Dumfriesshire over the past 200 years. Much of the information about them has been revealed thanks to the efforts of a publisher called James Urquhart, who indexed many hoards. Details including locations and dates of these hoards can be accessed in Edward Fletcher's *Buried British Treasure Hoards* (*see page 275*).

A bronze Iron Age torc was found inside a bronze bowl during peat cutting at Lochar Moss, Dumfriesshire. Other similar torcs have been found around Scotland and northern England.

Borders

A hoard of over 4,000 English and Scottish coins was discovered at Langhope Burn in the parish of Kirkhope, Selkirkshire. In addition to the coins there was a silver ring, brooches and other artefacts.

In the 1890s a hoard of silver coins was found about a hundred metres from Cocklaw Castle, Roxburghshire.

Northumberland

In 1735 a magnificent Roman silver platter was found by a nine-year-old girl on the banks of the River Tyne, at Corbridge, near Hadrian's Wall. The artefact was probably part of a fourth-century hoard because other items came to light between 1731 and 1760.

In 1747 fragments of highly ornate silver second- or third-century Roman vessels were found at Capheaton.

In 1975 the Roman Vindolanda Tablets were found near Hadrian's Wall. They consisted of more than 400 pocket-sized slivers of wood on which notes were written in ink.

Tyne and Wear

In the early nineteenth century a hoard of Roman brooches, bracelets, jewelled rings and some 280 coins was found near Backworth, Tyne and Wear.

In 1867 a bronze centre panel and boss from the wooden shield of a Roman legionary were found at the mouth of the River Tyne. The shield, which depicted a bull, was the emblem of the 8th Legion Augusta, a detachment of which served under the emperor Hadrian.

County Durham

A hoard of ninth- to early tenth-century Anglo-Saxon tools was found by fishermen in a stream in County Durham. The tools, used for farming and woodworking, included scythe blades, a sword and a knife.

There are also stories of treasure being hidden away near Durham Cathedral to prevent its confiscation by Cromwell.

Cumbria

In 1785 a tenth-century silver 'thistle' brooch was found by a boy in a field near Penrith, Cumbria. The brooch was substantial, and probably belonged to an owner with wealth and prestige. Other silver brooches have been found on the site, which became known as 'Silver Field'.

In 1855 a labourer ploughing a farm field just east of Carlisle found a pot containing around 11,000 Roman coins.

Humberside

In 1901 two girls playing in the village of Luddington, near Goole, lost a ball in a neighbouring garden. When they went to

retrieve it they found a gold guinea in a flower bed. They returned with their mother and apparently dug up another 40 guineas. Word soon spread throughout the village and people descended on the garden. It is said that several hundred more guineas were unearthed before the local constable arrived.

Yorkshire

A Iron Age hoard was found at Stanwick, North Yorkshire. The hoard consisted of several metallic objects including an ornate formed bronze 'horse mask' drinking vessel.

A tenth-century Viking hoard of ingots, hacksilver and several coins was found at Goldsborough.

In the nineteenth century a hoard of 350 silver coins was discovered near the fish ponds at Fountains Abbey.

In 1870 an Anglo-Saxon gold ring with a royal inscription was ploughed up in a field in Aberford; ninety years later another ring with a similar inscription was found in a cart rut at Laverstock, Wiltshire.

According to legend, precious relics lie hidden somewhere in the limestone rocks near Roach Abbey. In the 1920s treasure including a gold crucifix and caskets was discovered during renovations at Rievaulx Abbey.

In 1932 a pot containing 1,800 silver coins was found by a man digging a cabbage patch in the garden of his home in Elland, and in 1955 at Yearsley, a ploughman dug up a large hoard of coins dating from the Civil War.

In 1964 several hundred bronze Roman coins were found in a field at Swine, near Hull; some twenty-four years earlier a similar hoard had come to light a short distance away.

In 1967 a gold bracelet was found by a farmer in a ploughed field at High Hunsley; an identical one had been found a short distance away in the previous century.

In 1968 two young boys were on a rabbit hunt near to the

village of Bolton Percy. While poking at a burrow they disturbed a broken pot out of which tumbled 1,500 bronze Anglo-Saxon coins.

In 1982 a metal detectorist who was searching a wood near Wyke found a pot containing 700 coins dating from the Civil War. A few weeks later the same detactorist found another hoard from the same period, bringing the total number of coins to over 1,000. A smaller hoard of twenty-seven coins was found in the same vicinity three years later by another detectorist.

In 2003 detectorists found evidence in a hoard of what could have been the first Viking boat burial in England. The hoard consisted of coins, sword fragments and boat nails.

Thirteen pieces of Roman jewellery were recently found by chance in Catton, North Yorkshire.

Lancashire

In 1796 a boy playing behind his home in Ribchester found a mass of corroded metalwork that turned out to be a hoard of Roman military apparel including cavalry equipment and helmets.

It is said that much of the wealth of Heskin Hall was safely hidden away before marauders could breach its defences during the Civil War.

In 1840 a gang of labourers building flood defences alongside the banks of the Ribble at Cuerdale, near Preston, found a hidden hoard of treasure. One of the labourers split open what turned out to be a Viking war chest, which spilled out coins and over 8,000 pieces of scrap silver and ingots. Some locals believe there are more Viking war chests in the area. A hoard of 860 silver coins and a fine-quality cup from the Viking eleventh century was found at Halton Moor.

Cheshire

In 1968 workmen widening a road in a suburb of Macclesfield found an earthenware jar containing gold sovereigns.

In 2001 a metal detectorist found some silver medieval artefacts at Eccleston, and in 2002 an amateur archaeologist found a fifteenth-century silver-gilt crucifix in a farmer's field in Haughton. The 30 mm-long crucifix would once have been worn on a neck chain.

In 2003 a detectorist found a medieval seal ring in Nantwich.

Derbyshire

In 1831 workmen removing gravel from the River Dove in Derbyshire made a remarkable discovery. They began to notice silver coins turning up with every shovelful. Word quickly spread, and at one stage it is said that up to 300 locals were working up to their knees in the water. It's not known exactly how many coins were eventually recovered, possibly as many as 100,000. Some labourers were apparently able to set themselves up as farmers and traders from the proceeds of their finds.

Nottinghamshire

A large chest of gold and gems is said to lie at the bottom of the lake at Newstead Priory, Nottinghamshire. The story possibly has some merit because ecclesiastical relics were recovered from the lake during the eighteenth century.

There are also stories about gold and silver treasure that was hidden away close to Southwell Minster to prevent confiscation.

In 1966 workers on a building site at Fishpool unearthed 1,237 fifteenth-century gold coins, together with items of gold jewellery. It was the largest single hoard of gold coins ever found in Britain.

Three pieces of Roman jewellery have recently come to light in North Nottinghamshire through metal detecting.

Lincolnshire

A single hoard of 47,000 coins was reported to have been unearthed at Normanby, Lincolnshire.

In 1807 a hoard of 5,700 silver coins was found by a ploughman working a field at Tealby.

In 1826 an Iron Age shield was found in the River Witham, near Washingborough just outside Lincoln. The bronze shield featured the image of a boar and had small pieces of red coral on its boss.

In 1885 around 300 shillings and half crown pieces were found in a field at a farm near Boston after the plough horse trod on an earthenware jar.

Leicestershire

In 2003 a beautiful gold pendant featuring a cabochon-cut garnet gemstone was found in the Hinckley area. The metal detectorist who found it was at first convinced it was modern because of its stunning condition, but it was actually from the seventh century and worth several thousand pounds.

Staffordshire

When oak panelling was removed during the restoration of Littleton Hall in Staffordshire, a secret cupboard was found that contained a cache of gold coins. Seven years later twenty-five leather purses containing gold coins also came to light in the house. About the same time a third discovery was made, this time of a large silver chalice on adjoining land.

In 1960 a man gardening at his home in Stoke-on-Trent found a pot containing 2,000 Roman coins.

In 2001 a metal detectorist found a hoard of ninety-two silver and two gold coins in Tamworth.

Shropshire

An exquisite second-century silver mirror was discovered during the excavation of a Roman city a few miles southeast of Shrewsbury.

A couple of years ago a metal detectorist found three 3,000-year-old bronze axe heads in a field near Rednal, Oswestry.

A seventeenth-century gold ring was recently found near Halfway House, Shrewsbury, and twenty Roman coins were discovered at a farm near Market Drayton.

Flintshire

Maen Chwyfan, a 3.5-metre-tall Celtic monument in Flintshire, is said to mark the site of buried treasure. According to legend, over the centuries several attempts have been made to recover it, which have apparently always been thwarted by lightning and thunderstorms.

For hundreds of years it was said that a huge gold-coloured ghost haunted a barrow in Mold. The story seems to have had some merit because in 1833, workmen quarrying for stone found a grave that contained a gold cape and hundreds of amber beads. The 4,000-year-old cape, which is now housed in the British Museum, remains a unique example of prehistoric sheet-gold workmanship in Britain.

In early 2004 three metal detectorists found a hoard of fourteen pieces of Bronze Age gold and bronze jewellery and pottery including bangles, bracelets and necklaces near Wrexham. The hoard is estimated to be worth hundreds of thousands of

pounds. Two years previously another hoard of Bronze Age treasure was found in the area.

Denbighshire

Moel Arthur, a tall grassy knoll situated in proximity to the road between Nannerch and Llandyrnog, is said to be the site of the grave of Queen Boudicca.

Another story tells of gold treasure buried in the area, which is guarded by a Bronze Age prince who it is said uses strange lights and sudden storms to thwart treasure hunters.

Gwynedd

In 1890 a chalice and bowl dating from around 1250 AD were discovered by accident buried alongside a road in Dolgellau.

Powys

In 1958 four gold torcs were unearthed beneath a pile of slabs near a derelict farmhouse at Cefn, Llanwrthwl. In the same year a man passing by a nearby spring found a Bronze Age earring.

Ceredigion

A 4,000-year-old gold sun-disc, worn for religious ceremonies, was discovered by chance recently at Cwmystwyth Mines near Aberystwyth. The find, which is unique to Wales, was said to be as historically significant as the gold cape found at Mold.

Pembrokeshire

In 1996 a hoard of 467 silver and 33 gold coins together with a gold ring from the time of the Civil War was discovered in Pembrokeshire. The hoard came to light when metal detectorist Roy Lewis was asked to scan spoil heaps during the construction of a tennis court at Tregwynt Mansion near Fishguard.

A ten-year-old schoolboy found a medieval ring while out metal detecting with his father in a field in Pembrokeshire. His father commented that this was only his son's second time out detecting, and that he now thinks finds grow on trees.

Carmarthenshire

While contractors were laying pipes at Capel Isaf, Manordeilo in 1975, four gold bracelets were found buried beneath a large boulder.

Swansea

A metal detectorist recently found a 1,000-year-old gold-plated Bronze Age ring on the foreshore at Swansea. The ring was declared treasure trove and put on show at the National Museum of Wales.

Recently, a unique eighteenth-century silver brooch was found nearby by another detectorist.

Glamorgan

There is a story about a professional wrecker who worked somewhere around Dunraven Castle. His tactics included using lights near to the shoreline to lure ships to their doom, but one day he found his own son dead amongst the wreckage of a vessel.

Archaeological evidence has long confirmed that in ancient

societies it was the tradition to leave material offerings to the gods. Llyn Fawr has been found to contain several Bronze Age weapons such as axes.

A metal detectorist recently discovered a ninth- or tenth-century ring at Barry, and another found a thirteenth-century silver brooch in St Bride's Major.

Cardiff

The present Castle Coch at Tongwynlais is built on the site of a much older fortress. There is a local story about a ghost of a cavalier who roams the area looking for a hoard of gold. Another story, possibly connected, tells of a hoard of treasure that was hidden in an underground chamber by the warrior Ifor Bach.

Monmouthshire

One of the largest signet rings ever discovered in Britain was found in 1998 near Raglan, Monmouthshire. The fifteenth-century ring, which once belonged to a wealthy owner, was made of solid gold and designed to fit over a glove.

A Roman bronze cup featuring a leopard handle was found by a metal detectorist in Abergavenny.

Worcestershire

When a section of St Michael's Church, Abberley, Worcestershire was demolished, five medieval silver spoons were found concealed in the north wall.

Fifteen Roman coins recently dug up at Chaddesley Corbett are thought to be connected to a hoard of 419 coins found there in 1999.

Gloucestershire

There is a story from the seventeenth century about two men who found urns full of coins in a Bronze Age barrow near Cirencester. In one of the chambers they heard a groan, and a pair of embalmed hands extinguished the lamp. The startled men fled, the roof collapsed and all traces of what they had seen were buried.

During the nineteenth century, a hoard of more than 17,000 Roman bronze coins was found secreted beside the River Wye.

Recently a man found a pot containing a hoard 20,000 Roman coins while digging a pond at his home in Thornbury, south Gloucestershire.

A couple recently turned down the offer of a £1,200 reward for finding a gold leaf buried in the 24,000-acre Forest of Dean to attract tourism. The gimmick was similar to the puzzle set in the novel *Masquerade*, which sparked a nationwide hunt in the 1980s for a buried golden hare.

Oxfordshire

There is a legend that tells of buried treasure on Sinnoden Hill, Little Wittenham, in Oxfordshire. This treasure is said to have be hidden during the Roman occupation in an area called the money pit. One day a villager was digging in the pit, when he came across a chest with intricate workmanship. He was startled by a raven and it is said that being superstitious, he reburied the chest and returned home.

In 1940 a man and his wife were out walking their dog beside the River Thame, near Lammetts Hole. Something shiny caught their eye, and among the dredging debris they discovered five gold rings and some silver coins. It is thought that the treasure came from Thame Abbey and dated from the sixteenth century.

There is report of a hoard of 126 gold Roman coins found

buried near Didcot. Recently, a detectorist found a bronze coin in a field in Oxfordshire that featured the head of a Roman emperor who ruled for just four days. Because of the rarity of the coin it was valued at £10,000.

Buckinghamshire

During the nineteenth century a gold buckle was among items recovered from a burial mound at Taplow, Buckinghamshire. The sixth-century AD buckle featured several cabochon-cut garnet gemstones.

Two gold torcs and three bracelets dating from the late Bronze Age were also found by two metal detectorists near Milton Keynes.

Northamptonshire

In 1876 while workmen were digging for ironstone in Desborough, Northamptonshire they disturbed a number of graves. The richest one contained a necklace that featured several cabochon-cut garnets and gold beads. The necklace is the finest of its kind surviving from Anglo-Saxon England.

Hertfordshire

An Iron Age mirror was found by a farmer ploughing at Aston, Hertfordshire. The mirror, which was probably placed in the cremation grave as an offering to the gods, was damaged and recovered in two separate pieces a year apart.

In 1743 a hoard dedicated to a Roman god of war was discovered at Barkway, Hertfordshire. Another Roman hoard of gold and silver treasure was found at Baldock.

The British Museum recently paid £50,000 for a silver gilt statuette discovered in Buntingford.

Cambridgeshire

In 1694 a hoard of coins, gold rings and a silver brooch was discovered during ploughing in a field near Ely. The ornately decorated brooch stated not only who owned it, but also cursed anyone who took possession of it unless it was by free will.

It is said that the Abbot of Peterborough threw some of the abbey's treasure into Whittlesey Mere in Huntingdon to prevent it being seized by Cromwell. This story appears to have some merit because during the nineteenth century an eel fisherman netted a haul of silver and pewter dishes from the water.

A bronze ceremonial sword scabbard was recovered from the River Lark at Isleham. The Iron Age scabbard was engraved and once contained a long sword.

In 1959 a hoard from a Bronze Age foundry was discovered at Isleham. The hoard consisted of axes, spearheads, knives, hammers and decorated mounts.

In 1974, 200 metres from the A1 at Water Newton near Peterborough, a covered bowl was discovered that contained a leather purse wrapped in silver plate containing thirty gold Roman coins. A year later a metal detectorist found nine pieces of early Christian silver tableware in the same field.

In 1982 a hoard of 872 silver coins from the Iron Age Iceni Tribe of East Anglia was found in a pot in a field near March.

In 1989 more than 300 Bronze Age artefacts came to light at Flag Fen, near Peterborough.

There is a story about a scientist who worked on the German Enigma Codes at Bletchley Park during the Second World War. Worried about the outcome of the war he apparently put his life savings into two large silver ingots and buried them in a nearby wood. After the war he went to retrieve them, but the markers he had left had been lost. He failed to locate the ingots even with the help of a crude metal detector, and died soon afterwards.

Norfolk

Years ago, when Callow Pit, at Southwood, was filled with water it was said a chest of gold lay in its depths. According to legend, two brave men attempted to retrieve it, but the pit filled with a choking sulphurous mist and a black hand appeared from the water to reclaim it.

Gate Pond, near Coltishall, is said to contain the golden gates from the Church of St Mary at Hautbois, ransacked during the sixteenth century.

In 1815 a Viking shield, a gold torc and a hoard of coins were found by a farmer ploughing a field at Barney.

In 1844 a hoard of second- to third-century religious artefacts was found buried in a pot at Felmingham.

In 1879 a large, square Roman silver dish was found at Mileham. Other similar dishes have been found in Britain, but they are generally made of pewter, a cheaper substitute.

On a bleak winter's day in 1947, a farm labourer began work ploughing a field on Ken Hill, in Snettisham. He stopped the plough and found what he thought were pieces of an old brass bedstead, and put them aside to prevent them damaging machinery, thinking they may be worth a little as scrap. Several days later a local historian saw the pieces of metal and brought them to the attention of an archaeologist. What the labourer had actually found were several solid gold torcs and other fragments of gold. A full-scale archaeological excavation was mounted in the area, but unfortunately nothing else was found. It wasn't until three years later that more ploughing unearthed another cache of torcs, and over subsequent years some 450 gold items including ingots and coins have come to light in the area. An unconnected Roman hoard of a considerable quantity of scrap silver and gold was found in Snettisham in 1985, as a result of construction work.

In 1962 four first-century AD Roman silver drinking vessels were found in Hockwold cum Wilton. The cups had been delib-

erately crushed into bullion before burial, but have since been skilfully restored by experts.

A hoard of buried silver brooches was found by grave diggers at Pentney in 1977 – the delicately cut brooches date from the early ninth century.

In 1979 a hoard of Roman gold jewellery and gilded silver tableware was discovered near Thetford. Among the treasure was a large, engraved carnelian gemstone.

In 1988 a man walking in woods near Oxborough literally stumbled upon a ceremonial Bronze Age sword that had been thrust into the soft, peaty earth.

In 2001 a detectorist found a small hoard of twenty-two silver Iron Age coins, and another detectorist found a piece of medieval silver jewellery set with rubies.

Suffolk

One of the most famous treasure hoards in Britain was recovered from a ship burial at Sutton Hoo near Woodbridge. The finds, which are too numerous to mention here, date from the seventh century and form one of the most important collections in the British Museum.

There is a legend centred around the abbey at Bury St Edmunds. Edmund was an Anglo-Saxon king, and it is said that following his murder he was buried with a 30-cm-high, solid gold, jewel-encrusted statue of an angel, but nobody knows where.

A hoard of 475 particularly rare medieval coins was recently unearthed by a group of metal detectorists searching in Suffolk. Estimates put the value of the hoard as high as one million pounds.

A heavy bronze first-century Roman gladiator's helmet was found in Hawkedon – it is thought gladiatorial games were held just 20 miles away at Colchester.

In 1780 a large hoard of Roman coins including 500 gold examples was discovered near the village of Eye. Interestingly, the find spot was not far from that of the famous Hoxne Treasure, which was found by metal detectorist Eric Lawes in 1992 (*see page 25*).

In 1867 a pair of matching gilt bronze Viking brooches together with a sword were found at Santon Downham. The oval brooches were worn in pairs to fasten an outer cloak.

In 1907, a head that was part of a life-size bronze statue of a Roman emperor was found in the River Alde at Rendham. The statue was of Claudius, who succeeded in conquering Britain, and it may once have stood at Colchester.

Another bronze head of an emperor was found in 1834 in the River Thames near London Bridge. This time it was of a head of Hadrian, who built the wall across Britain.

In 1942 a labourer called Gordon Butcher was ploughing a field on a farm at Mildenhall. He stopped the plough and unearthed a large round dish. Beneath it he found plates, bowls, cups and other tableware. After cleaning the artefacts Gordon realised they were made of solid silver, and between them weighed a colossal 25 kilograms. The largest dish weighed eight kilograms by itself, and depicted an image of a sea god surrounded by attendants. The finds languished in the labourer's kitchen for four years until they eventually came to the attention of the authorities. The priceless hoard became known as the Mildenhall Treasure, and was claimed by the Crown. This was during a period before our modern treasure laws, and the finder received just £1,000 as a reward. As a final insult he was told he was lucky not to be facing prison for failing to declare it. A recent story has come to light that an ornate cup that was part of the original hoard has since gone missing.

On the outskirts of Ipswich, a man began to create a garden at his new home on a recently built estate. He unearthed a solid

gold torc, and several more were later found by a JCB driver. The torcs were valued at £9,000 each in 1968.

In 1999 an ornate 900-year-old silver cross was discovered at Thwaite. The religious relic had a loop at the top and was worn around the neck, possibly by an abbot or nobleman. In the same year a piece of Victorian costume jewellery incorporating three gemstones was found by a metal detectorist at Debenham. Ten more pieces of historical jewellery have been brought to light in Suffolk over recent years by various metal detectorists.

In 2001 a hoard of Bronze Age artefacts belonging to a founder was found in North Tuddenham. The hoard, which comprised eighty-two pieces in all, included spear and axe heads, parts of swords and knives, tools and moulds.

Essex

Local folklore states that Lexden Barrow, near Colchester, is the grave of King Cunobelin, who is mentioned as Shakespeare's *Cymbeline*. The royal burial site was said to contain armour and a table fashioned of gold, and interestingly in 1924 archaeologists excavated the site and found armour, gold cloth and a table made of bronze.

A hoard of Iron Age or Roman blacksmith's tools was recovered from the River Lea at Waltham Abbey. The tools, including tongues and pokers, were deliberately damaged before being placed in the river.

In the nineteenth century a hoard of coins was found by a farmer while he was ploughing a meadow in Bumpstead. In 1930 gold coins were also discovered in a ploughed field near the Manor House at Elmstead.

A hoard of eighth-century silver pennies was found at Woodham Walter.

In 1902 workmen on the site of a new bank in High Street, Colchester found 12,000 thirteenth-century silver pennies,

thought to have once belonged to moneylenders. In 1969 two more workmen working on another site in the same street found another 14,000 silver pennies hidden in a lead bucket.

Three pots of Roman coins were unearthed within metres of each other at Oliver's Orchard Farm in Colchester in 1983. In total over 6,000 coins were found, which had been buried over a period of three years.

In the 1980s a man walking beside a stream at Ashdon, near Saffron Walden, chanced upon a single silver coin. The find eventually lead to the discovery of 1,200 coins dating from the Civil War.

Just a couple of days after taking up metal detecting, Tony Calver found a Henry VIII gold coin. This was not a particularly unusual occurrence in the scheme of things, except that in this instance the coin was unique, and sold for £25,000.

Middlesex

In 1864 labourers found an Iron Age treasure hoard in Hounslow, Middlesex. The collection consisted of several bronze figurines of animals such as boar and dogs.

It is said that Middlesex yielded as many as seven separate coin hoards to various ploughmen during the 1860s.

London

Several Iron Age shields have been found in Britain. In 1851 a bronze shield was recovered from the River Thames at Battersea. The shield, which was deliberately placed in the river, was hammered in relief and patterned, and featured decorative enamelled studs.

A sword and sheath issued to a Roman legionary during the first century AD was found in the River Thames at Fulham.

In 1848 a large, elegant iron spearhead was found in the

Thames. It was Viking in origin and featured a herringbone inlay of twisted silver and copper wires.

In the 1860s a horned helmet was recovered from the Thames at Waterloo Bridge. The helmet was made from sheet bronze and was the first Iron Age example to be found in southern England.

A fabulous hoard of jewels and other treasure was found hidden in Cheapside in the seventeenth century – some pieces featured sapphires, opals and diamonds.

A hoard of bronze, pottery, glass vases and bottles was recently uncovered by a metal detectorist on the outskirts of London, in what is thought to have been the grave of a wealthy Roman.

Historical children's toys such as figurines made from pewter or copper alloys from the fourteenth to eighteenth centuries have been found on the mud banks of the Thames. Treasure hunters are up against competition here, however, since there is a Society of Thames Mudlarks.

Kent

In 1737 a boy playing in a coppice adjoining Tunstall Hall found a hoard of over 600 gold coins.

In 1886 the grave of a wealthy Briton, who had been alive when Julius Cesar invaded England in 55 BC, was unearthed at Aylesford Cemetery, near Maidstone. The grave contained several important bronze artefacts.

In 1849 a ploughman found 200 gold coins in a field at Rainham, and in 1968 a hoard of 400 hammered silver coins was unearthed on the Isle of Sheppey. Two other hoards totalling 500 coins dating from the Civil War have since been found at Catford and Lewisham.

A four-year-old boy, probably the youngest treasure finder in history, found a rusty tin in the hollow of a pear tree while

playing near his home in Tadley. The tin contained twenty-one gold guineas and half guineas.

An off-duty policeman metal detecting on an unmapped track in Ashford recently found a single Roman coin valued at £7,000.

At Hollingbourne a cache of Bronze Age weapons was recently found by another detectorist.

Sussex

A gold coffin is said to lie buried beneath the Long Man of Wilmington, and a silver one is reputed to be buried on Firle Beacon, Sussex.

In 1836 a ploughman unearthed several gold torcs in a field at Mountfield. How the treasure actually came to light is uncertain – the ploughman sold it to a scrap dealer for six shillings thinking it was made of brass.

Hastings, synonymous with the battle of 1066, has been the site of several hoards of coins hastily hidden away.

In 1866 several thousand coins turned up at a farmer's field at Storrington, and another hoard was found on a farm in Sullington.

In 1876 a labourer from Sedlescombe found 3,000 newly minted coins and a silver ingot in the area.

In 1940 a well-preserved iron Roman sword and scabbard end, together with some coins, were found in what was probably a soldier's burial site at Pevensey.

In 1932 a man digging a potato patch in his garden found an urn containing around 1,000 silver Roman coins.

In 1959 a schoolboy found some broken pottery on a farm on the outskirts of Lewes. The boy had heard a story about some coins that had been found there some twenty-five years earlier, and decided to take a closer look. His instincts paid off, for he found a hoard of 600 half crowns.

In 1999 a metal detectorist searching in Chiddingly, East Sussex found a boar that had once been gilded with silver. It was in the form of a badge, which had been worn on a cap once owned by a nobleman, a supporter of Richard III.

Surrey

In 1983 two metal detectorists discovered a Romano-Celtic temple at Wanborough, Surrey. The site had unfortunately been looted, but archaeologists were still able to recover over 1,000 Iron Age and Roman coins and other artefacts.

In 1985 a digger driver excavating gravel from the River Thames at Chertsey found a Iron Age shield. The Celtic shield, made from nine separate pieces of bronze, was unique to Britain and the rest of Europe.

Berkshire

A golden coffin is said to lie beneath Beedon Barrow in Berkshire. According to legend, when a barrow is disturbed the gods become angry and invoke violent storms, which is apparently what happened according to some nineteenth-century treasure hunters who were looking for the coffin.

Several pieces of prehistoric gold jewellery were recently found by a metal detectorist at a rally in Berkshire. The pieces just looked like wire and were nearly thrown away, but it turns out that they could be worth several thousand pounds.

Hampshire

A golden effigy is said to lie beneath Angledown Copse, a barrow in Hampshire. According to local folklore, treasure hunters abandoned a search for it after a headless horseman appeared at moonlight.

An ancient trackway called Maulth Way once ran from Winchester though Crondall and Aldershot Common. It has been the site of one recorded treasure hoard, and Anglo-Saxon gold coins have since been found there by locals.

Much of the treasure of Hartley Manor is said to have been hidden nearby before it could be seized by invaders during the Civil War. Some was rediscovered in the eighteenth century, but a hoard of coins is apparently still missing.

A hoard of about 250 silver coins was unearthed on the grounds of a farm near Itchen Abbas. It is thought that the coins were buried by retreating Royalist troops following the Battle of Alresford in 1644.

Four Roman hoards, one of which consisted entirely of gold coins, have been reported to have been found by ploughmen working throughout Hampshire during the 1850s.

The grounds of Blackmore House in Selborne have yielded a number of coin hoards over a period of 141 years. In 1741 a pond dried out, revealing a pile of Roman coins that had been placed there in a sack. Three years later the pond dried out again, and two young boys discovered an urn full of coins. In 1867 a second urn containing 100 silver coins was discovered, and six years later gardeners working a couple of hundred metres from the pond unearthed two massive pots that between them contained 30,000 Roman coins.

Wiltshire

There is an old report of a hoard of 56,000 coins being discovered somewhere in Wiltshire, and other coin hoards have been found at Stanchester, Bishops Cannings, Bromham, Castle Copse and Chisbury.

In 1910 a builder who was working on alterations to a house in Winterslow was digging a trench when he unearthed a jar full of coins. The builder's honesty has never been in question, but

the house owner was standing over him at the time, and he happened to also be the village bobby.

In the 1930s a thirteen-year-old boy walking a field while working as a beater on a shooting party picked up what he thought was a flint stone which split open, and inside were sixty-five gold Celtic coins. Some fifty years later a metal detectorist heard of the story, identified the location and obtained permission to search, and over a period of several days found a further fifty-three gold coins.

In the 1980s a hoard of Bronze and Iron Age artefacts came to light at Netherhampton, near Salisbury. The hoard consisted of miniature artefacts such as shields, tools and weapons; interestingly, some of the artefacts were already 2,000 years old when they were buried.

A pot containing eight miniature Roman statuettes was found at Southbroom, Devizes in the early eighteenth century.

A number of Roman silver coins, rings and other artefacts have come to light on farmland at Bowerchalke since 1992.

A hoard of 1,200 gold, silver and copper Roman coins, which was found in a pot by a schoolboy, have recently been bought by Wiltshire Heritage Museum for £50,000.

Dorset

During the Civil War, the then keeper of Corfe Castle in Dorset, Lady Mary Banks, is said to have thrown her jewels down the castle well to prevent them from being seized by the Parliamentarians.

In 1983 a farmer ploughing a field near to the village of Pulham chanced upon a medieval gold coin. He borrowed a metal detector from a friend and found a further ninety-nine coins, including some very rare examples from a hoard that had been dispersed across the field during 500 years of ploughing. The coins were auctioned at Christie's and realised £63,000.

In 1990 a detailed gold and glass manuscript pointer or eye guide dating from the late ninth century was found at the foot of the cliffs at Bowleaze Cove, near Weymouth, as a result of a landslip.

In 2001 a metal detectorist found a small hoard of sixteen Iron Age coins in Tarrant Valley.

Somerset

There are many sites around Britain where it is said the Holy Grail is located, one of which is at the bottom of Chalice Well, sited in the grounds of Glastonbury Abbey. According to legend, the Holy Grail is said to have been the vessel from which Jesus Christ drank at the last supper. One version is that Joseph of Arimathea used the cup to catch drops of blood from Christ as he lay on the Cross, and Joseph brought the cup with him when he travelled to Glastonbury. During the sixteenth century much of the treasure from Glastonbury Abbey was hidden away by the monks. Much of it was eventually given up under torture, but it is said that some sacred relics were secreted to somewhere in South Wales.

In 1661 an audience was granted to two individuals who informed Charles II that a vast hoard of gold, silver and jewels lay hidden in or near the village of East Monkton. The King granted permission for them to search in return for one-quarter reward, but it is said that the hoard was never found.

In 1693 a golden jewel was found a few metres from the junction of the Rivers Parrot and Thone at Athelney. The jewel, a reading pointer, is believed to have belonged to King Alfred the Great. The artefact was enamelled and made from solid gold, and is inscribed with the words 'Alfred Had Me Made'. The animal at the head of the pointer once had a stem attached. It is thought the jewel was hidden away during a period when ecclesiastical wealth was being plundered.

A rare brooch from the second half of the eleventh century was found in a churchyard in Pitney. The cast-bronze openwork brooch depicts a snake biting a four-legged animal which is in turn biting itself.

A hoard of either Iron Age or Roman horse harnesses and fittings was found at Polden Hill. The fittings, made from bronze, were cast already interlocking and elaborately decorated.

Devon

While digging a drainage channel at his farm to the south of Exmoor, in Devon, a man found a bronze bowl dating from the Iron Age. The ceremonial bowl had been beaten from a solid piece of bronze, and was undoubtedly left as an offering.

There is a story of a hoard of coins that is supposed to lie buried in an orchard at East Worlington. The story arises from a reference apparently made by the orchard's owner to his family on his deathbed, but the hoard was never found.

In 2003 a metal detectorist found a thirteenth-century gold brooch on farmland, and in early 2004 another detectorist found the scabbard of a fourteenth- or fifteenth-century sword or dagger at Dartmouth.

Cornwall

King Arthur's sword Excaliber is said to lie somewhere near Dozmary Pool, a stretch of water on Bodmin Moor. According to legend the wounded Arthur twice asked his faithful knight Sir Bedevere to cast the weapon into the water, but Bedevere couldn't bring himself to do so, and instead hid the sword and returned to the King.

Veryan Beacon is said to be the grave of a Cornish king named Gerennius. He was brought to his resting place by a

golden boat rowed by silver oars, which it is said is buried with him.

It is claimed that two kings lie in gold coffins beneath round barrows near Warleggan. As the story goes, should any treasure hunters try to dig them up they will be set upon by a flock of fierce birds.

Just north of Land's End is a place called Priest's Cove, an area where a notorious wrecker used to work. Some of his gang's tactics involved using false lights to lure ships onto the rocks. The seamen were put to death, the cargo seized and all evidence of the crime was washed away by the next high tide. It is said that treasure lies hidden in underground passages and caverns in proximity to Trethevy Manor and the surrounding cottages at Tintagel.

In 1818 the Rillaton Cup was discovered by a tin miner in a burial mound in Cornwall. The ancient cup, beaten from a solid block of gold, was a unique discovery to Britain until a similar one was found in 2001 at Ringlemere, Kent by detectorist Cliff Bradshaw.

In 1833, while a new road was being constructed across the Trelan estate in west Cornwall, workmen found a number of Iron Age graves. The artefacts recovered included a mirror, brooches, rings and bracelets.

In 1884 six gold Bronze Age bracelets were found during quarrying at Morvah.

Other Types of Treasure

THIS CHAPTER HAS been reserved for treasure that doesn't fit obviously into any of the other chapters, as well as for other ideas that I might have covered. When you start this sort of project people tend to make suggestions, which is of course appreciated – but some of these have been more sensible than others. They range from the proposal that uranium is a far more valuable commodity than anything else I could possibly be including, through to other suggestions that actually warranted consideration.

Categories of treasure included

Oil is a case in point. Probably like most people, I thought that in Britain oil was only found in the fields in the North Sea. In fact there is actually a string of onshore wells complete with Texas style 'nodding donkeys' in Dorset, Hampshire, Surrey and Sussex, producing about 40,000 barrels a day. Sadly, the only way to make an oil strike in Britain is by drilling. Had there been the slightest hint of 'up from the ground came bubblin' crude', oil would have been in.

Saffron was also mooted. It is valuable, of course, but so is all

farming. Orchids, as someone pointed out, grow wild, but many are protected species. Truffles, however, have been included.

Metals have been more difficult to decide upon. Many metals are quite valuable, but I've had to decide which ones were relevant to the treasure hunter, rather than for commercial exploitation. Many nonferrous metals have historically been traded for good money, but looking for them – taken to its logical conclusion – would have meant having to include scrap-metal dealing. I decided to draw the line at things most people are happy to wear next to their skins.

Finally, there are the wild cards, three of which I have included. Prehistoric treasure turns up occasionally, and can be found by anyone with a sharp eye from the age of five upwards. Then there are meteorites, which are literally worth a million pounds or more in some cases. The technique of dowsing has also been included here; it may not be something that will always find you treasure, but it could save you a fortune on excavation costs.

Silver

'There's silver in them thar hills.' This is a phrase that was originally written about gold, but it doesn't have quite the same resonance when the word silver is inserted instead of gold. The word silver derives from an old English term, seolfor, meaning lost, which in a modern context should probably refer to its value. The world price of silver is currently just £3.43, which is about one-hundredth the price of gold, barely even qualifying it as a precious metal. Silver's price peaked at ten times this in the 1970s, and speculators are apparently hoping for a revival.

The upside of silver is that it is an extremely versatile metal, used extensively in jewellery, and it is also an important constituent of photographic processes and some scientific

equipment. Modern British silver is 925 parts pure out of 1,000, and like gold it is measured by the troy ounce. Millions of ounces of silver have been mined in Britain throughout the centuries, and there is a fair amount of information on record. Given the effort to retrieve it and the returns (*see page 253*), however, only an overview of it is included here.

What is silver?

Silver is a nonferrous metallic element with the chemical symbol Ag. Silver has the highest electrical and thermal conductivity of any metal, and is the most malleable with the exception of gold. It is a commodity with a traceable history that goes back almost as far as gold, 5,000 years. In Britain the Romans added lead and silver to their invasion shopping list along with other metals such as tin, copper and gold. At one point during the occupation, Britain was the largest supplier of both silver and lead to the Roman empire, although Caesar was said to have been disappointed at the quantity of silver recovered from Britain.

Silver can be deposited freely, but it is more usually associated with other ores such as zinc, copper and particularly lead, which has an even more extended history, spanning 8,000 years. Post-Romanic silver mining in Britain dates from the 12th Northern Pennine mines, and has continued throughout the centuries in Wales, Scotland, Devon and Cornwall. From the mid eighteenth century silver mining was still big business in Britain and it only ceased comparatively recently. The price of lead, the major source of silver, plummeted in the 1870s due to enormous deposits being discovered elsewhere in the world.

How is silver recovered?

The lead mines throughout Britain have historically been the principal sources of silver. Once again it was the Romans who led the way, passing on techniques for extracting silver from

lead. The process was briefly as follows. The ore is first smelted to separate the lead, which is then poured into clay moulds forming ingots called pigs. The pigs are then placed into shallow hearths and heated to around 1100 degrees Celsius, the temperature at which silver melts, and the silver is separated and drawn off. Silver–lead ratios were generally high in Britain – several hundred ounces per ton in some instances.

Lead mining was a dangerous occupation, not least because lead is toxic, but also particularly following the invention of gunpowder. Miners would typically work in pairs. One would hold a chisel that another struck with a sledgehammer to produce holes in which charges were placed. Following the explosion, the miners would return to an often unstable environment to break down the loose rock and take the ore to the surface for processing.

Silver mines in Britain

One of the earliest recorded silver-mining operations in Britain is documented in the Doomsday Book. It records a small but thriving silver-mining industry along the west coast. There have been several other areas around Britain where silver has been extracted, including Alderley Edge in Cheshire, Stanton under Bardon in Leicestershire, and even the Isle of Anglesey and the Isle of Man.

Incidentally, several hoards of silver have been discovered on the Isle of Man, although these were unconnected with the silver mines. A 1,000-year-old hoard was recently discovered by metal detectorist Andy Whewell lying buried in a lead container. The hoard consisted of 464 coins, 25 ingots and an armlet, all of Viking origin.

The four major silver-producing areas in Britain have historically been the southwest, Wales, the northwest and Scotland. Locations where mines have existed include, Devon: Budleigh Salterton and the Tavistock districts; Cornwall: Callington,

Camborne, Liskeard, Mount's Bay, St Agnes, St Austell, St Just and the Wadebridge districts; Wales: Ceredigion; the northwest: Caldbeck Fells and the Braithwaite District; Scotland: Clackmannanshire, West Lothian, Ayrshire, Lanarkshire, Renfrewshire and Perthshire. Old workings are still evident in some locations.

Devon and Cornwall

Following early workings in the northwest, silver mining began to focus on Devon, and in particular around Bere Alston in the south. Between the late thirteenth and sixteenth centuries there were several mines in the region that collectively dominated British silver production, but mining there ceased briefly during the mid fourteenth century because of the onset of the plague and the ensuing lack of labour. Before this, production peaked with output some years exceeding 20,000 ounces, although the average was around a tenth of this.

During the sixteenth century there was a short-lived revival of silver mining situated around Combe Martin in north Devon, but by the latter half of the sixteenth century more productive mines had been discovered in Wales. Silver mining continued unabated throughout the southwest, and one report suggests that during the mid nineteenth century Cornwall was responsible for around a third of Britain's silver output. By 1872, however, the emphasis on lead–silver production had switched to the Isle of Man, and within ten years total Cornish silver production had fallen to just 10,000 ounces a year. In 1887 it ceased altogether.

Wales

Wales has a centuries-long silver-mining tradition. In 1638, under Charles I, a new mint was established in Aberystwyth to accommodate output from five Welsh silver mines. A plume of feathers was used to denote provenance on coins struck from silver

produced in the area. One mine that dated from the early seventeenth century was producing £24,000 worth of silver a year.

One of the principal sources of Welsh silver during the mid eighteenth century was the Llywernog Mine in mid Wales, about fifteen minutes' drive from Aberystwyth. First developed in 1742 during the reign of George III, early workings consisted of just two shafts, but by 1790 two further tunnels had been cut into the hillside, one of which struck the main lode. By the beginning of the nineteenth century, 'Pool's mine', as it became known after one of its leaseholders, William Poole, enjoyed a boom period employing sixty miners, and the lead alone was realising £19 a ton. The mine continued to produce lead and silver throughout several ownerships until it finally closed at the end of the nineteenth century. In 1973 the old mine reopened as a museum, which is still open today.

The Northwest

The north Pennine region has a rich silver-mining history dating back to the twelfth century, although there is now evidence that the Romans were there a thousand years earlier as ingots dating from that period have been found hidden in the area. During the 1130s and the remainder of the twelfth century, the region's total silver output is estimated to have been two million ounces. Following a climactic period of development decline quickly set in, and by 1212 production was said to be down to just 700 ounces.

Although the region around Alston Moor in Cumbria has historically been a significant producer of silver, little is known of the exact locations of these earlier workings. In later years the lead mines in Weardale and Allendale were also found to be rich in silver, and were worked extensively throughout the nineteenth century. One mine in particular, Allenheads, situated between Stanhope and Alston, was at one time said to be the largest silver mine in the world. It closed in 1896.

Scotland

The Scottish lead–silver mines have been historically linked with gold extracted from the region. Thomas Foulis, who was granted permission to mine for gold and silver by King James, engaged Bevis Bulmer to work the lead–silver mines of Leadhills. Bulmer, however, was more famous for making the greatest gold strike in Scottish history. In the early 1600s, a silver deposit was discovered in Hilderston, West Lothian, and the Leadhills become the most lucrative source of silver in Scotland. Between 1845 and 1919, 23 tons were recovered. The Alva silver mine in Clackmannan in the central region ran intermittently between 1715 and 1768 producing 5 to 6 tons of silver.

There is a story about an immigrant miner called Old John Taylor. He lived in several locations, including the Leadhills, where he eventually died in 1770, and despite contracting scurvy it is said that he lived to be 133 years old.

Scottish lead ore was richer at Wanlockhead than at Leadhills and the refinery ran there until 1910. One mine, the New Glencrieff, even briefly reopened in the 1950s. The Wanlockhead lead-mining museum is now open to the public.

Can treasure hunters still recover silver today?

The simple answer is no. From a treasure hunter's point of view, the process of extracting silver from lead by conventional methods is dangerous. Silver can sometimes be collected in mineral form, and any commercial value would be as a sample. But I say this with some reservation: the only two specimens I could find for sale were one from Wales (20 by 10 mm) with silver crystals, which was on sale for £6, and another from elsewhere selling for £4. Specimens have been recovered from locations around Britain, but they are few and far between, and the crystals themselves are tiny, less than 5 mm in most cases and microscopic in others.

The source that has produced the most silver specimens

historically is the Alva Mine at Clackmannan in the central region of Scotland. Mineral hunters used to scavenge the old spoil dumps, but there is apparently nothing left, and the place is anyway now out of bounds. The seventeenth-century Hilderston silver mine, Linlithgow in West Lothian, was another known location. Again, samples have been recovered there, but little is now left. Other areas where specimens have been recorded include the Callington District and Camborne, Redruth, Cornwall, and the Frangoch Mine, Ceredigion, Wales. Microscopic samples have in addition been recovered from New Cliff Hill Quarry at Stanton under Bardon, Leicestershire.

Platinum

Here is an interesting fact. Go into any jeweller's and ask for prices for three rings, to be made in silver, 18-carat gold and platinum. It will cost about seven times more for a ring to be made in gold than in silver, and two-thirds more for it to be made in platinum. Here's the interesting part – as a rough guide, platinum is only 50 per cent more expensive than gold, yet gold is nearly a hundred times more expensive than silver. Obviously you have to factor in the jeweller's labour, but it is odd, isn't it? Anyway, this has nothing whatsoever to do with the precious metals found in Britain, and in particular the high-priestess of them all – platinum.

In the many books, articles and papers that I unearthed while doing my research, in particular for the chapter about gold, I picked up a few snippets of useful information about silver, which from the treasure hunter's point of view is even more difficult to find. I didn't, however, find any information whatsoever about platinum. In fact, I wasn't even aware that platinum had ever been recorded in Britain until I came across one short paper on the subject. But it has – just. You can put

your chipping hammer down, because I can assure you that the account of platinum in Britain is extremely brief.

The group of several elements known as the platinum metals contains platinum as its most prominent. Platinum is rarer than gold, and 3 to 6 grams per ton of ore is considered a good average deposit. This is reflected in the world price, which is currently £470 an ounce. Platinum is traditionally mined in South Africa and the Soviet Union, although it is also found in Canada and the US. Besides being used for high-quality jewellery, of course, half the world's annual platinum supply goes into industry, particularly into catalytic converters that control vehicle pollution; as a result of current legislation demand for platinum has grown faster than supply over recent years.

Now here's the British bit – and don't blink or you'll miss it. In 1999 platinum was identified in stream sediments by scientists working on the Isle of Rum in the Inner Hebrides, Scotland. The sediments were traced back to their source, and seams 10 mm thick hosting metals from the platinum group were identified. This size of deposit was only one-tenth of what is normally considered viable for commercial mining, and therefore wasn't of sufficient quantity to make any difference to the lives of the island's twenty-three inhabitants. The discovery did, however, throw up the interesting possibility that platinum could also be deposited in other parts of Scotland.

If you are crazy enough to even consider the idea of actively searching for platinum, I'd seriously suggest you reread the gemstone chapter, and in particular the bit about diamonds. Come to think of it, if you are happy to search for something you have absolutely no chance whatsoever of finding, read the bit about the Holy Grail (*see page 244*). Having said that, I did find one record of a mineral sample containing platinum that was found at Kynance Cove on the Lizard Peninsula in Cornwall, although judging by the few tiny specimens known to exist globally, heaven knows what this was like.

Meteorites

As a treasure hunter, the most valuable metal, gram for gram, you can find anywhere on Earth doesn't originate on Earth at all, but comes from space. Welcome to the hideously difficult but ridiculously lucrative hobby of meteorite collecting.

Having just read about platinum, you may think I'm now moving beyond the bounds of reason for the treasure hunter, but this is not necessarily so. If records are anything to go by, and they are what I often go by, meteorite falls are far more common in Britain than platinum finds. Moreover, their values can be truly startling. In financial terms you can draw the comparison that silver is to gold as platinum is to meteorites, in other words at least a hundred times more valuable.

Meteorites can fall anywhere at any time, even in your own back garden. One did precisely that, in the Glatton fall of 1991. There have been other similar meteorite falls. One meteorite fell through the roof of a house in Perthshire in 1917, and more recently another bounced off a car. Before I go into detail about some of the meteorites that have fallen in Britain, let's get the definition out of the way. There is often a great deal of confusion about what is and isn't a meteorite, and there are several different types.

What is a meteorite?

Meteorites are some of the oldest rocks in the universe. They predate the Earth, at 4.5 billion years old. No two meteorites are ever the same, and structural and compositional features make each one unique. Everyone knows, usually from the news headlines, that meteorites can fall to Earth, and even occasionally do so in Britain. What exactly is a meteorite and where do they come from, and what is the difference between a comet, an asteroid and a meteorite?

Comet This is a celestial body that travels around the sun, usually in a large elliptical orbit. A comet's nucleus is frozen and vapourises when passing near the sun, forming a characteristic long luminous tail. Famous comets have included Haley's, Hale-Bopp and the more recent Shoemaker-Levy 9, which collided with Jupiter in 1995. Comets themselves do not actually fall to Earth, but they can occasionally collide with other material and cause it to do so.

Asteroid These ancient solid bodies move around the sun. Most asteroids are contained within what is called the asteroid belt, which is located between the orbits of Jupiter and Mars. Asteroids can be anything from the size of a boulder to several hundred kilometres across. When larger asteroids collide, material can sometimes be thrown out of orbit and, if caught by our planet's gravitational pull, can make it to Earth. Also, like comets, asteroids can strike other celestial bodies; this is how very rare lunar and Martian meteorites occasionally fall to Earth.

Meteorite Almost all meteorites were originally pieces of asteroids. What are called meteoroids orbit the sun or planets, and are occasionally captured by the Earth's gravitational pull. As a meteoroid enters the Earth's atmosphere, a visible streak of light called a meteor is produced by the high temperatures as it enters the atmosphere and breaks up. Dust-sized meteors, known as shooting stars, burn up before reaching the Earth. If parts of a meteoroid survive the passage through the atmosphere and reach the Earth they become known as meteorites.

Types of meteorite

The starting point for meteorite classification is the ratio of metal to rock present. In terms of composition there are basically three types of meteorite.

- The most common types of meteorite, if common is an appropriate term when talking about meteorites, are the stony varieties. Stony meteorites are made up of solid rock and have little or no metal content. Over 80 per cent of meteorites that fall to the Earth are of this type.

- The second most common meteorites are the stony–iron varieties, defined as having about equal parts silicates (stone) and metal (nickel and iron) present.

- The rare meteorites are the iron varieties, which are entirely composed of metal.

Lunar and Martian meteorites

The phenomenally rare category of meteorite includes those that have been proven to have originated from either the Moon (called lunar meteorites) or Mars (Martian metorites).

We know that planets and the Moon are occasionally struck by asteroids because of the evidence left in the form of craters. Some material from these collisions can occasionally make it to the Earth, but its rarity should not be underestimated. Meteorite falls are unusual anyway, but only about one in 3,000 is composed of lunar or Martian material, and there has never been one recorded in Britain.

If Martian and lunar meteorites are authenticated through known chemical compositions they immediately become of considerable interest to scientists. Meteorite ALH84001, which fell to the Earth in 1996, caused quite a stir in the scientific community. Some believed it contained evidence of early life on Mars.

Meteorite occurrences

Meteorites fall to the Earth randomly and should therefore be found in equal quantities all around the world, relative to land mass. The reality is quite different. Meteorites deteriorate or

become hidden much quicker in some environments than in others, and Britain is a case in point. Meteorites are generally found in areas where they can be spotted quickly and easily, or where conditions help to preserve them, such as on vast expanses of ice or dry, arid parts of the world like deserts. Arizona in the US has more meteorite collectors per square mile than does anywhere else on the Earth. Marvin Killgore, who lives there, hunts for meteorites professionally and has the largest private collection in the world. Some of his meteorites originate from the Moon and are worth several million dollars each. Oman is also a relatively new collecting hot spot, and hundreds of new finds from there are currently awaiting classification.

One of the main problems associated with hunting for meteorites in Britain is the climate. Temperate conditions cause iron content in meteorites to deteriorate, and vegetation and soft soil quickly conceal any falls. Of the 20,000 or so meteorite falls that have been recorded around the world, only twenty-three have so far of any certainty been in Britain. Yet it is estimated that there are between thirty and seventy falls in Britain each year, and that there could be as many as 70,000 meteorites lying around as yet undiscovered. British meteorites are on record from as far back as the fourteenth century, and the vast majority has been of the most common, stony variety. A couple of famous meteorite falls were recorded relatively recently at Glatton and Barwell.

On Christmas Eve 1965, residents witnessed a meteorite fall in **Barwell**, Leicestershire. Pieces bounced off a car, one smashed a window and another left a hole in a driveway. Locals and collectors scoured the area, and 44 kilos of material was collected. Rocks from pea to melon size were recovered, and some pieces were worth tens of thousands of pounds. Interestingly, although the area was thoroughly searched at the time, other pieces of meteorite have since come to light in guttering. Food for thought ...

On 5 May 1991, Arthur Pettifor was gardening at his home in the village of **Glatton** in Cambridgeshire. He heard a crashing noise in the conifers and went to investigate. He found a small black stone, about three-quarters of a kilogram in weight, which was still warm to the touch. The meteorite was soon authenticated, and Mr Pettifor used it to raise money for his local church before the meteorite was eventually acquired by the Natural History Museum. Had Mr Pettifor not been in his garden, this meteorite would never have been discovered.

There have been several other recorded meteorite falls around Britain. Here is a list of a few from the past couple of hundred years:

- Yaddlethorpe, North Lincolnshire – 1963.

- Ashdon, Essex – 1923.

- Appley Bridge, Lancashire – 1914.

- Middlesbrough – 1881.

- Harrogate, North Yorkshire – 1842.

- Basingstoke, Kent – 1806.

- Glastonbury, Somerset – 1806.

- East Norton, Leicestershire – 1803.

Searching for meteorites

The best time anyone has of finding a meteorite is immediately after a fall. The most effective technique is to use a metal detector, which will register any metallic content in a piece of rock. Another method is by using what is called a meteorite cane, which is basically a strong magnet attached to the end of a walking-type stick.

Most meteorites are smaller than an orange, very heavy, angular and black, although in Britain they may have a rust

red-brown hue. The main distinguishing features of a meteorite are the thumb-like prints on the outer surface produced as the fusion crust forms when melting occurs as the meteorite enters the Earth's atmosphere.

Areas to look for meteorites include places where rocks are visibly out of place. Farms are a good bet – farmers remove stones from ploughed fields to protect machinery and they may discard one nearby, or even use an unusually heavy one as a doorstop. Avoid coastal areas, since the tide and salt will quickly destroy a meteorite.

One of the main reasons why meteorite finds are so rare in Britain, besides the conditions, is that they can so easily be mistaken for other material. Iron pyrite or industrial slag are two main culprits, but because of their colossal value potential meteorites are certainly worth keeping an eye out for.

Finally, just to dispel one myth – meteorites are not white-hot when they hit the ground!

Meteorite values

Depending on which way you look at it, a piece of meteorite can vary from being absolutely stratospherically expensive, to almost unbelievably cheap. Surprisingly, you can buy yourself a genuine piece of meteorite on the open market for as little as $1 (50p). You only get about one gram's worth, but that's still extremely reasonable when you consider what meteorites are.

Even more surprising, in my view, as only three examples exist in private hands, is that pieces of genuine lunar meteorite are also available on the open market, and again are comparatively affordable. Of the 20,000 or so meteorite finds that have been recorded around the world, only about sixty have been lunar and fifteen Martian, yet I found a fleck of properly authenticated lunar meteorite, visible to the naked eye, on sale from a reputable dealer for $25 (£12). There were also several other specimens priced at around $50 (£25) per square

millimetre. Although this all sounds very reasonable, it still works out at over $1,000 (£500) a gram, and there were some other samples that were much more expensive.

The simple fact is that if you found a kilogram piece of lunar rock anywhere in the world, which you could easily hold in the palm of your hand, you could instantly consider yourself a millionaire. Equally interesting is the British market. The prices charged for meteorites by dealers depend not only on the rarity of the class of meteorite, but also on the amount of material available from any one fall. Meteorite collectors are interested in the fall itself, the event, and as there have been so few in Britain, and the amount of material made available has been so comparatively little, the desire for British meteorites has driven prices up to levels comparable with lunar falls on the world market. Meteorites found in Britain have historically been significantly more valuable that those from elsewhere and this will probably always continue to be the case. This is partly due to the lack of falls, but also to the fact that the majority of British material has ended up in museums, and museums don't sell, although they have been known to trade for specimens they want. That $1 (50p) a gram world price needs to be multiplied by a least a hundred for a British sample. It's also worth noting there seem to be a lot more 'sold' than 'for sale' signs attached to British meteorites.

Rob Elliot owns one of the largest meteorite dealerships in the world, and coincidently lives in the UK. He has a private meteorite museum, and runs a dealership called Fernlea Meteorites in Scotland. Rob is one of the few lucky people to have actually found a meteorite in his twenties, which he sold to Patrick Moore for £23. Fernlea Meteorites and other dealerships around the world are very keen to obtain any new meteorites, particularly from Britain. Here is an approximate guide to current prices being asked for samples from witnessed falls throughout Britain:

- Slices of the Wold Cottage fall (1795) – $350 (£175) per gram.

- Slices of the Appley Bridge fall (1914) – $200 (£100) per gram.

- Slices of the Perthshire fall (1917) – $250 (£125) per gram.

- Fragments of the Barwell fall (1965) – $100 (£50) per gram.

- Fragments and slices of the Glatton fall (1991) – $750 (£375) per gram.

Rob Elliot's address can be found in Further Information (*see page 276*).

Truffles

'Truffles in Britain? You have got to be joking!' That was the less than helpful remark I received from one foodie friend upon mentioning that I was covering truffles in this book. As mentioned earlier, truffles are second of only two edible subjects covered in this book.

I do find truffles intriguing, not least because they are traditionally only associated with Italy and France, and yet just 25 miles across the Channel the general perception is that they don't exist at all. Maybe it's the soil, maybe it's the climate or maybe it's the absence of one of several other factors that contributes to the reason why even experts are sometimes unable to properly explain why these culinary gold nuggets grow in certain regions but not in others. Truffles are, however, found in Britain, and besides the fact that they are considerably valuable, just the fact that they grow in Britain warrants their inclusion in this book.

What is a truffle?

Being a man of simple tastes, in food in particular, I had to defer to others better in the know to properly grasp the passion

truffles invoke in both chefs and people with refined palates and deep pockets. Earthy, sensuous, pungent, erotic, mystical and intoxicating are just some of the words kindly lent to describe truffles.

One variety of subterranean fungi associated with certain areas of southern Britain is called the English Black Summer Truffle (*Tuber aestivum*). English truffles are dark in colour, have a knarled surface and a marbled beige inner flesh, and are nutty in flavour and less aromatic than their European counterparts.

Where are truffles found?

One of the earliest culinary references to truffles from Britain can be found in Isabella Beeton's *The Book of Household Management* (1861). In it she writes that the common truffle can be found in Hampshire, Wiltshire and Kent. There are also other early reports of truffle hunting in Britain. William Leach, who arrived from the West Indies in the 1800s, had such a love of truffles that he embarked on a four-year quest to find the best in England. He finally settled on Patching, near Findon, West Sussex and established a thriving truffle-collecting business that saw him through the rest of his days. Around a hundred years later, an Irish lady called Mary Hick also spent her days near Patching collecting truffles. She was renowned for evading trackers who were keen to know the source of her abundant wares, a secret that she apparently took to her grave.

Truffle hunting was a popular pastime in Britain right up until the Second World War, particularly among people who were suitably placed, such as farmers, fruit pickers and travellers. One of the last known professional truffle hunters in Britain was a man called Alfred Collins who worked, as many others did, the Winterslow area of Wiltshire until his retirement in 1930. It was said that on a good day he could collect 10 kilograms of truffles, and that he had such a high regard for his two dogs (*see below*) that he carried them home in hand-crafted

leather baskets attached to his bicycle. Even today, there are still a few truffle hunters in the Wiltshire area, and there are organised truffle hunts on the Longleat estate.

How are truffles found?

An established method of searching for truffles is by using either trained dogs or pigs. Alfred Collins used two Spanish poodles, which have great scenting powers and can detect truffles from several metres away. Dachshunds and other breeds of dog have also been used, and it is said that William Leach used pigs.

One method employed to train animals was to rub pieces of truffle on their noses, and to also give them small pieces of bread in which truffles had been wrapped, which of course encouraged them to seek out more. It is documented that some of the better two-legged truffle hunters could actually sniff out truffles themselves, and even feel them underfoot. I doubt, however, whether this is of any help to the amateur. It is assumed that you own neither a pig nor the relevant breed of dog, but luckily it is possible to hunt for truffles without four-legged help, and there are still a few areas in which they can be found.

Forests and woodland containing beech and oak trees are the best truffle-hunting grounds, although silver birch, chestnut, hawthorn and more than one variety of conifer are also associated with them. Beech or oak in particular, combined with one other species in an established locality, might offer a fighting chance of finding them. Soil is also important; it needs to be dry and light, chalky or clay.

The truffle-hunting season starts in late summer and goes through to February or March. One clue to the location of a truffle can be small clouds of yellowish flies hovering above a patch of ground near to the roots of a tree, or even a fly that can be roused by poking around with a stick. The British truffle typically grows to 25 mm and usually lies no more than 250 mm

underground, and more often than not just beneath the surface. Care should taken to recover truffles undamaged.

What are truffles worth?

British truffles are not as valuable as their European counterparts. The main reason for this is that connoisseurs now prefer the more aromatic French and Italian truffles, and let's face it, if you are going to spend ridiculous amounts of money on fine dining, you may as well have the best. Truffles can be preserved, but I am told that they are best eaten soon after they have been collected as their flavour quickly dissipates, and they are particularly delicious shaved raw onto pasta and omelettes.

In 2004 a 10 kilogram crop of truffles was discovered near the village of Bedwyn on the Wiltshire/Berkshire border. The exact circumstances of the find remains a mystery, but it was of a size unheard of in sixty or seventy years. It is believed that the spores may have travelled in the dung of imported beef stock. Some of the truffles were bigger than anything previously recorded. One alone weighed nearly half a kilogram and was worth £150 by itself. The total crop was valued at £3,000.

If the idea of searching for truffles seems a little too labour intensive, you could consider growing your own. One company offers truffle-impregnated hazel or oak trees from £25, but this approach has been tried numerous times on the Continent and the success rate is abysmally low. This doesn't appear to have deterred the royal family, though. Unlikely as this may sound, it is understood that the Duke of Edinburgh was planning a truffle farm at Sandringham.

Prehistoric treasure

With the exception of bottles, gemstones, fossils and perhaps gold, the vast majority of treasure these days is found with a metal detector. The clue, as they say, is in the title. Metal

detectors are useful instruments, but to work at all an artefact of course needs to be at least in part made of metal. The problem with metal is that it has only been around for 5,000 years, whereas humans have been around for a lot longer. Welcome to treasures of the Stone Age.

One of my earliest memories of treasure was at junior school, in the form of our formidable form teacher, Mrs Simmonds. Among her other peccadilloes, she would regularly inform us that she selflessly walked 10 miles every day across the local hills, come rain or shine, simply to educate us. One day she produced a piece of grey stone, or at least that's what it looked like to us ten-year-olds, but, as she enthusiastically explained, it was in fact a flint axe head.

Much of whatever else she told us about the artefact is now as vague as the rest of my education, but I do remember that she eventually gave it to a museum. I know the hills very well, though. I have walked them several times since and have always kept my eyes open. All this happened over thirty years ago, and despite her extremely sprightly manner I suspect that as Mrs Simmonds was nearing retirement then, she is probably no longer with us.

Material evidence such as this provides the only insight we have into the lives of the people who lived in prehistoric Britain, since there was no written word. Prehistoric Britain was a hostile environment. Bears, wolves and lynx still roamed the land, and there were probably many tribal conflicts. Weapons must have been used not only for hunting, but also for defence.

Some 16,000 years ago the Ice Age retreated from what we now call Britain, and it was still part of the European landmass until the English Channel was formed in around 6500 BC. Early Britons were nomadic hunter-gatherers. They used stone, flint, animal bone and other simple materials for tools and weapons. Settlers began farming in Britain in 3000 to 4000 BC, and buildings were constructed from wood felled with stone axes from

the vast forests that still existed. Flint was masterfully worked and eventually sophisticated weapons, such as the bow and arrow, were developed. Finely crafted tools and earthenware were made, as well as items for personal grooming like antler combs. These early tools and weapons were treasured and some had religious significance; axes and other implements have been discovered in ancient burial mounds.

Searching for early worked flint is probably most productively achieved in conjunction with other treasure hunting such as metal detecting. The likelihood of making a find otherwise is too remote. Although there are obvious flint locations around Britain, it would be safe to assume that as prehistoric treasure has been found as far north as the Hebrides and as far south as Cornwall, you have as good a chance wherever you are. The techniques employed by beachcombers – looking when the sun is low on the horizon, in the early morning or evening if possible – and keeping your eye out for shards of grey stone that seem out of place work reasonably well. Those doyennes of the metal detector hoard, ploughed fields, are perfect flint-hunting locations. Places to avoid include mountain pathways in primary geological locations, where billions of shards of stone would drive you insane.

Stone Age finds

A five-year-old boy recently found a 6,000-year-old axe head while searching for pottery with his mother in a field in West Malvern, Worcestershire. The axe head, which looked like a large, smooth stone, was taken to the Ashmolean Museum in Oxford for closer examination.

In 2004 Jamie Stevenson was walking his dog along Portsmouth beach. He picked up a stone to skim across the water, but noticed that the edges were sharp. Hampshire Museum's archaeological department described it as a nice example of a flint axe, probably used in Stone Age carpentry

some 8,500 years ago. The axe head was returned to Mr Stevenson.

The law regarding finds is different in Scotland. In 2003 a man from Fife found a 6,500-year-old axe head, which was immediately claimed by the Scottish Crown. The finder's position was that he didn't steal it, or ask to find it, and therefore it belonged to him. Police were called in and, facing prosecution, he was eventually forced to hand it over.

Legal requirements and codes of practice regarding all forms of treasure hunting have been outlined in other chapters (*see pages 000* and *000*), so they will not be covered here again. If you should make a find of this nature, even if you are within the law, it would be a little remiss not to report it. It could lead to an important archaeological discovery, or at the very least a local museum might appreciate the donation.

Values of prehistoric finds

The above considerations seem to be reflected in the fact that there is very little of this material for sale, but for the diehard capitalists out there I did manage to find these few examples:

- Very large Neolithic battleaxe or axe hammer, well worked, pale green stone – £325.

- Neolithic battleaxe or axe hammer, splayed blade, hole through centre, found in northern England – £210.

- Neolithic arrowhead, found in Northampton – £25.

- Neolithic scraper/arrowhead, undamaged, crudely worked, found in Eye, Suffolk – £25.

- Neolithic knife, light grey 'flint blade' with worked edges, undamaged, found in Eye, Suffolk – £15.

- Small Neolithic scraper, light grey, undamaged, crudely worked edges, found in Lincolnshire – £5.

Dowsing for treasure

In the late 1970s a businessman local to us bought an entire school that he wanted converted into a private residence, and the building contractor I was working for at the time got the job. The property was 250 years old, and I was present when the oak floorboards were pulled up in the old hall, revealing a thick block of dust around the side that contained numerous old finds including some coins. One task was to locate the old drains, and in particular where they converged before joining the main system. The problem was, the drains were so archaic that even the combined knowledge of several experienced builders could only pin them down to an area about the size of a living room, and no one knew how deep they were.

Being a young labourer at the time, finding the drains fell to me – or more precisely to me and a much older chap, who thankfully immediately decided that desperate situations called for desperate measures. He took two metal wall ties, unpicked them and formed them into two L-shaped dowsing rods. With surprisingly little ribbing from the workmen who had gathered to watch, he plotted the area and selected a location, and in the absence of any better suggestions we began digging. About 5 feet down we found where the pipes converged, and to be absolutely fair he was no more than 3 feet out. Of course this could have been luck, but he also plotted the correct direction of the drain.

If it wasn't for that one event, I would frankly have seen dowsing as something that was strictly the preserve of the Glastonbury set. Generally, when I hear the words harmony and energy presented as material evidence for something, I feel an eyebrow involuntarily rising. However, much in the same way as I can't understand why as a Libran I am so much like a Libran, as opposed to those who are not Librans, I believe that the fact that so many people do believe in dowsing, and that so much

appears to have been discovered using the technique, warrants a little investigation. (By the way, the astrology comparison was drawn long before I found the quote at the end of this chapter ... how spooky is that?)

The history of dowsing

How far the art of dowsing actually goes back through history depends on when you want to start counting. There is a 4,000-year-old engraving on a statue that appears to be of a dowser, and a passage from the Bible has been interpreted as referring to it. Certainly, by the fifteenth and sixteenth centuries, in Germany in particular, dowsing was an established art used for prospecting, and during the seventeenth century a French baroness travelled throughout Europe with her husband successfully locating mineral deposits including some gold and silver. In the same century a book was written on the subject, which was later translated into English, and in Russia dowsing was taught as a science.

What is dowsing?

Take a couple of pistol-shaped rods or a forked hazel twig, walk up and down a field until they twitch or cross, and directly beneath your feet is where the gold will be buried. Add the odd theory about magnetism and you have the sum total of most people's understanding of dowsing. Of course, this is not what dowsing is about at all – your intuition tells you that. Moreover, once you accept you have intuition – something else that also bears no scientific scrutiny – you only need to take one further step to embrace dowsing as something that may be credible.

Because so many different techniques are used by dowsers, including remote dowsing, which involves using a pendulum above a map to locate a distant object, you have to accept, if you are going to believe dowsing works at all, that something beyond the physical is occurring. There are two ways to look at

this. Either you can believe something is fact simply because someone tells you it is, or you can accept something is possible because there is sufficient evidence to support it, but you simply can't explain why, which is my stance.

I would leave it at that, but having had to trawl through reams of mainly esoteric psychobabble trying to find some consensus of intelligent opinion as to why dowsing appears to work beyond reasonable probability, I now feel I'm entitled to an opinion. The dowsing rod is apparently seen more as a conduit between the self and the target, rather than as a tool in itself, so dowsing could be an as yet unexplained extension of our five senses – possibly a gift all of us possess – and the degree of success each of us achieves may be dependent on how attuned we are.

Dowsing techniques

People have used dowsing to look for and find just about everything, from treasure, to minerals, water, pipes and power lines. There is even remote dowsing, mentioned earlier, which has been known to locate missing people. There is also a technique called personal dowsing, which looks into issues of health, diet and allergies. What most people traditionally understand as dowsing involves looking for something in close proximity to a possible source.

The four main types of dowsing tool are:

- **Rods** L-shaped rods, usually in a pair. These are typically made of metal such as coat-hanger wire.

- **V Rod** Forked twig, traditionally made of hazel but can be either plastic or metal.

- **Wand** Long rod held in the hand. A find is indicated by circular or oscillating movements.

- **Pendulum** Heavy weight such as a metal nut attached to twine, but many variations have been used.

One technique of dowsing associated with the most commonly used rods is as simple as one could hope to expect. A rod is held in each hand by the shorter end, with the long ends facing directly in front and parallel to the ground. They should be held with minimal pressure, allowing them to swivel freely. The area you wish to search should be walked carefully and when the target is located the rods should cross. Dowsing tips include:

- Approach the area from different angles to accurately identify a target spot.

- Walk alongside a target so that the rods may move to indicate its position.

- Prepare yourself by clearing your mind, and carry a piece of what you wish to find.

Things located by dowsing

The range of finds claimed to have been made by dowsers is fairly extensive. A remote dowser was once called in to locate a couple who went missing in their car in Canada. Observers were mystified when the dowser identified a spot on a map that was in the middle of a lake. Divers were called in, and they made a macabre discovery. The couple had driven across a frozen lake, and had fallen through.

There are many recorded examples of oil strikes credited to dowsing. In 1943 a farmer convinced a wild-catter (an independent oil explorer) called Ace Gutowski that oil lay beneath his land. The claim rested on nothing more sophisticated than a bottle dangling from a watch chain, but it turned out to be the largest oil strike in Oklahoma in twenty years. Dowsers have also been employed in mining and exploration projects. Boreholes have been the most common targets, and many professional dowsers claim to have a 90 per cent plus strike rate.

There are several historical references to ore being found in

Britain using dowsing, particularly lead and tin. Britain's most successful dowser is Jim Longton, a retiree who lives in Euxton, Lancashire. He first discovered he had the skill to instinctively locate things as a young boy. Finds credited to Jim include Viking silver brooches worth £40,000 in 1990, and his latest find, a seventeenth-century shipwreck. He is currently looking for more shipwrecks for salvage companies.

If you are sceptical about dowsing, and prefer to take the view that as there is no scientific explanation common sense should prevail, I'll leave you with this quote:

> I know very well that many scientists consider dowsing as they do astrology, as a type of ancient superstition. According to my conviction this is, however, unjustified. The dowsing rod is a simple instrument which shows the reaction of the human nervous system to certain factors which are unknown to us at this time. *Albert Einstein*

You may be interested to learn that there is a British Society of Dowsers that publishes a quarterly magazine and a good British book on the subject, both of which are listed in Further Information (*see page 276*).

Further Reading

Books

Adamson, G. F. S., *At the End of the Rainbow – Gold in Scotland*, Goldspear (UK) Ltd., 1988.

Blakeman, Alan, *Bottles and Pot Lids – A Collector's Guide*, Millers, 2002.

British Museum, *British Fossils* (3 books), Caenozoic, Mesozoic, Palaeozoic (Natural History), British Museum.

Callender, R. M., *Gold in Britain*, Goldspear (UK) Ltd., 1990.

Camm, Simon, *Gold in the Counties of Cornwall and Devon*, Tormark Press, 1995.

Firsoff, Val Axel, *Gemstones of the British Isles*, Oliver & Boyd, 1971.

Fletcher, Edward, *Buried British Treasure Hoards and How To Find Them*, Greenlight Publishing, 1996.

Hedges, A. A. C., *Bottles and Bottle Collecting*, Shire Publications Ltd., 1975.

Muller, Helen, *Jet Jewellery and Ornaments*, Shire Publications Ltd., 2003.

Weller, Sam, *Let's Collect British Gemstones*, Jarrold Colour Publications, 1976.

Magazines

Antique Bottle Collector, www.abc-ukmag.co.uk

BBR (*British Bottle Review*), Elsecar Heritage Centre, Barnsley, S. Yorks s74 8HJ. Website: www.onlinebbr.com

Common Scents Magazine, www.commonscents.org.uk

The Searcher, www.thesearcher.co.uk

Treasure Hunting, Greenlight Publishing, The Publishing House, Hatfield Peverel, Chelmsford, Essex CM8 1WF. Website: www.treasurehunting.co.uk

UK Journal of Mines & Minerals, www.ukjmm.co.uk

Further Information

Clubs and organisations

National Council for Metal Detecting – General Secretary,
51 Hill Top Gardens, Denaby, Doncaster DN12 4SA.
Website: www.ncmd.co.uk

The Federation of Independent Detectorists –
http://fid.newbury.net

The Pot Lid Collectors' Society – K.V. Mortimer (Chairman), c/o
B. P. Collins Solicitors, Collins House, 32–38 Station Road,
Gerrards Cross, Buckinghamshire SL9 8EL. Tel: 01487 773194

British Shell Collectors' Club – www.britishshellclub.org.uk

The Gemmological Association of Great Britain – Membership
Department, Gem-A, 27 Grenville Street (Saffron Hill Entrance),
London EC1N 8TN. Tel: 0207 404 8843, Website: www.gem-a.com

The British Society of Dowsers – 4/5 Cygnet Centre,
Worcester Road, Hanley Swan, Worcs. WR8 0EA.
Tel: 01684 576969. Website: www.britishdowsers.org

Equipment and courses

Panning Equipment (Wales) – T. H. Roberts & Son, Parliament
House, Bridge Street, Dolgellau, Gwynedd LL40 1AH.

Gold Prospecting Courses – The General Office of the School
of Continuing Education, The University, Leeds LA2 9JT.

The Scottish Gemmological Association – PO Box 28309,
Edinburgh EH9 8AG, Scotland. Website: www.scotgem.co.uk

Museums

Gold Panning Equipment – Licences and Panning Instruction (Scotland), The Museum of Lead Mining, Wanlockhead, By Biggar, Lanarkshire, Scotland ML12 6UT.
Website: www.leadminingmuseum.co.uk

Mine Tours – Dolaucothi Gold Mines, Pumsaint, Llanwrda, Carmathenshire SA19 8US. Tel: 01558 825146.

Bottle Museum – Coddswallop Elsecar Heritage Centre, Barnsley, South Yorkshire S74 8HJ. Website: www.coddswallop.org

Whitby Museum – Pannett Park, Whitby, North Yorkshire YO21 1RE. Tel: 01947 602908. Website: www.whitbymuseum.org.uk

The Llywernog Silver–Lead Mine – Ponterwyd, Aberystwyth, Ceredigion, Wales SY23 3AB. Tel: 01545 570823
Website: www.silverminetours.co.uk

Fernlea Meteorites – The Wynd, off Dickson Lane, Milton of Balgonie, Fife KY7 6PY. Tel: 01592 751563
Email: fernlea4@aol.com

Additional Information

Department of Culture Media & Sport –
Website: www.culture.gov.uk

Portable Antiquities Scheme – The British Museum, Great Russell Street, London WC1B 3DG. Website: www.finds.org.uk

Metal Detecting Information – Website: www.ukdetectornet.co.uk

Bottle Digging Books and Information –
Website: www.antique-bottles-and-glass.co.uk

The most comprehensive database of mineral and gemstone occurrence online – Website: www.mindat.org

A comprehensive database of fossil-collecting locations in Britain – Website: www.ukfossils.co.uk

Index